First Light

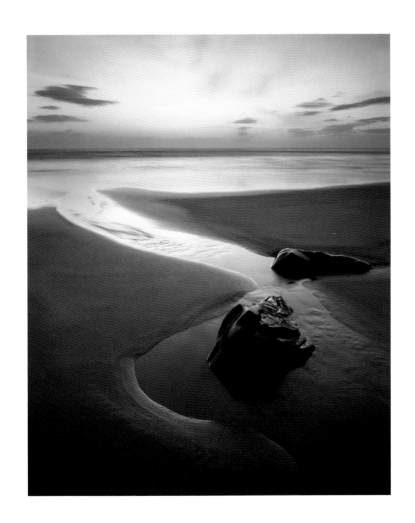

First Light

A Landscape Photographer's Art

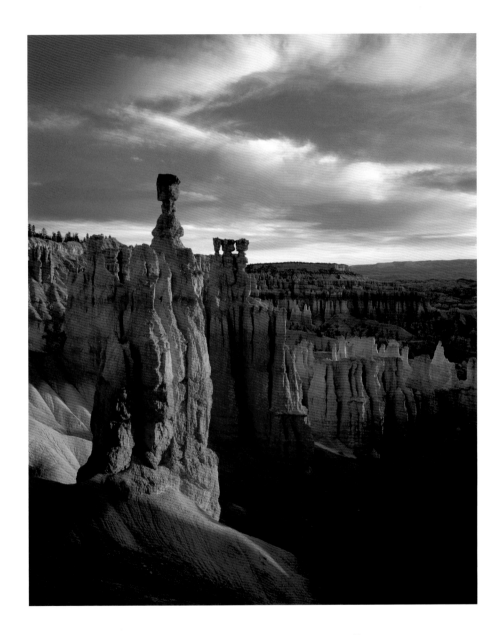

JOE CORNISH

Foreword by Charlie Waite

Argentum

First published 2002 by Argentum, an imprint of Aurum Press Ltd,
25 Bedford Avenue, London WC1B 3AT

ISBN 1 902538 24 2

1	3	5	7	9	10	8	6	4	2
2002		2004		2006		2005		2003	

Designed by Eddie Ephraums

Reproduction by Falcon Press (Stockton-on-Tees)

Printed and bound by CS Graphics in Singapore.

Half title page: *Sandy Mouth twilight, Cornwall*

Title page: *Thor's Hammer, Bryce Canyon*

Contents

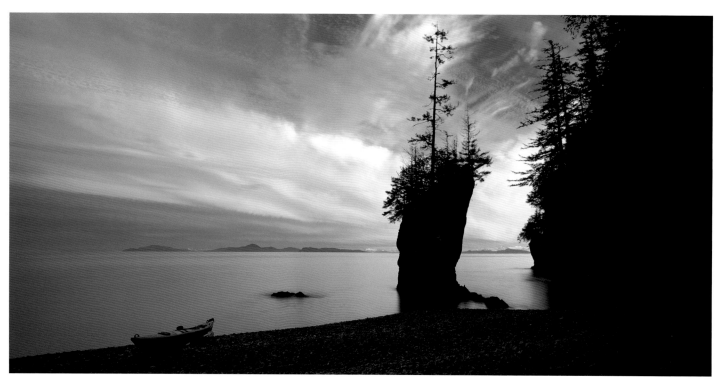

Prince William Sound, Alaska Joe Cornish

Foreword

When, after admiring an exhibition of work by a landscape photographer, a couple of visitors from the US were offered the opportunity of meeting the artist, they politely declined, saying that, although they had not met him in person, they felt that they already knew the man. In this instance the photographer was not Joe Cornish, but it might well have been. For anyone who has seen Joe's memorable and distinctive work will immediately realize that it is a true reflection of the nature of a man who is completely immersed in his art.

In landscape photography, technical competence is not enough. Too often, photographers fail to convey to their audience the emotional impact of the landscape that inspired them to take the picture in the first place. In Joe's case, however, his immense technical skills and his aesthetic judgment are always subordinate to his primary artistic purpose – to project his own feeling for his subject into the centre of the viewer's consciousness. Indeed, when I look at one of Joe's wonderfully observed images, I get the sense that he has almost literally seduced his subject, whispering and wooing it to disclose its most intimate secrets to him; for there can be no other explanation for the poignancy and the charisma that well up from deep within his photographs.

When we look at one of Joe's pictures we, in turn, are seduced and find ourselves compelled to commune with the landscape just as he did. We encounter no visual hurdles that might deflect or distort our understanding, instead we are presented with an image which enables us to transcend our mundane comprehension of landscape and transports us to an altogether higher level of appreciation. What we are witnessing is an exchange between photographer and subject matter mediated by Joe's finely tuned visual antennae, his deep reverence for the land around us and his ability to steadily and skillfully refine his work in the very measured way that large format photography demands.

In reading *First Light* we are not overwhelmed by technical details, which are introduced only insofar as they are relevant to the author's description of the making of the individual images. Instead we are offered a series of fascinating narratives, with thought-provoking references to the geological origins of the landscapes, which are perfectly pitched to enable us to roam through the book relishing the images while at the same time learning something of the feelings that inspired them.

As the title of this book suggests, Joe, like all visual artists, is acutely aware of the pivotal role played by light, and with his deep understanding of the nature of light he creates a gloriously burnished feel, particularly in his seascapes. In his first chapter, Joe argues that Light, together with Timing and Composition, is one of the three foundation stones upon which the craft of landscape photography is built. But there is surely a fourth, the art of seeing, and no one looking at this ravishing book can doubt that it is a gift which Joe Cornish has in abundance.

Charlie Waite

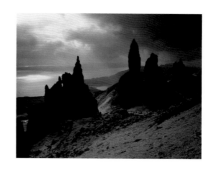

The photographs in this book are dedicated to the memory of
Vincent Diamond,

a true friend and a true hero

also,
to Jenny Earle, and our children, Chloe and Sam,
for tolerating my absences and supporting me all the way.

From 'This is the American Earth' by Ansel Adams and Nancy Newhall

To the primal wonders no road can ever lead; they are not so won.
To know them you shall leave road and roof behind;
* You shall go light and spare.*
You shall win them yourself, in sweat, sun, laughter,
* In dust and rain, with only a few companions.*

* You shall know the night – its space, its light, its music.*
* You shall see Earth sink in darkness and the universe appear.*
* No roof shall shut you from the presence of the moon.*
* You shall see mountains rise in the transparent shadow before dawn.*
* You shall see – and feel! – first light, and hear a ripple in the stillness.*
* You shall enter the living shelter of the forest.*
* You shall walk where only the wind has walked before.*
* You shall know immensity,*
* and see continuing the primeval forces of the world.*
* You shall know not one small segment but the whole of life,*
* Strange, miraculous, living, dying, changing.*

* You shall face immortal challenges; you shall dare,*
* Delighting, to pit your skill, courage, and wisdom*
* Against colossal facts.*
* You shall live lifted up in light;*
* You shall move among clouds.*
* You shall see storms arise, and, drenched and deafened,*
* Shall exult in them.*
* You shall top a rise and behold creation.*
* And you shall need the tongues of angels*
* to tell what you have seen.*

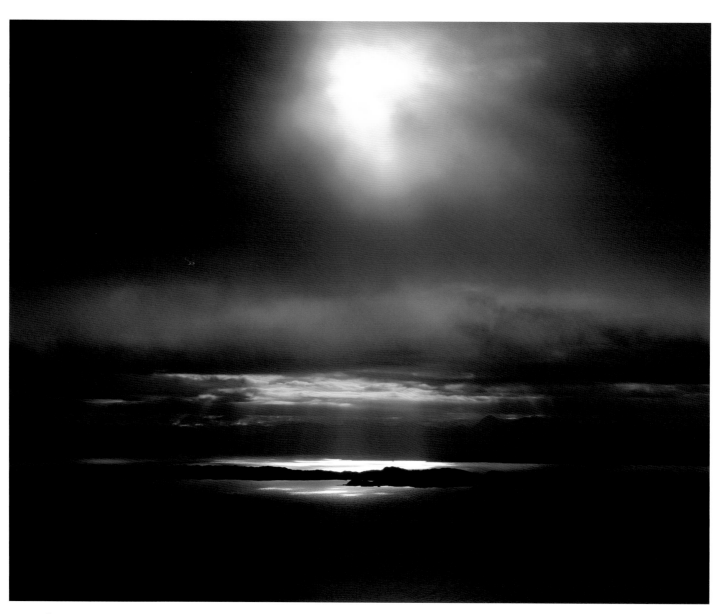

Dark sun, Rona, Inner Hebrides

Introduction: First Light

First, light. Everything else follows, for light is the language of photography as well as its raw material. As a poet uses words, so a photographer uses light.

My photography is an attempt to express the most beautiful and powerful qualities of the light that I encounter. When I plan to take pictures, it is planning for light, and when I make my pictures I seek to capture its essence. While I often use first light – dawn – I also work in the fading light – dusk. Sometimes I even work in the middle of the day, as this book will reveal. For the title is really about priorities. First? Light!

Striking and dramatic, soft and luminous, transient and dappled, the quality of light is intimately dependent on the landscape off which it is reflecting, so there is no single formula for perfect light. Tuning-in to its differing qualities and potential can be learned, but is largely also felt, sensed. If we 'feel' light, our pictures will touch hearts, have an emotional impact. Light is the doorway to emotion, and the landscape photographer must learn the combination that unlocks it.

All photographers must learn techniques of focus, and of correct exposure. Just the right amount of light for the film, neither more nor less, is a prerequisite of fine photography. Yet while light is the river on which our technique sinks or floats, it is also the sky above, the emotion and spirit in our work, conveying mood, atmosphere, meaning. Light is a universal language with depths and nuances I am still learning. That is why my journey as a photographer will continue to be guided by the simple rule: first, light.

Joe Cornish

TLC: Timing, Lighting, Composition

Develop an infallible technique, then put yourself at the mercy of inspiration.

Zen maxim

'The camera sees both ways,' as the saying goes. Forward to the outside world, backward into the soul of the photographer. But before the camera can see clearly in either direction, the photographer must master perception and craft. The technique of a photographer goes far beyond sharp focus and good exposure. In my view, landscape photography is built on three foundations: Timing, Lighting, and Composition – TLC.

While we live in a space–time continuum from which there is no escape, stills photography can deep-freeze moments of time. Like all genres of photography, landscape is the art of time capture, and the principle effect of timing is on the quality of light. But timing also affects the story in the picture. What moment do I choose to photograph? Does a flock of sheep graze the field in the middle distance? Is a climber captured on the skyline of a nearby hill? Is the exposure made as shadow passes across that distant mountain? Is the photograph of a tree made when wind movement will soften its branches? Is the sky clear, or full of ominous clouds? All these elements form part of a landscape story.

What about light, the raw material of photography? One of the paradoxes of shooting landscapes is that less light often makes a better picture. This does not mean under-exposure. It means that low sunlight, or twilight, or sometimes simply shade, will produce superior modelling, texture, colour, and atmosphere compared with bright midday sunlight. The phrase 'less is more' can certainly be applied in landscape photography. As the title of the book implies, landscape photography is the story of light and the photographer's relationship with it.

The word photography means 'drawing with light', and it is line, depth, shape, space and focus within the edges of the frame that creates composition. We may choose elements that suggest balance or tension, chaos or order, energy or serenity. We may prefer effects that have depth, or which are flat and two-dimensional. We can use lenses to stretch and exaggerate, or to compress and juxtapose, or which are neutral in perspective. We have, literally, infinite possibilities. Arguably, composition is the most distinctive signature of a photographer's style.

Out in the field I compose more or less instinctively. I strive to see the image in relatively abstract terms. The view camera presents the image upside down on the ground glass, which helps me see in a more abstract way. In life, our mind's eye ignores distractions and effortlessly zooms in and out on the focus of our immediate attention. Yet when we examine a finished print our eyes become remorselessly critical, spotting the photograph's every flaw and imperfection.

Part of the photographer's journey is to develop 'mind's-eye override'. This is what I mean by abstract seeing. We must learn to see truthfully what is there in the viewfinder, whereas our mind's eye sees only what it wants to. We must learn to see the world through the eyes of the camera and film, understanding their strengths and limitations. Only then can we learn to master composition. Only then do we truly draw with light. And only then will the camera truly see both ways.

The ancients

The Isle of Skye is the largest and best known of Scotland's Inner Hebrides and the magnificent Cuillin Hills in the south of Skye are a magnet for British mountaineers and climbers. Although there are higher mountains on the Scottish mainland, it is said these are the only peaks in the United Kingdom that truly require technical climbing skills.

While the Cuillin draw the most attention from tourists, walkers and climbers, photographers are more likely to be drawn to Trotternish in the north. The long mountain ridge running north–south along the peninsula has a series of uniquely dramatic rock features on its eastern face. The highlights occur at the Quiraing in the north and at the Storr in the south. It is the Storr that has the most photographic potential.

The main photograph here was taken on my very first visit to the Storr, and is of the Old Man, a gigantic spearhead-shaped tower, and its family of ancient rock turrets which glower beneath the Storr itself. To get there involves an ascent of around 300 metres from the road below, and with the aim of capturing first light I had set off well before dawn. Some blue patches of sky had given me hope, but banks of cloud kept snuffing out the influence of the rising sun.

I used the time to explore the sheltered area between the Old Man and the mountain, suitably known as The Sanctuary. After three hours, hunger was beginning to get the better of me, when I realized a break in the cloud was tracking east and the sky was lightening. I had time to set up the one angle I was confident would work backlit. In anticipation of what was to come I decided to use a warming filter (for I knew the overall lighting balance was cold) and a neutral density graduate, knowing the filter would tend to silhouette the towers. For a fleeting moment a shaft of sunlight passed across the scene. I made my exposure and reloaded as quickly as I could. Although I took one more picture, the light had gone. By midday I had finally managed to eat some breakfast, but it was over a week before I saw the processed film and knew the morning had been worthwhile.

Theatre of light

A couple of years later I returned to Skye, accompanied by my friend David Ward. We had both set aside some days for personal photography. It was inevitable that the Old Man of Storr would be a favourite subject, and the small image on this page was shot on one of our early morning missions.

The higher viewpoint reveals the epic scale and grandeur of the Old Man's setting. A loch in the middle distance, the coast with the waters of the Minch beyond, the island of Rona, and, on the horizon, the Cuillin hills, all create a fantastic backdrop. It was a glorious midsummer morning with a perfect cloudscape to complement the clear blue sky. And yet, somehow, this lighting does not suit the landscape as the brief sunbeam had done in my original version. Silhouettes and darkness seem more compatible with a landscape that could be a setting in the Lord of the Rings.

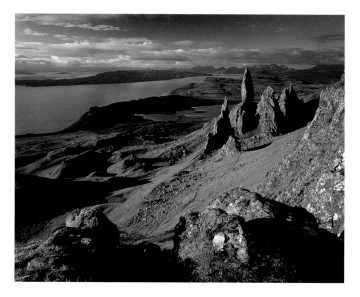

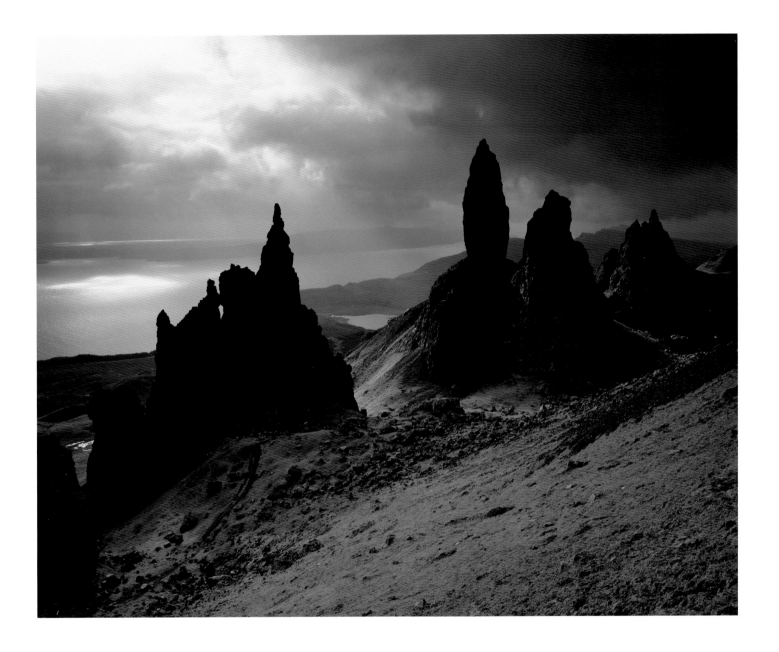

Time traveller

A mountain stream is quite literally a cutting-edge zone in the landscape, and a rocky streambed is, in geological time, an area of permanent change. High rainfall, freeze/thaw and steep topography combine with gravity to promote rapid erosion. Much of the loose material lying in the stream – the gravel, stones and boulders – originated at higher elevations and arrived in floodwaters. In a real sense these are 'landscapes in transit'.

This chunk of red rock in Arklet Water in the Trossachs of Scotland makes a good example. Most of the rock around it is part of a highly convoluted section of the stream, characterized by undercutting and sinkholes. In this steep passage of the watercourse, most loose materials have washed downstream to a calmer stretch, but this red boulder has become wedged *in situ*.

Clearly different from the bedrock where it is stuck, its colour tells us it did not originate here. Perhaps it was carried by floodwaters, but it may have hitched a ride on a long-since vanished glacier for part of its journey. It might have been plucked from a mountainside, or it might have been a fragment of some much larger rock on a mountaintop. It might be thousands of years old, or millions. What we can be sure about is that its journey has yet to end, even if its fate is to be broken up into ever smaller fragments, so that it eventually returns to the sandy form from which it came. For that is the fate of rock: to travel through time in a never-ending cycle of creation and destruction. Every landscape, however small, may tell a long and violent story, if you can read the clues.

In the main photograph, shot in September after a long dry spell, a shaft of sunlight has managed to penetrate the leafy canopy that fills the valley. The blue sky reflects in the water, creating a dramatic chromatic contrast. To capture the colour as I saw it I knew would require filtration because, even with the sun, the ambient colour balance beneath the bridge was very cold. I selected an 85C warm-up, which might seem like a drastic step, but the well-preserved blues indicate it was the right choice.

The cold light of day

The smaller picture on this page is of exactly the same spot, made the previous year with a wider-angle lens. There was more water in the stream, and I made no effort to correct for the colour. I remember being surprised, when I saw the transparencies at the lab, that the red of the rock had been almost snuffed out by the cold light.

The long exposure in both versions eliminates detail in the water, an effect which here sets off the rock quite well. For me the colour is so much a part of the story that it is the main image I prefer, although there are some aspects of the early version that I feel are better. The best of both worlds might be a combination of the colour of the main image with the composition of the early one. No doubt I shall return to this stream again.

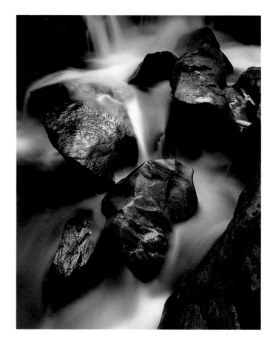

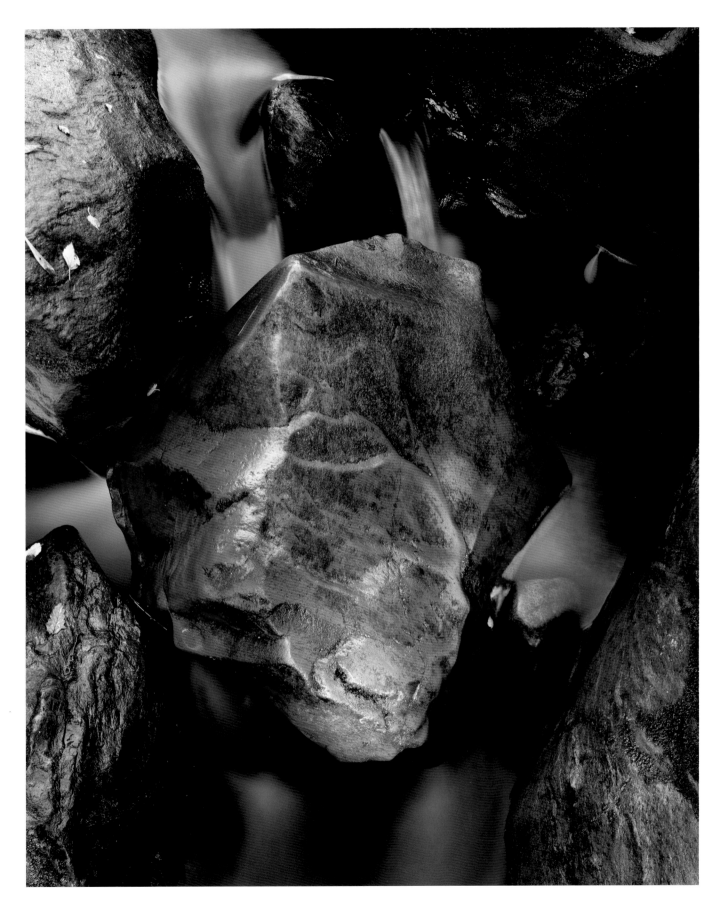

A winter's tale

I spend more time photographing landscapes in the winter than in any other season. Ice, snow and frost can all be inspiring subjects, naked trees provide a stark, graphic contrast with the soft luxuriance of summer, and even the colours can be more rich and sharp in winter than at other times of year. Of all winter's highlights, softly fallen snow is outstanding, transforming the landscape briefly into that magical place we call winter wonderland.

In Britain, at least, part of that magic is in its rarity. Where I live in North Yorkshire, snow falls an average of four or five times each winter. It usually arrives in showers driven on a strong northerly wind. The white stuff may briefly stick to the side of trees; or, if it's cold and dry, it blows and drifts into great sloping banks beneath hedges and walls.

But, just occasionally, a windless snowfall covers everything – every tree, every branch, twig and blade of grass. It muffles sound, leaving an eerie silence. Under a blanket of cloud, the light becomes so uniform it is hard to tell which way is up. When such snow fell one February morning, I knew there would be little chance of making more than one photograph, and there certainly wouldn't be time to go far. Although it was still snowing I shouldered my tripod and camera bag and set off out the back door, across the village and up the hill.

I walked up Cliff Ridge quarry, and though I know it well, the snow had so completely changed the scene, I lost the path and even my sense of direction. Eventually I arrived at a favourite spot, where a sinuously curving larch tree helps frame a view towards Roseberry Topping, our local landmark. There was no-one around, but I was not the first one there that morning. A deer's tracks were already printed in the snow.

The snow was not especially thick, but there was enough, and soon it stopped falling. Within half an hour the clouds began to break, and I made four photographs as mist briefly wreathed Roseberry in the rapidly warming air. Within another half an hour the sun had appeared, the wind had risen and the silence was replaced by dripping water and the occasional swish of snow dropping from branches. Winter wonderland had lasted less than one hour.

A view of home

The small image shows the very first time I photographed this view on a late autumn morning four years earlier. Tightly cropped by the 6 x 12cm camera I was using at the time, and slightly spoiled by a spreading vapour trail, it nevertheless establishes the formal relationships of the viewpoint.

I have subsequently returned here countless times, photographing at different times of the year and day. The view in the other direction is more distant but just as good, looking south to the gently rippling line of the Cleveland Hills. It may not be the Grand Tetons, or even Snowdonia, but it is home.

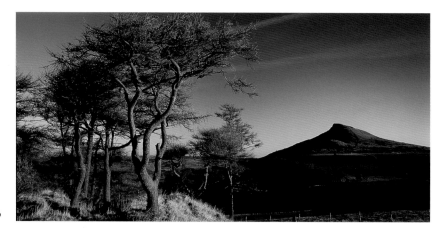

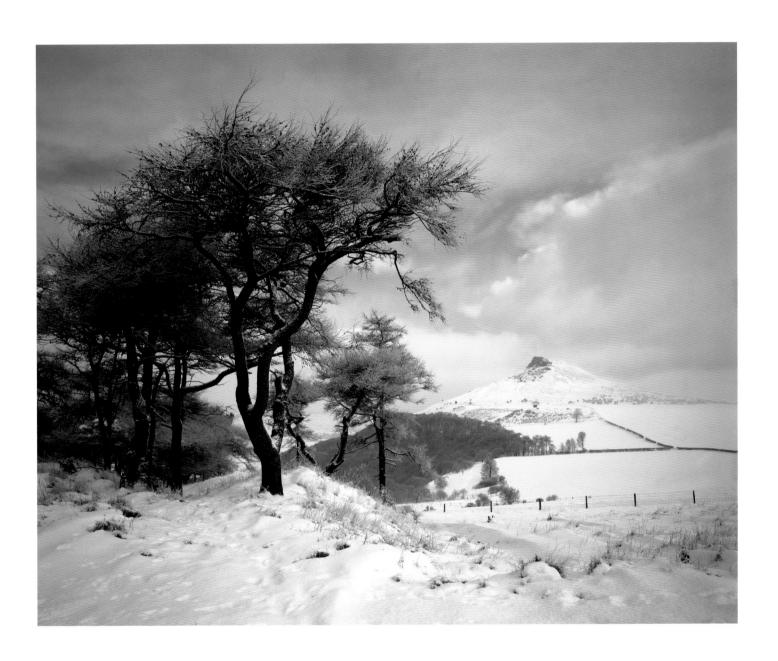

Prickly customer

It may not have been mentioned in the chapter introduction, but good luck also plays its part in landscape photography! I was on the island of Fuerteventura with my family, giving workshops and lecturing for a British photo-training company. The morning was free, and since one of my fellow tutors was the legendary London-based advertising photographer John Claridge, I volunteered to chauffeur his workshop group to their location. It was a botanical garden, and I took the opportunity to watch John dispensing wisdom to the delegates. Inspired by his suggestions, I set off in search of a picture.

Only cacti and other succulents survive the hot, desert climate of Fuerteventura, and the botanic garden is a showcase of them. I set out to do something as graphic and abstract as possible. It was obvious immediately that I would have to shoot into the light. Shooting with it would produce featureless highlights, and fiercely dark shadows. I needed to find a subject that fulfilled my lighting and compositional values. And to isolate it from the surrounding environment I would need a long lens.

When I eventually settled on the prickly customer in the main picture, all seemed straightforward enough. But the very close working distance proved tricky to focus, and positioning the camera so that the spiny leaves organized themselves into a satisfactory relationship all took time. When I was finally ready to shoot, the shadow of a tree had started to encroach onto the cactus. I worked as quickly as I could, but methodically, for rushing might result in camera shake, always a greater risk with close-ups. By the last of three exposures, the shadow was approaching the heart of the composition, where luminous green backlighting glowed in the centre of the plant.

I had not wanted the shadow of the tree, yet of the three processed sheets, it is the third and last film that works best, the blue shadow areas adding a subtlety and mystery I had not previsualized while composing. For me, the biting sharpness of the sunlit spines balanced by the soft, cool tones of the shadows make the picture. I am sorry to say that the success of the shot is more down to luck than good judgement!

Close-up, or macro?

I managed two more images that morning, one of which is reproduced here. This funny little cluster of Mickey Mouse ears certainly has interesting colour, but ultimately it seems to lack the clear design structure and the lighting quality which characterize the main image.

Although both these photographs can be described as close-ups, neither is true macro photography, when the reproduction size of the object on film is half life-size or greater. The large view camera, with a greatly extended bellows, can become a very awkward instrument to manoeuvre around a relatively small object. Compensation for bellows extension (so-called bellows factor allowing for fall-off of light) can create unworkably long exposures in anything but the brightest light. In practice, about half life-size is the limit for macro work with large format in the field. Half life-size calls for an exposure increase of one stop.

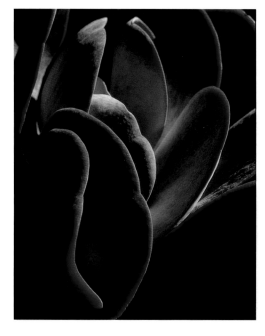

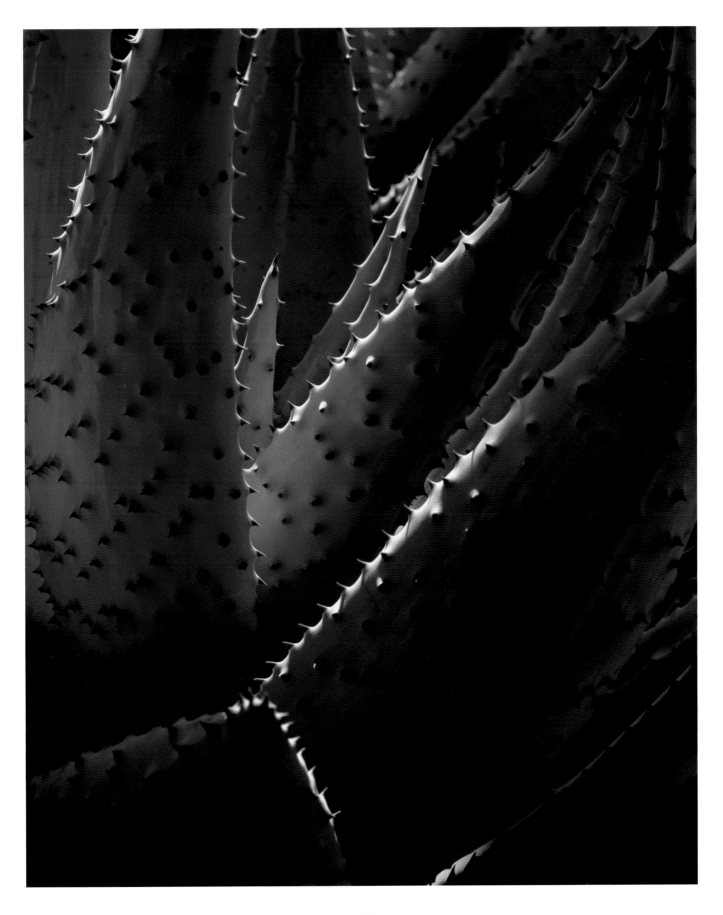

Solitude standing

High on the hill that looms over the tiny village of Hawnby in the North York Moors, an old oak tree stands alone. It died some time ago, perhaps from a lightning strike, and now its only companions are a few sheep and the relentless wind. This isolation makes it a stark, graphic subject, but one that needs exceptional conditions to make the most of its potential.

It was winter. I had been out onto Hawnby Hill with my camera the afternoon before, but the wind had been too strong. Now I was working in my office at home. From the southwest, brightness was edging under the sheet of cloud that had sat there all day. Was the wind lighter than yesterday? I would have to return to find out.

I knew that something special was possible, because, before setting, the sun would fall into a perfectly clear band of sky above the horizon. As I climbed the hill I remembered the landscape photographer's mantra, 'If you've seen it you've missed it;' in other words,

anticipate the light, don't react to it. I needed to be there and ready when the sun appeared.

But without the light it can be hard to predict its effect. Arriving before the sun, my instinct was to fill the frame with tree, to maximize the drama when the sun lit up the gnarled branches against the thunderous sky behind. So I composed in the portrait format, and when the sun started to appear the impact was indeed dramatic. But there was something missing. Where was the story? Where was the solitude, the idea of the lonely tree standing firm against the elements? My frame-filling shot was too cluttered.

There was just enough time for a change. I backed off, switched to a horizontal format, and recomposed. There were only three minutes of sunlight remaining, but I was in the right place at the right time. The timing made the lighting, the lighting determined the composition, and the composition needed space and simplicity to emphasize the power of the individual elements: tree, moor and sky.

Millennium dawn, afternoon

On 1 January 2000 I took my family and a couple of close friends out onto Hawnby Hill for a Millennium-welcoming stroll. It was a fine afternoon, albeit not spectacular. However, as we looked up at the oak from the slopes below, I was struck by the beautiful swirling shapes of the high cloud. It was this rather than the warm sunlight on the foreground that impressed me most, so it is the sky that dominates the composition.

A polarizer increased the contrast between sky and cloud, and also helps define the tree against the sky. Although it is the same tree, and even the same time of year as the main photograph, the different angle, lighting and composition gives an image of totally different mood and atmosphere. In this version the timing is less critical, but still determined the exact pattern of the cloud, which started to weaken and clear shortly after the picture was taken.

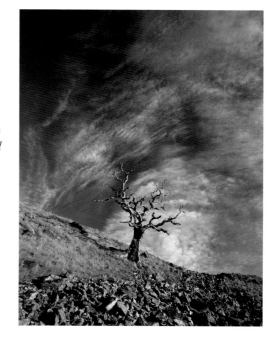

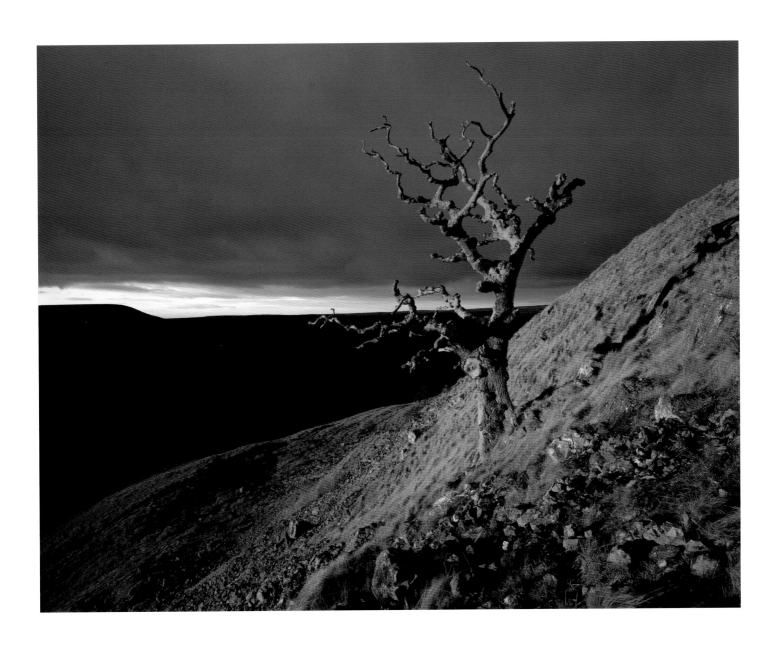

Saltburn sunset

Much as I love using it, the sheer size of large-format film can create complications. Unlike 35mm and most medium-format cameras which hold film reliably flat in a tightly defined gate, 5 x 4in (and larger) sheet film is more loosely positioned in a traditional double darkslide, or a quick load back. A certain amount of 'give' is inevitable due to the mechanics of loading. Furthermore, when the light-tight darkslide is withdrawn, differences in atmospheric pressure or humidity between the camera innards and the micro-environment behind the film itself may encourage the film to flex fractionally, or 'pop'. In this one respect our technology has gone backwards, for these problems did not afflict the users of glass plates. Early photographers will no doubt have lamented its weight and fragility, but no-one can deny that glass is flatter and more stable than film, and this contributed significantly to the superb technical quality of their work.

Most advertising photographers, especially those working on 10 x 8in, routinely tap their film holders before loading to ensure the film is sitting down in the holder. Having withdrawn the darkslide, they leave the film to settle for several seconds before exposing. Had I done this, I might have avoided the imperfections which blight the two images reproduced on these pages. Both are fractionally out of focus in the foreground. It is possible I made a genuine focusing error on both occasions, but more likely that at least one of them suffered a film movement.

The main image is based on anticipating, rather than reacting to, the situation. I had determined to find a simpler, less cluttered part of Saltburn beach than the other picture here, shot a few days earlier. As the sun dropped below the thin cloud on this July evening I knew the red rimlight on the foreground stone and the sand lip of its moat were essential lighting and compositional elements. A deep lens drop was required, and a three-stop neutral density graduate helped balance the light sky and reflections with the dark foreground. I made my exposures as the sun stood briefly framed by the end columns of the pier, the final moment of the day. Had I got it right? As I discovered at the lab later, the answer was, frustratingly, not quite.

Work in progress

The small image on this page has as dramatic a sky as I could have wished for, and the rimlight on the rocks is also special. It is too bad that, whatever the reason, imperfect focus on the foreground spoils it for me. Visually, I prefer the less cluttered foreshore in the main picture, too. The effect is cleaner, calmer, more tranquil even.

In every other respect, the composition, lighting and timing aspects in both images are pretty good, but technical shortcomings mean that they are not good enough. As far as I'm concerned then, it's work in progress. The sun won't be in the right area again until next summer, but it's not such a terrible ordeal to return for another try. Next time, I'll tap the film holder.

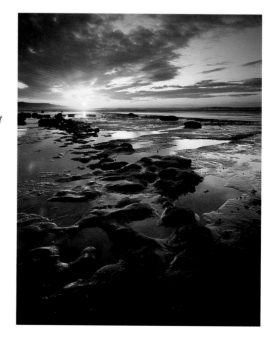

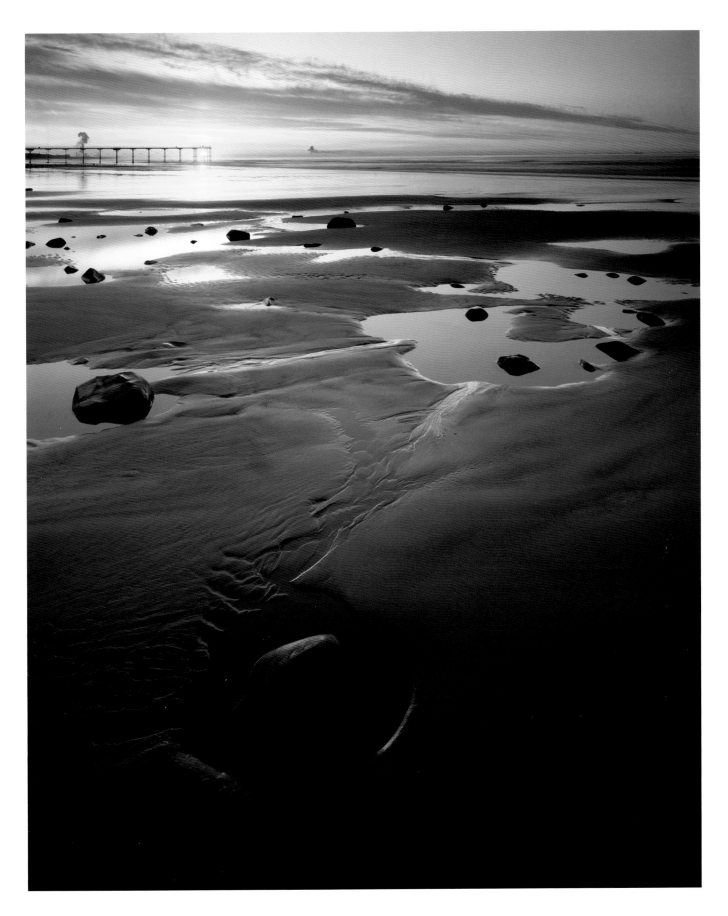

Industrial, complex

Teesside, in the north-east of England, has an uncompromisingly industrial character, with a skyline of cracking towers, refineries, steel mills, smoking chimneys, and even a nuclear power station. On the face of it there is little here to appeal to a photographer whose passion is wild, natural landscapes.

I remember once reading that legendary movie director Ridley Scott had spent part of his childhood in Middlesbrough. The sets of *Bladerunner*, the film that established his reputation, were at least partly inspired by recollections of Teesside's industrial sprawl, glowing like an apocalyptic vision against the night sky. I, on the other hand, was born and brought up in Devon, land of cream teas, lazy summer days and ecocentric politics. A bigger contrast to Teesside is hard to imagine. Maybe that is why I have found this industrial panorama near to where I now live a mesmerising, surreal and addictive subject.

Just to the south of Middlesbrough stands a ridge of hills. From Eston Nab, the whole of Teesside opens up, from Stockton to the mouth of the River Tees. Offshore, up to a dozen container ships lie at anchor, awaiting their turn for the pilot's guidance to dock. One fine winter day I climbed the hill, hoping for a bit of *Bladerunner*-style inspiration. The late afternoon sun had softened under high, hazy cloud. In late daylight the industry and surrounding landscape of roads, pylons, terraced houses and patches of wasteland was a jumbled mish-mash, all of equal visual weight, like a map on which all the words are the same size. Although too complex at this point, I knew that darkness might bring some simplification, and with it, focus.

The sun set, and with it came an incredible, fiery afterglow. I needed some key element. That key was the road. With a polarizer, I now had a long enough exposure to produce a full 'lines of light' effect, traced by vehicle headlights during the exposure. The twilight was ebbing fast. There was time for just two exposures, both at the same settings. By the time I had re-checked my light readings, hoping my exposures were long enough for the flow of traffic, the colour had all but gone.

Crossover light

The small image was taken on an early outing to Eston Nab. My aim was to turn the subject into a landscape, with wild moorland juxtaposed against the industry. There was insufficient light in the main image to have included such dark foreground.

In the main photograph, the long exposure and effects of reciprocity failure appear to have enhanced the on-film colour. Increased tonal contrast and intensification of artificial light distortions add to the drama of the scene. Unlit areas have dropped out into near-darkness, giving focus to the artificial lights and a greater sense of depth. This is a good example of cross-over light, where timing is critical. With the remaining after-wash of daylight and the artificial lights in balance, it is neither day, nor quite yet night, and that's often the perfect time for photographing industrial or urban architecture.

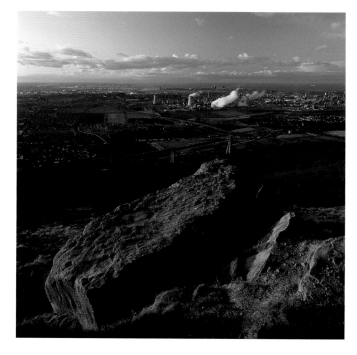

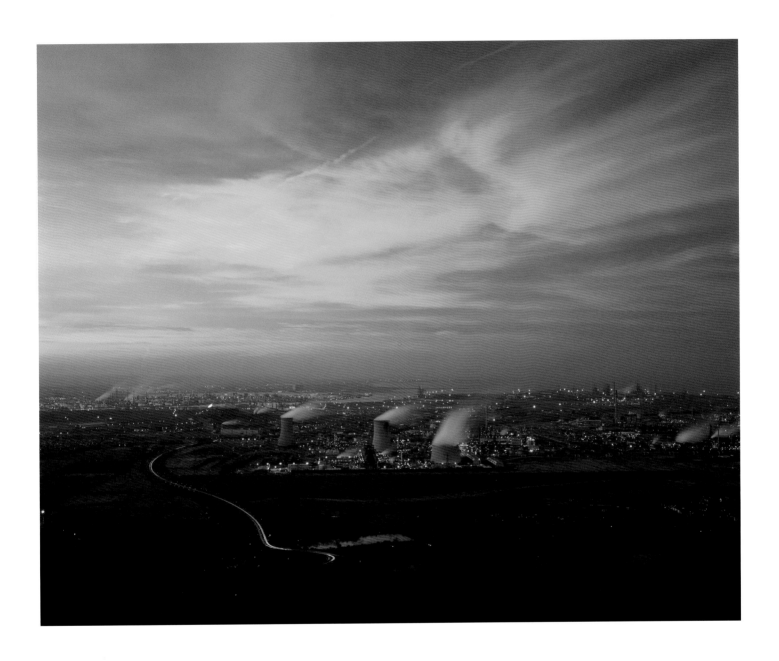

Shell pocket, twilight

It was a beautiful afternoon in the middle of winter. In a secret cove only accessible at low tide, I found this tiny pocket of shells, cradled in a hollow of wave-pounded limestone. The sun had already set. Would there be time to use the remaining twilight? Was it possible to achieve sufficient depth of focus? And in a cove ringed by vertical cliffs, could I escape the trap as the tide started to rise?

The composition seemed to fall into place, but a couple of spotmeter readings suggested it would be too dark to shoot ISO 50 Fuji Velvia. An aperture of f/32 would be needed for enough depth of field, translating into an exposure of several minutes once reciprocity failure had been calculated. However, I was carrying a few sheets of ISO 100 Fuji Provia F, which preserves its reciprocity characteristics better than most films.

As the light faded, the shells began to disappear in the gloom, but the oncoming darkness posed a new opportunity. The light from my miniature torch could now be seen when aimed at the shells. I would paint them with light. Although this was a technique I had not used before, it was my only option.

But would the tungsten light from the torch create an ugly colour cast? Could I avoid a 'hotspot' effect on the shells? And the tide was already encroaching fast. An exposure time of 30 seconds on Provia F gave me long enough to paint evenly, and I made three exposures. As usual, I would process them individually and adjust the development time if necessary. (Pushing and pulling E6 transparency films is a routine matter when shooting individual sheets. Although contrast and colour balance are slightly affected, these changes are less significant than producing perfect exposure.) I kept making exposure readings, lengthening the exposure time a little with each successive sheet of film as the light faded.

I packed up as quickly as I could, and, heart thumping, waded out through the oncoming tide. The water washed over my boots, but I was going to make it back to the main beach. I felt exhausted, relieved and exhilarated. As far as timing and lighting were concerned, I had pushed this one to the limit.

Limestone magic

There is something other-worldly about these limestone cliffs at Mewslade, on the Gower Peninsula of South Wales. The surface textures are extraordinary, and the cool, pale tones of the rock make it very responsive to the light as it changes through the day.

The companion photograph on this page was shot the day after the main image. It was clear once again, but hazier, and accordingly I looked at tighter compositions, trying to keep the sky to a minimum. In the example on the right I have nevertheless shown enough of the location to put the detail in context. Where the sun is shaded from the tidal pool in the foreground, a strong reflection results. The main focus of the composition is the bizarre, wave-sculpted formation at the base of the cliff.

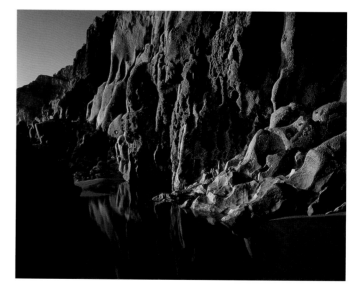

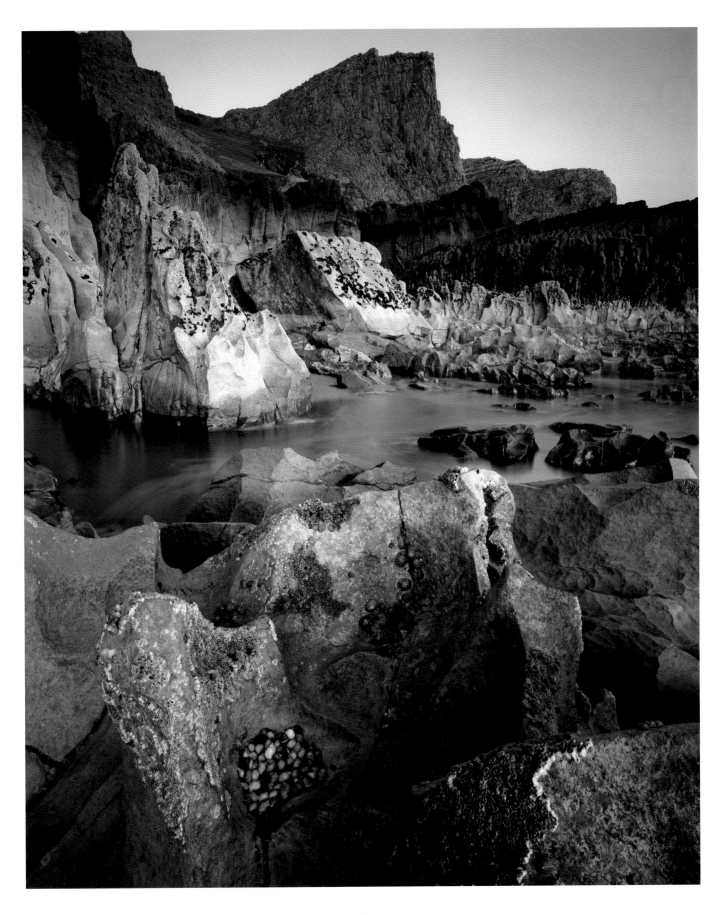

Drystone wall

One of the cardinal rules of landscape photography is simplicity. Natural things, wild plants especially, often seem chaotic and randomly scattered. Wildness is, by definition, out of control, yet without some sense of order, a photograph rarely communicates effectively. Therefore wilderness landscapes, particularly in damp, fertile environments, inevitably make the landscape photographer's life challenging. In contrast, agricultural landscapes are patterned with neat field divisions, hedgerows, walls and crops, and punctuated by features such as gates and stiles, or an isolated broad-leafed tree.

I am drawn to the wilder places, but in England, apart from the coast and a few patches of ancient woodland, there is no true wilderness. However, we have our wild margins, such as the moorland to the right of the drystone wall in the main picture. To the left of the wall, sheep have cropped the grass short, while to the right, bracken, tussock and wild grasses compete for space either side of a footpath.

It was dawn, and my main concern was to capture the beauty of the frost in a strong, simple picture. It was clear that the perspective of the drystone wall leading towards Roseberry Topping could echo the hill's near-symmetrical cone. Deep frost had lightened the top of the wall, and the remnants of the previous day's frost could still be seen on the north-facing side of the capstones. The frosty foreground was not only cold to touch, for the blue sky (its only light source) ensured that it remained cold in colour as well, while dawn sunlight warmed the bracken on Roseberry beyond. This colour contrast gives additional depth to a composition that already has strong perspective.

The foreground stones are, in reality, not large, but the wide-angle lens and the focusing flexibility provided by lens tilt (of the view camera) enabled me to exaggerate their presence. In this graphic framework, even the chaotic frosted bracken on the right of the wall seems less distracting than it otherwise would be. A strong and simple composition helps convey a sense of the place, the time, and the light in a way that a complex one could not.

Focus on format

I had investigated this angle on Roseberry on a winter dawn some years earlier. Back then I was still using a Hasselblad, a fine 6 x 6cm rollfilm camera with excellent Zeiss lenses. The Hasselblad can, of course, be used for landscape work but, like most non-bellows cameras, the zone of focus is always parallel to the film plane. In contrast, the view camera (or field camera) can place the zone of focus at an angle to its film plane, allowing the photographer to focus on elements at different distances simultaneously, providing they intersect the zone of focus. This makes the view camera ideal for landscape work.

Sunlight across the entire image area means that the early version lacks the colour depth of the drystone wall photograph. And with no clouds in the sky and hazy air quality, the light is inevitably less dramatic.

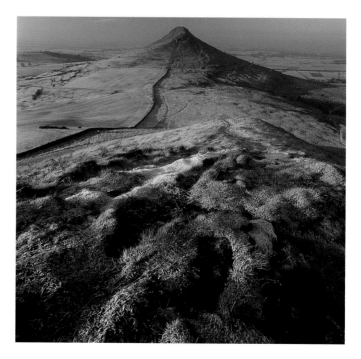

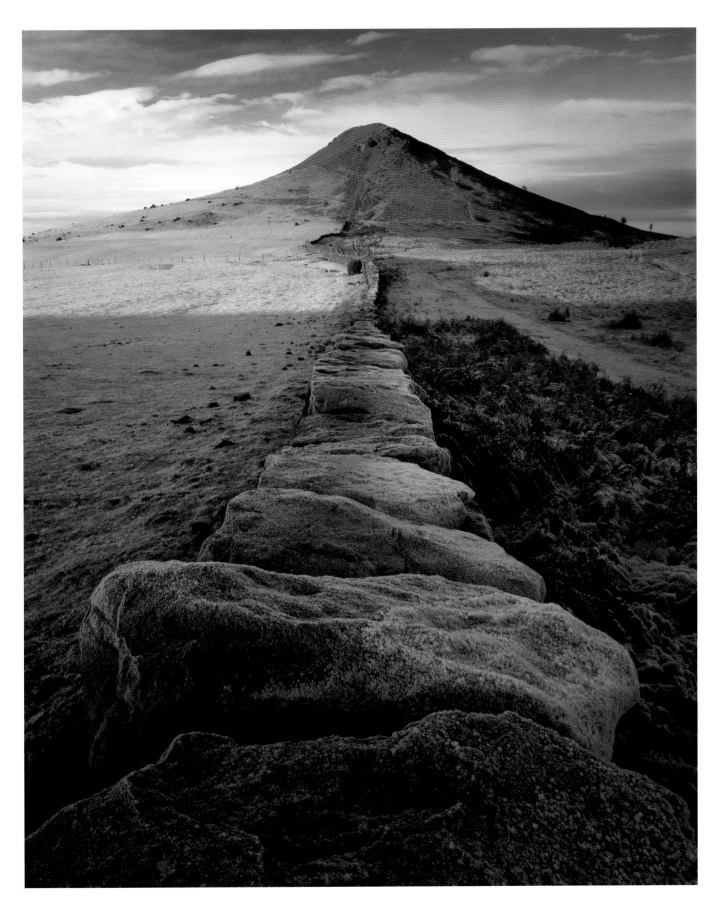

Foreground background

I have always been intrigued by visual depth. As a student of fine art I made mixed-media pieces that linked what lay at my feet through the middle distance to a horizon. Even when I first started taking photographs a fascination with wide-angle lenses quickly followed, for their apparent depth of field and emphasis on space seemed to correspond to my way of seeing.

Much of my life has been spent walking, and a feeling of moving through the landscape is something I seek to capture. Not that I want hiking trails leading into all my pictures! But I enjoy using visual elements that invite the viewer into the picture space, that help give a sense of being there. In doing so I aim to create an active compositional framework which conveys a sense of energy and movement. Stills photography need not be static.

I am frequently asked for 'tranquil landscapes'. I do appreciate the therapeutic value of restful images, but have a feeling that, subliminally, they send a message that the landscape is a passive, changeless, gentle place. That is not how I see it. For me the landscape is dynamic, in perpetual change, and the right foreground helps tell that story.

The essential tools required for this approach, apart from a wide-angle lens, are a medium- or large-format camera, preferably with movements, a strong tripod, and neutral density graduated filters (ND grads). The ND grad is an essential tone and contrast control device, helping bridge the gap between the bright sky and the darker landscape (although these filters can be usefully employed in other positions, see Temple of Light, Chapter 3, for example). It enables film to see more like the human eye. The tripod is the foundation stone of a landscape photographer's technique. The platform it provides allows the camera to record the scene with great detail in any lighting conditions. And the larger the format, the less quality is lost in enlargement. The fine detail that underlies photographic quality gives a more real experience of the subject. For me, that is the main justification for carrying such an instrument into the landscape.

The tilt controls of a view camera allow the foreground, middle distance and background all to be placed within the zone of focus, so that sharp detail can be achieved throughout the picture space, at least in most circumstances. Sharp foreground detail gives a strong, tactile sense of the subject, while continuous focus links it to the background, reinforcing the illusion of three-dimensional depth. A little imagination lets the viewer step into the picture and take the eye for a walk.

My friend Nick Meers pulls my leg for these photographic obsessions. He and I share a passion for Alaska, and when he returned from there recently he sent me an inkjet print of one of his photographs from the trip with the caption, 'Enough foreground for you m'lud?' His gentle teasing carries an obvious message: that I may be stuck in a stylistic straitjacket. Consequently, I have worked hard to make more use of longer lenses, and sometimes I now shoot pictures which are nearly all sky. But even these images usually manage to convey depth. And anyone studying the technical notes at the back will notice my preference for the wide-angle 90mm lens (equivalent to a 25mm on the 35mm format). I suspect 'depth of field' is a photographic fixation from which I may never escape.

Finally, a glance through this book will reveal that the majority of the main images are in the portrait format. Odd for landscape photographs? Perhaps, but the portrait format gives me more scope to make positive use of foreground elements. It emphasizes the depth (rather than the breadth) of the landscape.

May Beck

Just south of Whitby, May Beck drains the northern edges of Fylingdales Moor, a location famous, or notorious, for the 'golf balls', Britain's early warning system during the Cold War. Those enigmatic and gigantic structures have now disappeared, to be replaced by another equally baffling and even uglier pyramid-like edifice. Fortunately, this is not visible from May Beck, which tumbles through quite a steep-sided valley before meeting the River Esk at Sleights village.

In the winter this valley is stark and colourless; in spring and summer it is overwhelmingly green. But in autumn it has a few weeks of wonderful colour, and it was in early November that I made the picture opposite. The day was a cloudy one, and for most open landscapes it would have been poor light. However, I did know that in such light, textures and details glow. I was seeking a composition that placed the stream and fallen leaves in their woodland setting, without the distraction of a white sky.

I was concerned that the soft light might produce a flat, shapeless result, with little sense of depth. But as

I explored below a solidly built Victorian footbridge, the correct solution appeared. A side channel of the main stream was flowing in and out of a circular depression in the rock, an intriguing foreground detail. The quality of light on it was noticeably enhanced by the absence of light from immediately above. As I knew from my years working in the studio, the bridge was acting as subtractive light, casting a subtle, soft-edged shadow over the foreground, and giving it more shape and sense of depth as a consequence.

From the foreground leaves to the distant trees, the tilt action of my field camera allowed me to place the elements all in the same plane of focus. This avoided the need to stop down the lens excessively. Even so, low light meant a longish exposure was inevitable, and with my favoured ISO 50 Fuji Velvia I would still need a shutter speed of around eight seconds, enough for reciprocity failure to produce a green cast. To counteract this effect, and the coldness of the overcast light, I chose an 81EF light-balancing filter.

The struggle for inspiration

It seemed my original choice of filter was about right, for having made the main picture I used a milder 81D filter on a subsequent composition, and the result was much less satisfactory.

Finally that afternoon I took the angle that appears on this page. It is the same little area of the stream under the footbridge (whose shadow can be detected on the right-hand side). I worked terribly hard to make it interesting, but I find it forced and uninspired.

Sometimes it's hard to know why some shots work and some do not. Learning when not to photograph is one of the most important lessons of photography. Trying really, really hard is not the same as getting it right. Ultimately, what makes an inspired picture still remains a mystery!

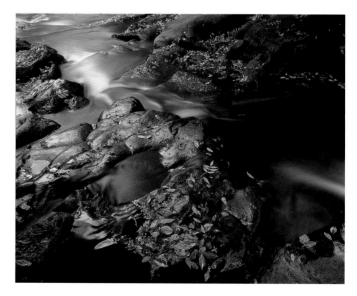

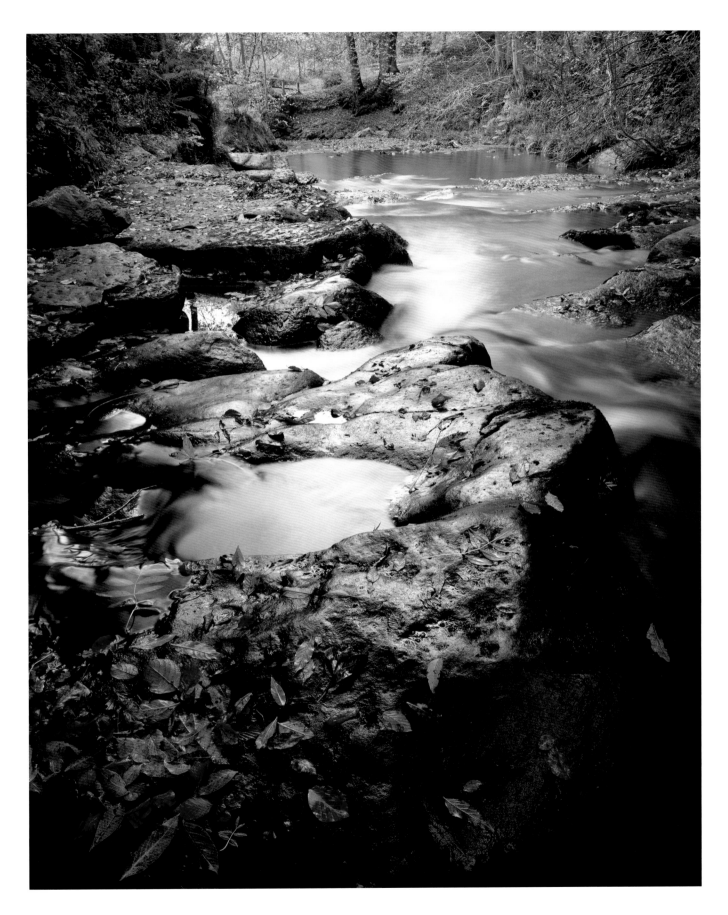

*R*ock flows through it

I am beginning to despair of my ability to make commercial landscape pictures. Every year I receive lists of picture requests from various photo libraries, and every year I am asked for peaceful, contemplative landscapes that are generic, which is to say you can't tell where they were taken. Far from being still and tranquil, my compositions are frequently full of movement, and I aim to capture the essence of a particular place, which is about as non-generic as you can get.

The main photograph here illustrates the dilemma. This amazing little canyon in the back-country of the Paria-Vermilion Cliffs wilderness in northern Arizona is about as bizarre and unfamiliar as it could be to someone raised among the cosy, green, patchwork landscapes of Devon. What attracted me most were the sweeping curves, the pitching crests and waves of stone, the barely contained sense of energy. To emphasize these qualities, and to ensure good focus throughout, I selected my widest-angle lens, a 58mm (equivalent to 16mm on 35mm). I was in a tight spot,

standing on tiptoe while trying to push my head back through the rock behind me so I could view the ground glass screen. There's probably still a head-shaped depression in the canyon wall.

Having created the most dynamic, flowing composition I could, it was essential that the light complemented that idea. When the sun shone, the contrast was instantly unworkable, producing solid patches of bleached colour, and deep shadows which dominated the picture. Fortunately, there were enough clouds to produce moments of soft light, and that was when I made my exposures. Even in the relatively uniform light, various swells and hollows in the scene still created adequate light and shade.

Whether I have captured the essence of the scene is debatable, but I doubt whether anyone who had visited the site could mistake it for anywhere else. This photograph is certainly not generic, and the swerving perspective is about as restful as a ride on a rollercoaster. I guess this is yet another photo-library reject.

Reading the rocks

Just around the corner from the main picture, the canyon presents a simpler, and in some respects, stronger composition. The small photo was shot a few hours before the main one. The predominant light source here is the cold blue sky, hence the almost lilac tones in the lower centre of the composition. Sunlight on the canyon wall around the corner is reflecting warm light (top centre), and it is the contrast in colours between cool and warm that I like best about this photo.

Neither of these images would be much good as a stock shot, being just too strange, too unfamiliar, to be really accessible. Nevertheless, the main shot is one of my personal favourites from various adventures on the Colorado Plateau. The sense of movement, the swirling perspective, and a choice of directions on the way ahead invite us to continue the journey. And as a metaphor for life, that's not bad.

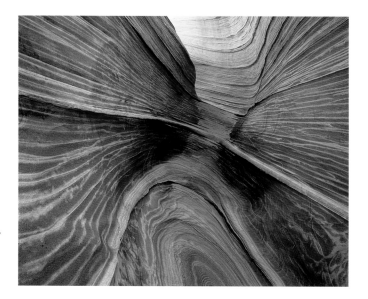

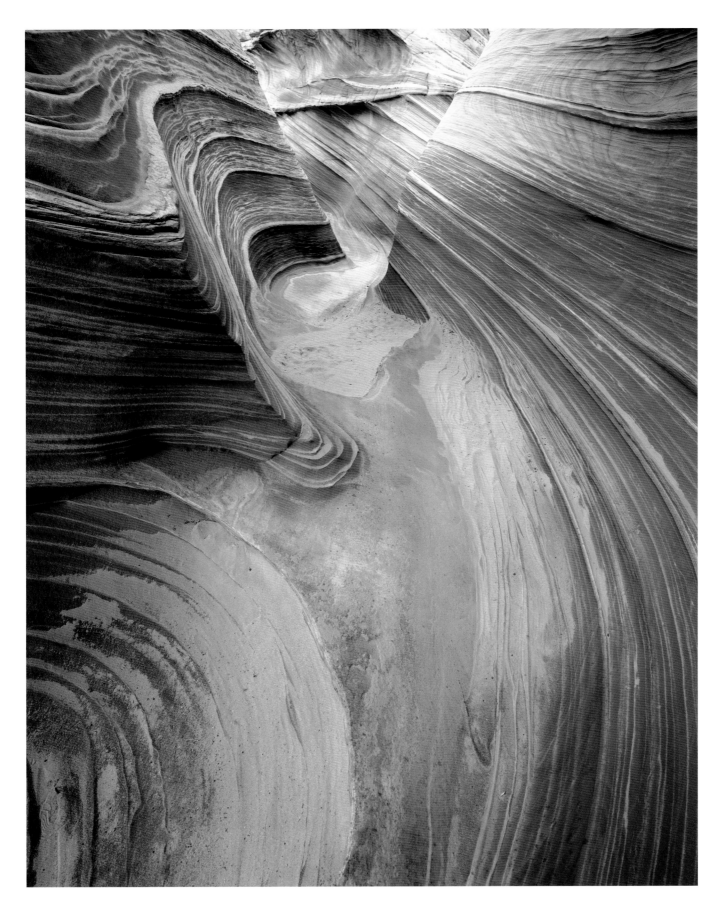

An unlikely wildness

Many coastlines will tend to be at their least populated but most raw and romantic (in the wild landscape sense) during the winter. But this stretch of shore, between St Aldhelm's Head and Houns-tout Cliff on Dorset's Purbeck coast, has another reason for being so amazingly empty. A long-distance footpath follows the clifftop above, but when I tried to descend to the beach, briars and alder blocked my way. There is no access whatsoever.

Believing this land to belong to the National Trust, for whom I was on assignment, I muscled my way through the undergrowth, anticipating I would find a path and an alternative route back later on. Once on the shore I was delighted to discover chalk boulders, a subject I had never really tackled before. After a certain amount of time exploring I opened my photographic account with the main photo (opposite).

Shot quite soon after my conversion to shooting 5 x 4in on location, this image betrays some inexperience in the ways of large format. The top corners are vignetted. I failed to anticipate this because I did not preview the composition with the lens stopped down to its taking aperture and the lens has photographed the edge of the polarizer's ring. I was almost certainly too excited and preoccupied with adjusting the lens tilt to notice the vignetting danger. It is true that I could crop the corners out, but not without disturbing the balance of the composition, so I prefer to leave it uncropped, vignetting and all.

High pressure and fine, still conditions had led to a slight build-up of haze, and this has resulted in a soft atmosphere, a quality reinforced by the one-second exposure which has motion-blurred the lapping sea water.

After a fine sunset I set out to find the path I was convinced would lead me safely back to the clifftop. There was none. I did eventually improvise a way out and I was grateful for the length of winter twilight as I trudged back to my vehicle, parked a couple of miles away. I later discovered that this was not National Trust land after all, which explained the lack of access. Finding such wildness in overpopulated southern England still strikes me as unlikely, and wonderful.

Environmental enigma

The western profile of St Aldhelm's Head can be seen in this smaller image, which is shot looking in the opposite direction to the main one. From the clifftop a magnificent panorama opens of the Dorset coast looking westwards to the Isle of Portland. By a quirk of fate the British Army has jurisdiction over a broad expanse of this coastline, in the Lulworth ranges. Sometimes this means access is closed to the public (although not here at St Aldhelm's) when the ranges may be used for firing practice.

While such military activities would appear to be quite incompatible with environmental protection, it is a well-known fact that army ranges actually shelter some of the wildest, most biologically diverse sites in England. It still seems strange to me that many wild species find it easier to co-habit with the occasional tank or exploding shell than a steady stream of ramblers and dog walkers!

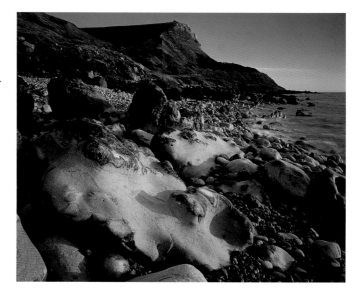

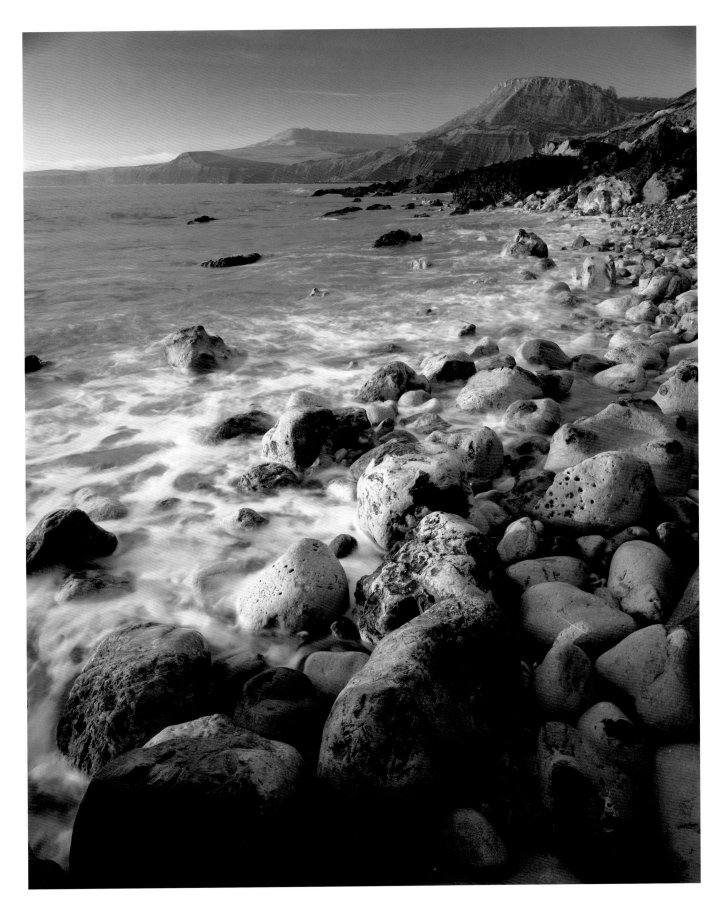

Lindis Pass

It is interesting to compare these beautiful, stark, pre-alpine hills in New Zealand's South Island with the rainforest of Fjordland in Chapter 6 (Enchanted Forest). Fjordland lies on the west coast of South Island, whereas the whole Lindis Valley area is east of the Southern Alps in dry, rain-shadow terrain. The prevailing westerly winds drop most of their rain and snow on the west coast and high mountains before they reach this land-locked heart of the South Island. And the east coast is equally far away, with more mountains blocking the passage of much humidity from that quarter. The result is that the South Island's interior has an almost continental semi-arid climate.

Even so, I was surprised to find a landscape so devoid of trees. Only tough tussock grasses appear to thrive here, but they do complement the shape of the hills. In the late-afternoon sunlight, a vast, soft blanket of colour appeared to have been draped across the entire panorama.

My first inclination was to avoid the road and use a longer lens to isolate the dramatic ridge in the distance. Had I done so there would have been little scope for including the clouds, which significantly improve the sky. And while the road adds nothing to the image aesthetically, it is still a part of this landscape, a reminder that this is not some long-lost wilderness, but a pass through which people travel regularly. However, the strongest reason for adopting a wider approach was the glimpses of red provided by some of the ground cover at my feet. This colour, and the tactile grasses, give a depth to the composition that reflected my feelings about the place better than a tightly framed detail of the ridge could have done.

Writing this at a distance of 12,000 miles, literally a world away, my memories of New Zealand are dominated by one in particular. I recall the overwhelming purity of the air and light. Especially in the dry centre of the South Island, that clarity was breathtaking and sometimes confusing, making distances appear less than they really were. This is not always an advantage for photography. A landscape unmoderated by even the slightest haze or humidity can sometimes seem a little too stark for comfort.

Kiwi badlands

North of the Lindis Pass, the road drops down into a wide, flat basin, surrounded by mountains. This is Mackenzie country. Near the township of Omarama is a steep escarpment whose geology is reminiscent of the American West. The Omarama Clay Cliffs are dramatic badlands, too steep and too rapidly eroding for vegetation to stabilize their slopes.

When my brother and I finally found these fascinating formations, we had already used the dawn elsewhere and initially I doubted the harsh midday sunlight would inspire me to do anything other than observe. But I was wrong. Reflected light from the sunlit cliffs was so strong that I was able to photograph formations in the shadows and still retain colour in the sky.

These folded, fluted forms seem to have a visual connection with the Lindis Pass hills, a connection which may reflect common geological origins.

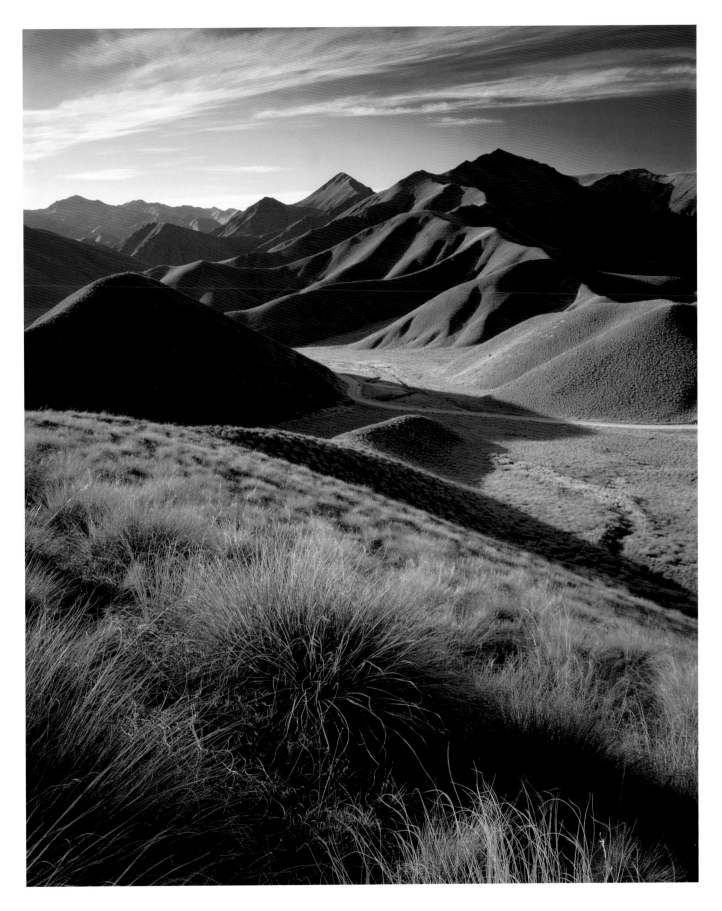

Saltwick Nab

Like many photographers, I came into the profession by assisting. After a couple of years in America, I returned to England and, like millions before me, moved to London in the hope of making it. I found work with an agent who represented car photographers, and soon became familiar with the routine, in which painting vast seamless studios white was the main activity!

Being in the car studio convinced me this was not the life for someone who loved being outdoors, and who loved creating pictures through photography. Clearly this was indoors, and all the creativity, such as it was, lay at the hands of the art director. The photographer seemed little more than a highly paid technician.

Shooting cars is a very unforgiving business. It is as well to realize quickly that you are photographing a mirror in the shape of a car. Every surface reflects directly according to that well-known basic law of physics, 'the angle of incidence equals the angle of reflection'. This is why a car studio has to be a vast enclosing space without seams, edges, details or blemishes. Perfectionism is an essential attribute of the car photographer, and the lessons learned were useful for someone who was to become a landscape photographer. Certainly when it comes to reflective surfaces, I find it easier than most to anticipate the potential and the problems.

The wave-cut platform at Saltwick Bay is a fine example. Almost half the content of this image is reflected light from the wet, dark, wave-cut platform of the beach. The magic of reflection has allowed me to dramatize the shady, barnacle-covered rock plinth in the foreground, without losing detail on the sunlit headland of Saltwick Nab beyond. A strong ND graduated filter was vital, for this balances the sky to the reflection. Without the filter, the sky would be hopelessly washed out, or had I exposed for the sky then the foreground would have been impossibly dark.

Although a little front tilt was used to link focus front to back here, most of the depth of field is provided by stopping down to the smallest aperture I normally use, which is f/32. A smaller f/stop produces diffraction, which is likely to soften any sharpness gained through depth of field. Certainly that is the case with my 90mm lens, something I discovered through trial and error.

Revealing texture

The tremendous power of the sea has washed most of the beach clean, leaving only the largest rocks. But the cliffs continue to be undermined by the relentless energy of the waves, yielding a boulder nursery in the high-tide zone. On these slopes, gravelly red sand from the soft centre of the bay meets and covers some of the boulders.

I have found this a productive spot for the study of texture, and it is a bonus that these rocks are mainly rich reds and yellows, while some are clad in a layer of green seaweed. On this page is such a study. My first exposure, made in bright sunlight, was crisp and sharp. But it is this soft light example that I prefer. The luminous shadows do not block the eye's exploration of the picture and the whole composition seems better poised.

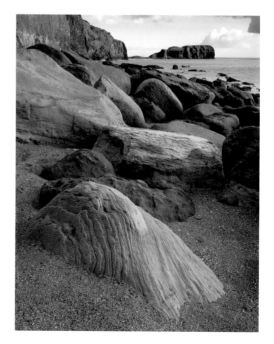

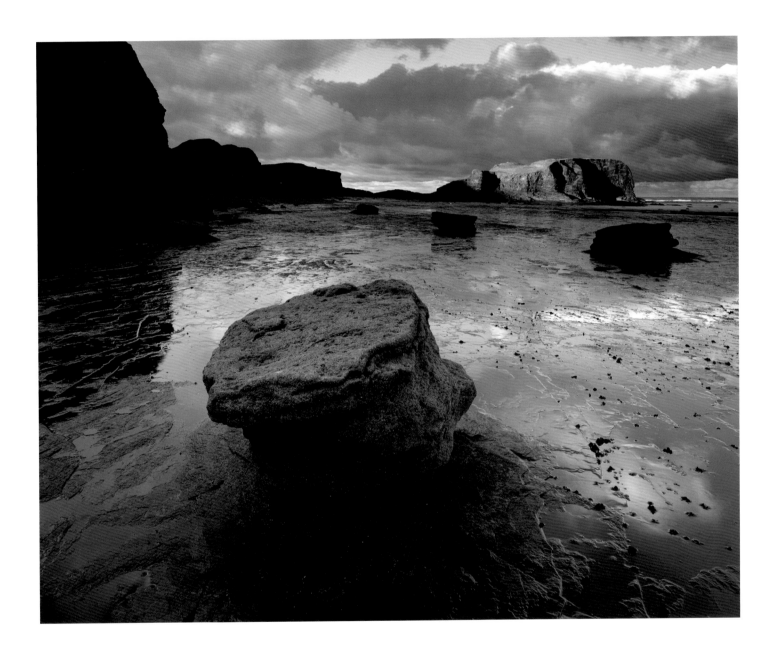

Highlands icon

I reckon the most imposing scenery to be found in the British Isles is in the Scottish Highlands. Arriving from the south, I always feel the Highlands really begin at Rannoch Moor. This bleak and beautiful high plateau is surrounded by mountains, and partly covered by lochs, smaller lakes and streams. Intense glaciation has sculpted the mountains and left numerous characteristic features such as drumlins and erratics. Of course, there is now no permanent ice and snow in Britain, but the Highlands can have prolonged coverings during the winter.

Standing proudly at the north end of Rannoch, like a lion surveying its territory, is Buachaille Etive Mor. This satisfyingly symmetrical peak with its awesome rock faces is nowhere near being Scotland's highest mountain, but it acts like it is. It strikes a pose, like a Matterhorn among Munros. Situated where Rannoch meets Glen Coe, its location and its beauty make it an icon of the Highlands.

I would love to be able to say that the main photograph was taken only after an arduous hike across unyielding terrain, but I am afraid anyone who regularly uses the main A82 route from Glasgow to Fort William will know I was only about 40 metres from the road! Sadly that means I was not working in peaceful contemplation, but with the sound of snarling trucks and speeding cars never far away. Still, the ice fringes of the river had caught my eye at dawn earlier that morning and, once I started working, I soon became totally absorbed in what I was doing. The two foreground rocks and the oval ice island were the critical foreground elements that had to be resolved. For a long time I struggled, believing the right-hand rock to be too bright, but all my attempts to exclude it failed. In the end it became perhaps the most important single detail.

It had been a glorious morning, but as I worked the cloud was building relentlessly behind the mountain, and was threatening to cover the sun. I made my exposures knowing that if I delayed any longer I might well end up with nothing, or a much colder-looking soft-light alternative.

High noon, low sunlight

Within ten minutes of taking the main photograph the sun had gone, never to return that day. The small picture was made an hour or so later, after the arrival of cloud but before the onset of sleet and snow.

Taken in the middle of December, the main photo was also shot in the middle of the day, contrary to my normal practice. But, Scotland is so far north that in winter the sun is low in the sky throughout the short hours of daylight. Therefore, even at midday the sunlight is warm on the landscape, casting long shadows, but its rays are too feeble to melt the snow. Best of all, dawn is at a civilized hour, and at the end of the photographic day there is still plenty of time for afternoon tea...

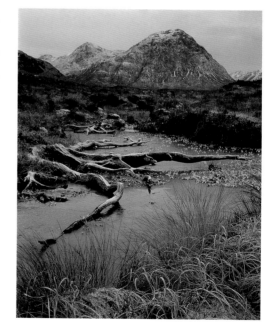

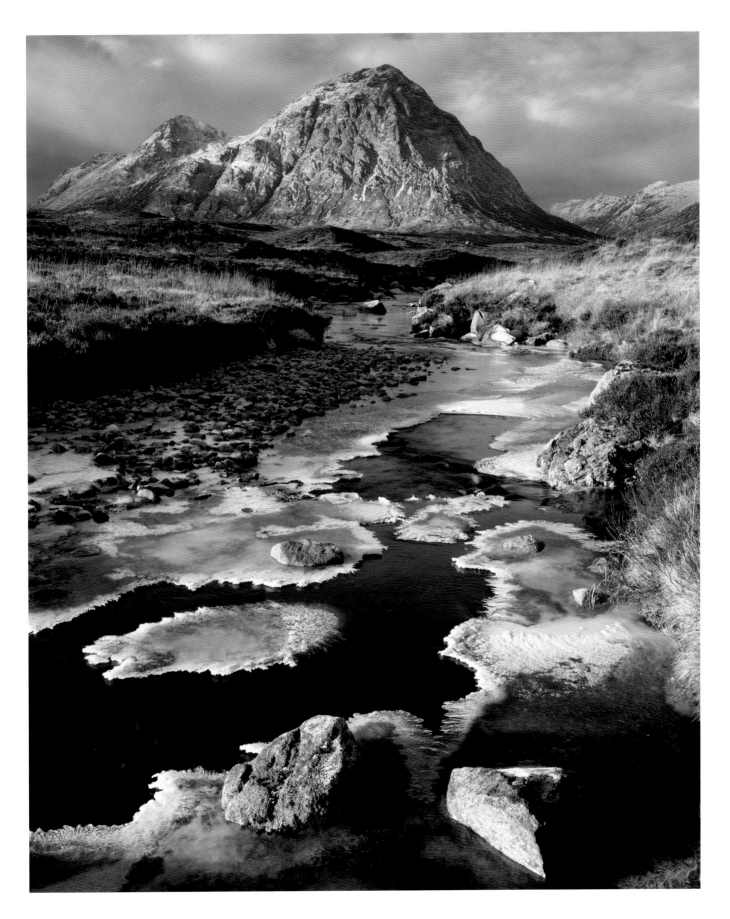

Carnewas cliffs

England's westernmost county, Cornwall, is rightly famed for its outstanding coastal scenery. Projecting into the Atlantic Ocean, it has two distinctive coastlines. Facing the English Channel, the south coast is broken by rheas (drowned river valleys) and has a gentle quality derived from its benign climate and sheltered coves. Vastly different, the wave-beaten, windswept north coast faces the full fury of Atlantic storms. As well as mighty granite headlands and sheer cliffs, there are also beautiful sandy beaches, popular with surfers and families alike.

To survive on these high cliffs, plants need to love salt, and be tolerant of high winds, but mild temperatures ensure that such plants thrive, and arrive early in the year. Thrift, campion, harebells and other wildflowers flourish on the clifftops during April and May. At Carnewas, these wildflowers enjoy the protection of the National Trust. This property leads to the magnificent beach known as Bedruthan Steps, more of which can be found in Chapter 6 (Bedruthan sunset).

The sea stacks that form the legend behind the name Bedruthan Steps can be seen in the background of the main photograph. But here I chose to give prominence to the clumps of thrift that occupy the foreground. Having determined that these tiny points of colour should be my main focus, the difficulty was to draw the eye through the frame, and bring out the shape and colours of the foreground. Typically vigorous lines of Atlantic surf continued to roll into the distant sea stacks and, fortunately for me, fluffy white cumulus drifted low in a changing sky.

Ideally I would have waited a little longer, so the setting sun could bring warmer colour to the foreground. But advancing cloud from the west was clearly going to scupper that plan. Having carefully applied a little tilt to the lens standard of my field camera, producing a reasonable focusing compromise with a subject occupying many different planes, I stopped down well and made two exposures. Within minutes, the sun had slipped behind cloud and the moment was gone.

Contrasting compositions

Shot from almost the same spot as the main image, but a few days earlier, the small photograph shows the view looking in the opposite direction. In this version, the wildflowers are better, and the light is arguably preferable to the main image as well. But although late sunlight improves the raw cliff face, the visual impact of this rock mass is to block the eye and stifle the composition.

In the main picture, the evocative seastacks draw the eye through the picture and out to the distant headland, while the little clouds marching overhead draw energy back through the composition, framing and completing the image. Even the waves play a part, reflecting the rhythms in the foreground. Although its colour and foreground detail may be slightly poorer, the overall atmosphere and quality of movement, depth and space of the foreground/background relationship make it, for me, the more effective of the two photographs.

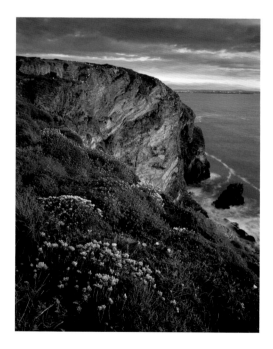

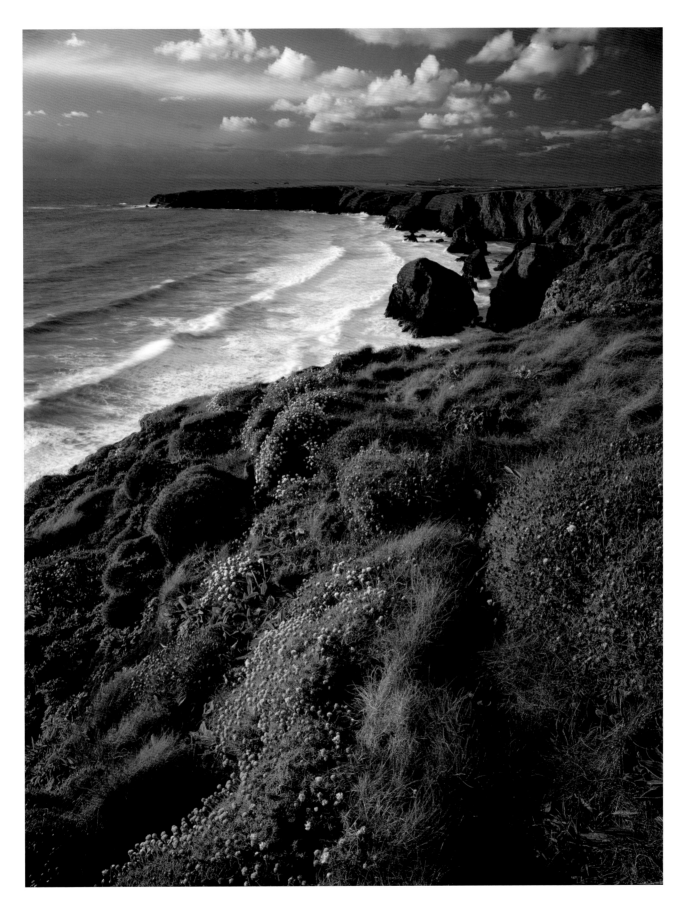

The Devil's Garden

It is obviously a great privilege to get paid for doing something you love. And there are few things I love more than photographing the incomparable landscapes of the Colorado Plateau, in America's desert southwest. Through his company Light & Land, Charlie Waite has given me the opportunity to make regular visits to Utah and Arizona as a leader of small groups of enthusiastic photographers.

When planning an itinerary for each group I naturally concentrate on places to which I have been before, and where I therefore know the best times of day for the light. In addition, with each year's tour I aim to go to three or four locations I don't know, making it a bit of an adventure for me as well as for my companions. One of these explorations took us into the Escalante area, where we journeyed down the 'Hole-in-the-rock' road, a broad gravel track that runs southeast from Escalante to Glen Canyon.

Our main afternoon destination was the slot canyon known as Peek-a-boo, which proved interesting but photographically limited. On our return to Escalante we decided to make a swift detour to the Devil's Garden, a little-visited location of dramatic sandstone monuments. The formations are scattered over a wide area and when we arrived the sun was fast disappearing behind the Straight Cliffs, a few miles to the west. I felt frustrated, having failed to get my group into position to capture the late sun. But I knew the high cloud might produce a fine sunset, so suggested we stop and wait.

I found a composition using the graceful curve of an old branch, and three sandstone monuments involved in some conspiratorial conversation. Bleached grasses in the foreground looked wonderful in the calm evening air, but there was no sign of sunset. It grew darker, but as we were on the verge of giving up, a fantastic pink afterglow lit up the eastern sky. The colour tracked swiftly overhead to the west, briefly illuminating the landscape before nightfall. It was a little glimpse of heaven in the Devil's Garden.

Raw light, Wild West

Escalante is reputed to be the last town in the United States to have a paved road running through it. The isolation and grandeur of the surrounding scenery certainly evokes the spirit of the Wild West, but today the town seems far too sleepy for John Wayne and company. The Escalante River is a tributary of the Colorado, and has carved out amazing canyons through this wild terrain. The picture on this page depicts a typical slick rock landscape just south of the river.

Extremes of temperature and periodic heavy rains will have been the main agents of erosion here. Shot in the middle of the day, sharp, bright sunlight glancing down the steep rock face reveals the texture of the exfoliating sandstone layers against a brilliant blue sky. As an illustration of geological processes it probably succeeds, but I feel the harshness of the light makes it a brutal rather than inspirational photograph.

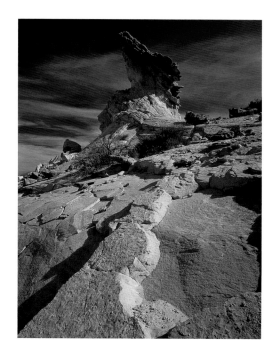

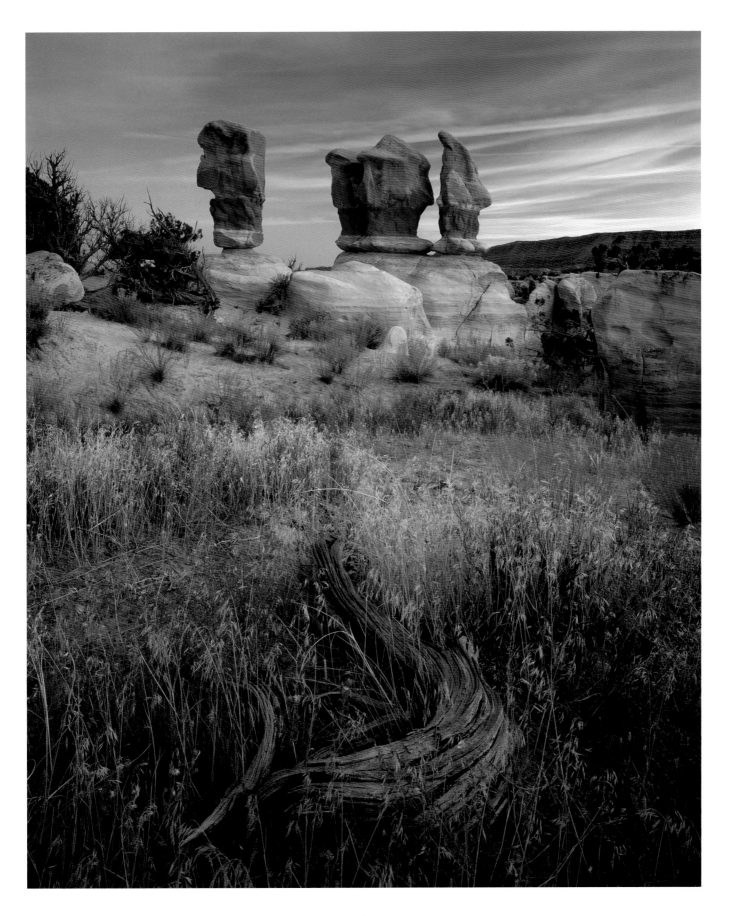

Burton Cliff

The Dorset coast is predominantly south facing, and this makes it an ideal location to visit in winter. Here at Burton Bradstock, the magnificent vertical cliffs face just west of south, and on a winter afternoon enjoy the full effect of the sun as it sets into the English Channel. The main photograph was made on assignment for the National Trust, which owns the land on the clifftop above. Even these mighty cliffs are no protection against erosion, though. Heavy rains and frost, combined with storm-driven spring tides, have produced the numerous recent rockfalls visible beneath the cliff, indicating that in a few thousand years, the Trust may no longer own anything there apart from fresh air!

This is a landscape with many of the qualities I love: strongly contrasting colour, flat water that gives perfect reflections, and a foreground rich in detail and texture. The yellow cliffs (warmed by the low sun) and the blue sky (slightly deepened by a polarizer) give the photograph impact. But it is the grid-like foreground and the reflection of the cliffs that provide both visible and psychological depth to the image. Shooting at 45° to the grid of limestone joints, diagonal lines lead in from the lower corners, intersecting to form a centred design. This helps control the one-sided asymmetry of the receding cliff face at the top of the picture.

When I began to assess the potential of this scene there was less water in the foreground, but by the time I had set up my tripod and 5 x 4in camera, the rising tide had begun flooding in. People were walking along the beach, apparently right in the middle of my composition. But if I waited for them to stroll gently out of sight, it was clear I would lose the foreground grid under water. So I made my exposures as soon as I could, at a point when the foreground rock platform was nicely balanced with watery reflection. The human figures on the beach, softened by a touch of motion blur, are an imperfection I can live with.

The origin of the idea

Sorting through my filing cabinets recently, I found this early version of the wavecut platform of Burton Bradstock. Shot on 35mm Kodachrome in the middle of the day, it naturally has a very different colour palette to the main image, shot on 5 x 4in Velvia. Yet the compositions are all but identical.

This does beg the question: have I not moved on at all in the intervening fifteen or so years? I will be charitable to myself and take the view that the idea was well resolved in the early image, and just required some good light to fulfil its potential. In this sense, the Kodachrome is simply unfinished business.

It is intriguing to note a complete absence of rockfalls in the early version. Does this mean that the new rockfalls, visible in the main photograph, will be scrambled into shingle by storms, or does the shingle ebb and flow in height, sometimes covering the larger rocks, sometimes exposing them? I would be fascinated to know the answer.

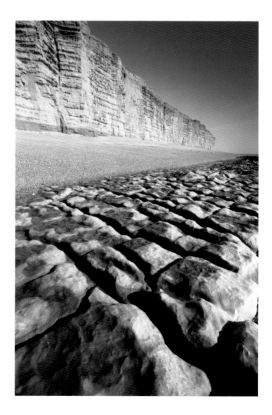

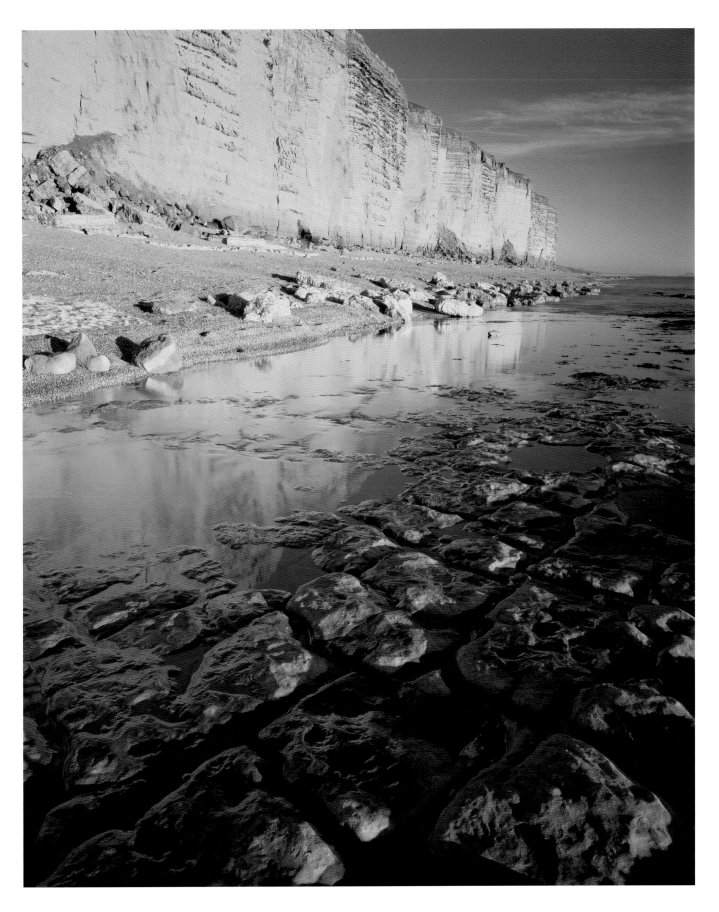

Out of the blue

In my belief that the landscape photographer's primary objective is to be a faithful witness to nature, I usually strive for the most natural-looking colour possible. But what is natural colour? Scientifically it can be measured in degrees Kelvin; it is possible to analyse and understand the colour of different light sources; and we know that different makes of colour film have a different colour palette. But declaring what is natural is subjective, for no two people see colour exactly the same.

Perhaps disgusted by the gross over-filtration effects in which some have indulged in the recent past, there are photographers who claim they never use filters of any kind. Perhaps they fear that filters corrupt the truth and purity of their work. But this 'whollier-less-filtered than thou' attitude denies the truth: film does not see colour in the same way as the human eye. These photographers therefore present the colour casts and distortions imposed by film and the ambient light, but which the eye 'filters out'. It is not nearly such a natural approach as it may seem.

Look at an average white-skinned face in tungsten light. To the eye it is still a white face, but to film it is orange. In fluorescent light, film sees skin tones of a sickly green pallor. And in open shade lit by a clear blue sky, film will see a face blue with cold. Film sees what can be measured with a colour meter, with any variation from the 5500 degrees Kelvin (for which daylight film is balanced) being quite noticeable. Our brains apply enough filtration in most lighting conditions to preserve what we regard as natural. So we do not see like film. But, used with wisdom, filters can persuade film to see like us.

Of course, there are times we exploit the distortions of daylight deliberately. Who would want to neutralize the gorgeous warmth of sunset? And when photographing a delicate ice detail in the shade, cold blue light suits the subject. But in other situations a correction filter can reproduce the natural colour beauty we see with our eyes and our hearts. We live on a blue planet, and many unfiltered landscape photos suffer from 'the blues', cold tones, even in sunlit areas, which are at odds with our feelings and memories of the subject. With light-balancing filters and a little experience we can re-create the colour we believe is true.

These observations are mainly for the colour transparency user. Colour negative materials usually allow for corrections at the printing stage. Even so, it is easier to print a correctly colour-balanced negative. It makes good sense to correct in-camera (when necessary) with all colour films if possible. When working outdoors, all the other distractions of picture-taking make it easy to forget the question of colour balance. But to be truly in control of the expressive dimension of colour photography, we have to be fully aware of colour temperature, and filter when necessary.

The whole subject is given added complexity as we enter the age of digital photography. Theoretically, this offers new depths of control in colour management to photographers, and the prospect for retrospective colour-correction and fine-tuning are truly exciting. Will this mean an end to filters? Who knows, but while transparency film remains my capture medium of choice, I will continue to need them.

When the great photojournalist Eugene Smith was asked if it was true that he only used available light, his reply was brief, 'Sure, I use daylight, tungsten, flash, whatever light is available.' That encapsulates my own approach with filters. Sometimes I use them, sometimes I don't. It all depends on the way I want the colour to look. We may have the blues, but we can filter our way out of them if we choose.

Pentire blues

One of the reasons I love beaches and rocky shores is the effect of water on all those raw, unvegetated surfaces. Wet rock becomes a blank canvas, waiting to take up the colour of light. With direct sunlight the actual colours of the rock or sand may predominate, for the sun is much stronger than reflected light most of the time. But once it goes behind a cloud, or sets, the sky can act out a play of colour on this damp, reflective stage.

Although blue is a colour we associate with sadness, cold, and a melancholy mood, most of us also find it beautiful. The blue sky, whether clear or filtered by cloud, ensures blue is the dominant colour of the planet, and an ever-present colour of the great outdoors. Sometimes we can reduce its influence with a filter, at other times it is a great foil for complementary colours in the orangey-red area. But there are occasions when it can be the only colour, the one theme in a monochrome image.

The main photo (opposite) was shot on the rocky foreshore below Pentire Point, near Polzeath in North Cornwall. There is a hint of pink in the sky above Trevose Head in the far distance, but the image is all about blue. Shot on a midwinter afternoon with a bitter northwesterly wind blowing hail and sleet showers in from the north Atlantic, it is a pretty accurate impression of how it felt.

It wasn't really what I was hoping for, though. Earlier in the afternoon big patches of clear sky had suggested some late sunlight, and, eternal optimist that I am (aren't all landscape photographers?), I'd imagined the late sun pouring through the clouds, filling at least part of the bay with golden light.

So the composition I had set up was never visualized as it is seen here. Not long after this single sheet of film was exposed the weather took a decisive turn for the worse, and I was heading back to Polzeath village with rain streaming off my camera bag. It was only later when I examined this solitary exposure at the processing lab, that I realized the single-colour theme had worked, producing a mood altogether more mysterious and unpredictable than the one I originally had in mind.

Painting with light

The smaller image on this page is another good example of a single-colour theme. This was shot on Polzeath beach, with these foreground pools a short-lived memory of the retreating tide. The late summer sun has set some 25 minutes or so before, and the not-especially-interesting evening sky has condensed into a magnificent afterglow. The tidal pools are direct reflectors of the sky (the angle of incidence equals the angle of reflection – schoolroom physics), and the sense of space is enhanced by the use of a super-wide-angle lens.

Like the rocks in the main picture, the sand and water is simply a stage for the colour of the sky. We know the sand is not deep purple, just as the rock is not blue, but that does not appear unnatural or disturbing for it is simply a function of the light, part of the magic of photography. Who needs paint when the sky can do it for us?

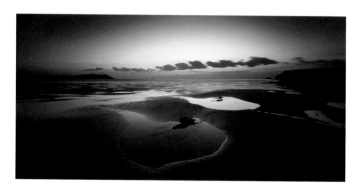

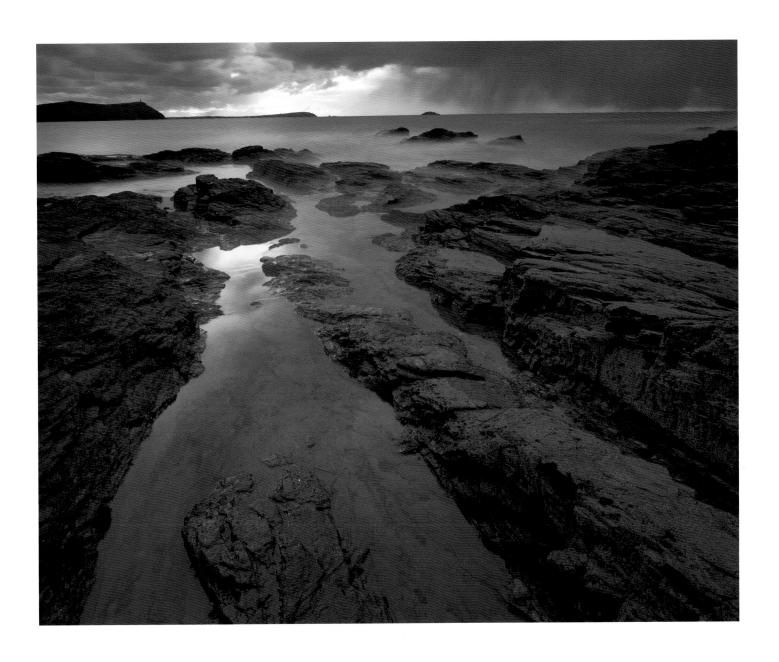

After the storm

When I was a fine art student, one of our external college tutors was the painter Terry Frost. His work was at the forefront of abstract colour-field painting, and although his canvases are impressive for their huge size and the simplicity of the designs, their impact on me stems mainly from their use of complementary (opposite) colours.

At the time I didn't know that lessons learned from seeing these works were applicable in photography, but with hindsight I can see how their influence has informed what I do.

Of course, some art teachers insist on the importance of drawing, and emphasize its role as the foundation of good art, and rightly so. In photography, composition is the equivalent of drawing. But colour is not something to be demeaned as a bit of pretty decoration that is added in at the end. It is a fundamental part of the art, whether painting or photography.

Take the page opposite. When I took this picture I had already passed this tree countless times, and photographed it on a few occasions. It made a fine composition, but I had yet to capture the most dramatic colour possible. Finally, one afternoon fulfilled all the conditions that I knew were needed.

The wind was westerly to north westerly, so the air was clear but punctuated by numerous heavy rainstorms. While one such storm was overhead, I could see the sky clearing from the southwest. I was out of my office and up on the ridge (about a mile or so from where I live) in less than half an hour. Being November, the hills were clad in the rich colours of late autumn. Around 20 minutes before setting, the sun appeared, turning the tree and the hills a brilliant gold.

The tonal contrast in this image is only average, and nearly all the impact comes from colour (chromatic) contrast. The golds/reds/browns of the trees and landscape sit at the opposite end of the spectrum to the thunderous inky blue of the sky. It may not be abstract colour-field painting, but the aesthetic principles are identical.

Un-complementary view

It is easy to appreciate the value of complementaries by comparing the impact of the main photo with a spring afternoon version. This also has a strong sky, laden with shower cloud, and sunlight on the landscape. The composition may be horizontal, but the viewpoint is the same. The two pictures are so very different it may not be fair to compare them, but without the benefit of complementary colours the smaller photo seems more mundane and familiar.

I am sometimes asked what sort of filter was used to achieve the colours in the main shot, and the answer is 'none', for no colour-alteration filter was used. The colour is purely a result of being in the right place at the right time. A filter was used, however: a very light (one stop) ND graduate to feather down the top of the sky a touch. To the darkroom printer, this is analogous to burning in just enough to frame the composition, without over-dramatizing the sky.

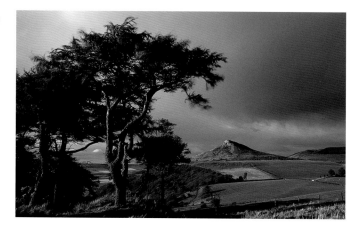

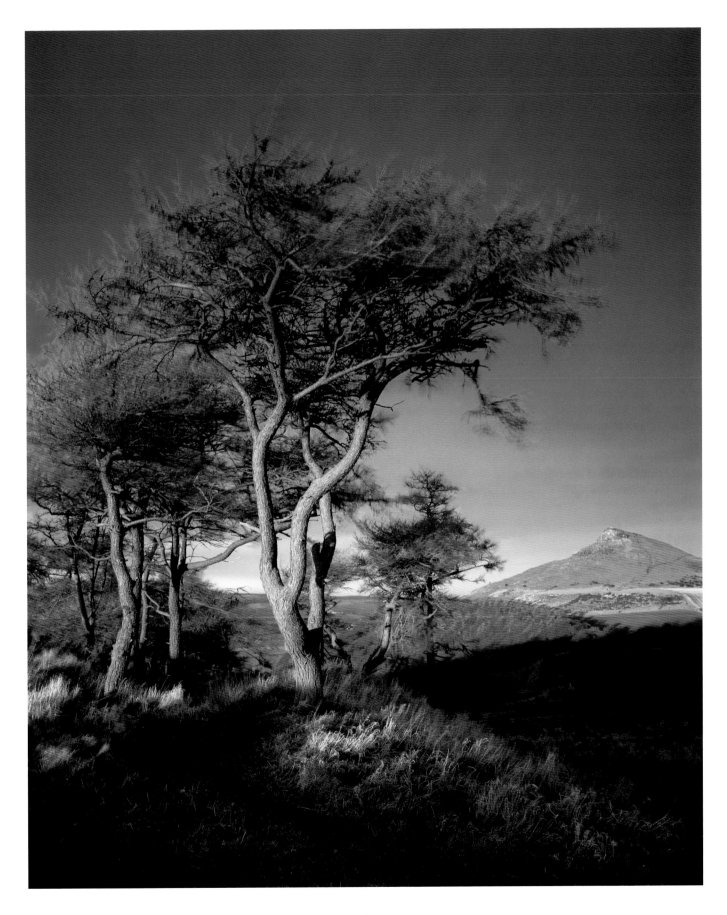

Tidal treasure

I think some of the greatest landscape photographs are details. Ansel Adams' marvellous black and white studies of ferns, dogwood roses, aspen trees and so on move me more than the monumental vistas for which he is famous. And other photographers, such as Eliot Porter and Peter Dombrovskis, have turned the landscape close-up into an art form, using large-format colour film to celebrate nature's intimate beauty.

Doing close-ups with a large camera is no easy trick, but the results of such labours, especially when an exhibition-sized print is made, are truly breathtaking. Until I began working with a view camera I'd felt little motivation to shoot close detail, for my main focus was the quality of light. Since moving to large format I have come to realize that what is good-quality light for the sweeping view, ain't necessarily so for the close-up. Which is useful, because there are now days when I can get good work done even if the light is distinctly undramatic.

These shells on Clifton Beach (south of Hobart in Tasmania) were shot on such a day. For any scenic photography it would have been hopelessly overcast, but for a subject so rich in textural detail and colour it was ideal. My main problem was to overcome the shock and excitement of finding so many beautiful colours and shapes all together, all simply washed up in the tide. The unbroken blanket of even cloud meant I wasn't distracted by the demands of spectacular, fast-changing light.

In spite of this, the photo you see here is, in certain respects, incomplete and unsatisfactory. Oh, I know technically it is fine. The exposure is correct, as is the filtration, 81D to balance the cold, soft light, and the colour looks gorgeous. Every detail is picked out by the bitingly sharp lens, a Macro-Sironar corrected for close-focus work. But the composition is not quite right. Perhaps I should have cropped out the bits of rock that appear at the corners and edges. All I know is it isn't quite there. One day I'll just have to force myself back to Tasmania for a reshoot...

The universe in the landscape

Half a world away, I found the detail on this page at Whitby. The treasure here is round, water-worn stones rather than shells, but the light was identical in character, as was the filter used. In this picture I borrowed the compositional idea from scenic landscape photography, seeing the stones as the landscape, and the rock wall as the sky beyond.

There is no conscious deep, hidden meaning behind such a tactic, simply a feeling that using such a convention makes the subject more accessible. In any case, the idea of 'a landscape within a landscape' appeals to me.

And depending on how you see things, deep meanings can lurk in these intimate details. I have always been fascinated by the way energy patterns are echoed on a cosmic scale, from the shells on a beach to spiralling star clusters, from microscopic to intergalactic. Such patterns and connections give us an aesthetic framework to appreciate the awesome scale, power and beauty of the universe.

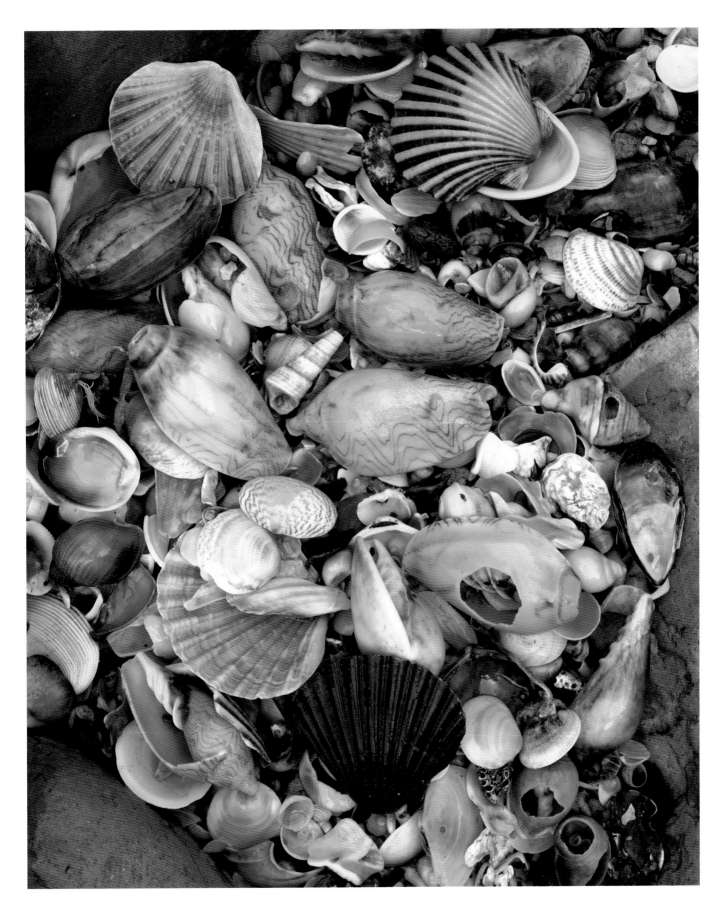

Le Gouffre

From 1986 to 1995 I spent large chunks of my working life taking photographs for European travel books. Although not well-paid work, it was fantastic experience which allowed me to develop and fine-tune my photographic technique, as well as visit many fascinating parts of the continent and Ireland. The main focus of the books was architecture. I spent much more time shooting buildings than landscape, and acquired some knowledge and a great interest in that subject as a result.

But it was the locations where the landscape really touched me that I remembered and subsequently returned to. Brittany is one of those places. Surrounded on three sides by the Atlantic Ocean, like its British cousin Cornwall to the north, Brittany is a region that lives by the rhythm of the sea. Its economy depends on fishing and tourism, and its mild climate can be attributed to the warm waters of the Gulf Stream. That in turn influences the type of farming that can flourish inland.

On a family holiday there I had a chance to get re-acquainted with a few parts of Brittany's wonderful coastline. We camped north of Treguier, and the photograph opposite was taken quite near our campsite, at the fortress-like granite headland of Le Gouffre. I had set myself the task of capturing the heather and the lichen-dappled granite, but I wanted to include the headland beyond. To do so successfully would mean filtering the sky down to prevent over-exposure.

My spot meter indicated that three stops of ND grad would be needed to hold tone in the sky's brightest area. But my main concern was the overall colour. The foreground light came from the cold blue and grey sky overhead, the sun's warmth having been largely muffled by advancing cloud. And my exposure on ISO 50 Fuji Velvia would be at least eight seconds, a speed at which reciprocity failure can cause this film to shift toward green.

It seemed a risk at the time, but I selected the 85C warming filter for my main exposures. This filter corrects daylight for tungsten film, but it turns out to be an excellent converter of very blue daylight for daylight film, as this example proves.

Unfiltered? Unbelievable!

I deliberately made an unfiltered exposure of this scene by way of comparison, and that picture appears on this page. Having shown these examples to a few people without first explaining what I did, the reaction has generally been that the cold one must be filtered blue, while the warm version is unfiltered.

Such reactions vindicate the use of an extreme filter, and previous experiments had proved to me it would probably work here, so it wasn't exactly a shot in the dark. While we may anticipate rocks shifting in colour according to the light, we have expectations of the way certain plants will look, and the heather surely seems more natural in the warm version.

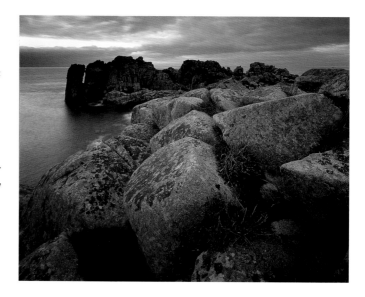

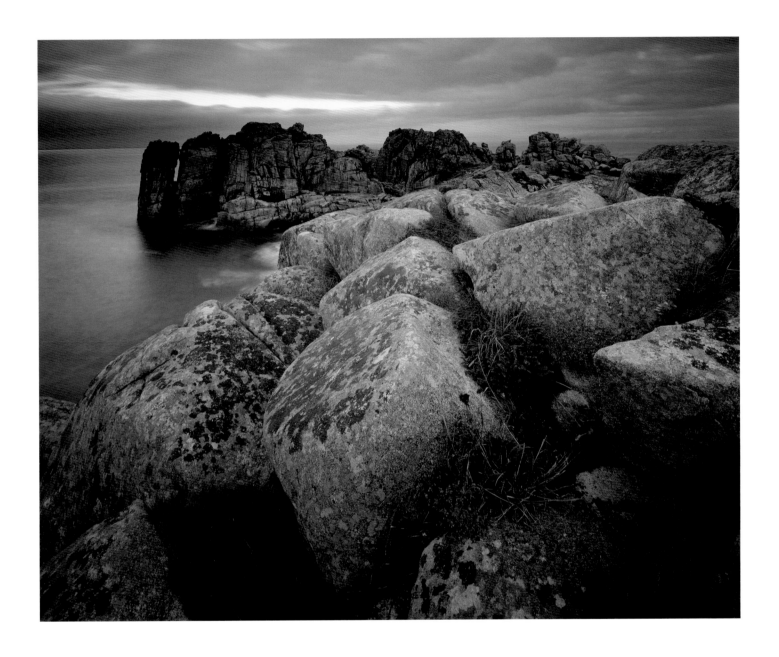

Glorious mud

Paddy's Hole is a tiny fishing port just on the inland side of South Gare, a massive breakwater which protects the south side of Teesmouth. It is picturesque in a surreal sort of way, for behind its pleasing cluster of brightly painted fishing boats and ramshackle huts throbs the steaming engine of industrial Teesside. At least, that is the view of it made familiar by painters and photographers.

Typically, that interpretation would be made at high tide on a sunny afternoon, with the boats bobbing about in the harbour. But my own favourite version of Paddy's Hole was shot at low tide, when the exposed, oozing silt became a miniature landscape in the gloom of a dusk twilight.

On the face of it this is a straightforward shot, which works through a simple device, the meandering drainage channel leading the eye through the picture space. Reflected in the channel and the mud banks, the dusky colours of the sky give an almost toned patina to the image, like a monochrome print. The colour unifies the composition, while the boats stranded on the mud add a narrative context.

What you don't see is the photographer struggling, waders ankle deep in sticky mud, camera bag perched precariously on a black bin liner straddling two slippery rocks. The tripod was equipped with optional 'snow-shoes', flat pads which help it to float on soft surfaces, but even so it had sunk several inches into the slime. It was important to stay focused on the image and the moment, and ignore the distractions – such as whether I was about to drop a film back or meter into the mud. However, the background difficulties a photographer suffers are not the concern of the viewer. Indeed, if the image seems effortless, that's as it should be. The photograph itself is what matters, not the steps taken to create it.

In some respects, making pictures of such unpromising subject matter is preferable to photographing a monumental mountain range. Mountains are usually diminished by a photograph, but the magic of light and the alchemy of photography can transform a muddy channel into something intriguing, and almost beautiful.

Paddy's Hole picturesque

On this page, Paddy's Hole takes on a different guise late one summer afternoon. This is the view beloved by local artists and photographers.

I think it may have been Leonardo da Vinci who said, 'We know more about the universe above than the earth beneath our feet.' Considering how dependent we, and our fellow animals and birds, are on the microbial life supported by mud and soil, and the vegetation it nurtures, perhaps landscape photographers should pay it more attention.

Trouble is, mud is rarely inspiring subject matter, although intertidal mudflats occasionally provide an exception. Once the sun is off its surface, smooth saturated mud becomes an excellent light reflector, taking up the colour of the sky above. Even so, I wouldn't trade places with the bold hippopotamus...

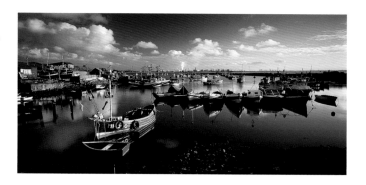

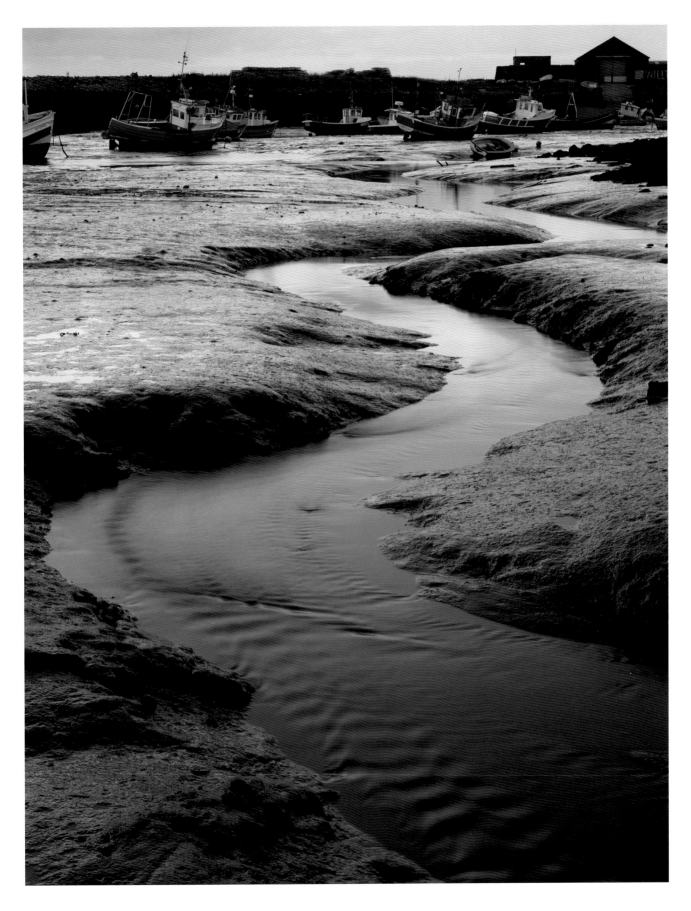

*A*utumn water colours

Leaves changing from green to the variegated warm tones of autumn is the principle reason that this is a favourite time of year for many landscape photographers. In Britain it is often a long, drawn-out season. Many leaves start turning by the end of August, but winter storms rarely strip the trees bare before December. Rain and wind are frequent, belying the poet's claim that this is 'the season of mists and mellow fruitfulness'. Oh that it was, for poor weather frequently limits the scope for autumnal pictures.

However, it was in late October that a spell of settled weather encouraged me out onto the North York Moors, to the little-known beauty spot of Falling Foss. In a wooded valley, the stream of May Beck leaps over a sheer drop of 50 feet (17 metres). It is lovely, but even in full flood this is no North Yorkshire Niagara.

From the path through the woods, a well-framed view of the waterfall appears. On this day, though, the strong sunlight created unworkable high contrast, so I shelved that idea and instead started to explore the stream itself. I found the best solution just above the fall itself. Set beneath steep north-facing banks and thick woods, the stream here lay in shade, even though it was midday. Bright sunlight was shining on the south-facing woodland in the valley beyond, and the warm colours there reflected off the shaded water at my feet, as did the blue sky. Best of all, there were newly fallen leaves, thousands of them, some clustered in eddy currents, others perched artlessly on the boulders where they had fallen, providing me with scale and contrast.

Wellington boots were the photo accessory of the day. All told I spent nearly two hours standing in the water, trying different angles and variations on the theme of leaves with reflected light on water. My tripod needed draining off afterwards. The main image was made with a macro lens, corrected for close-focusing work. The swirling, flowing colours reflected on the water make a dramatic setting for this modest subject. Remarkably, the light on the foreground needed no colour correction. The only filter used was a light ND grad to hold the reflection highlights.

Man with a plan, and better alternatives

A few days later I returned to Falling Foss in much more overcast conditions. This proved satisfactory for the standard view of the fall itself, where soft colours and low contrast help produce a reasonably luminous result. Being the standard view, though, something magical was required to lift it, and there is nothing in the timing, lighting or composition here that is exceptional.

I'd had this framed angle in mind on the day I made the main photo, and the harsh sunlight had initially provoked disappointment. But by seeking other possibilities, I ended up with a far better solution, one I had not imagined beforehand. There is nothing wrong in having a plan, but the landscape is imperiously oblivious to our hopes and expectations, and the challenge is to be open to alternatives to the original plan.

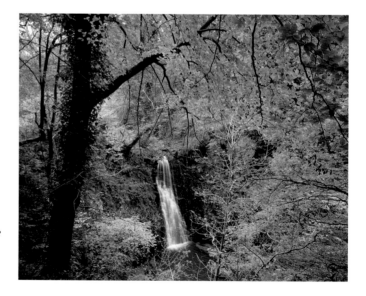

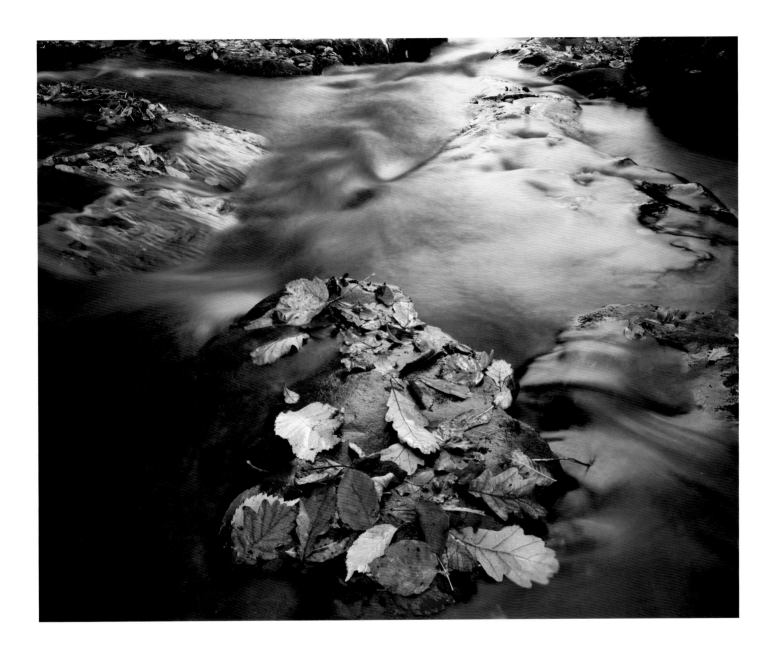

Green and pleasant land

'Green sucks, Joe' was a remark directed at me on more than one occasion by the first photographer I assisted, Mike Mitchell. It is true that Mike was not a landscape photographer, but he did work on location, and when he did so would avoid grass and green trees as if they were a plague. Fear of green is not an uncommon affliction among photographers, and the reasons for it are varied and difficult to explain. It seems to be the colour that films respond to most differently, and while some films have dull, flat greens, others can seem excessively vibrant. Any green cast, for example caused by fluorescent lights or reciprocity failure, seems to impart a sickly, cold atmosphere which most people agree detracts from a picture. And landscape photographers face the challenge of blanket green during late June, July and early August, when, in Britain especially, the countryside seems unrelieved by any other colour.

Of course, green is the dominant colour of plants and so is truly the colour of life. We cannot ignore it, and landscape photographers cannot avoid it – not for long, anyway. To prevent green overwhelming other colours, it is good to have strongly contrasting colours within a scene. Its chromatic opposite, red, is ideal and poppies in a green landscape are the perfect contrast. In the absence of poppies, however, there are other potential solutions, and the main image here illustrates some of these.

The view overlooks the village of Swainby, nestling below the western flanks of the North York Moors. Shot in June, the previous year's bracken has yet to be smothered by new growth, so the foreground is an attractive orangey brown. In the distance, fields of oilseed rape cut bright yellow into the green patchwork landscape. And, importantly, the early summer growth has yet to darken into the chlorophyll-rich green that can look so dull. But the most significant redeeming feature of the colour here is the dramatic sky, where the clouds are underlit gold by the late afternoon sun. Cover the sky with your hand and the landscape is merely green and pleasant.

Breaking all the rules

Taken in the same month the previous year, the small photo (this page) was shot with a 210mm long standard lens. I kept the sky to an absolute minimum because there was nothing in the sky worth including. The horizon line, in which the tiny pinnacle of Roseberry Topping can just be seen, is included only to provide context.

I know the main photo breaks a cardinal rule of composition by placing the horizon line at the halfway point rather than at the thirds. But this is what felt right at the time. The light in the clouds would have been bisected by the edge of the frame had I pointed the camera any lower, and the base of the foreground tree would have been cut off if I had tilted it further up. As it stands, the light in the sky and the tree are satisfactory. That matters more to me than rules.

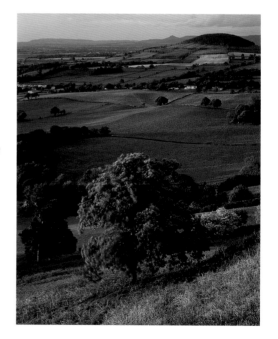

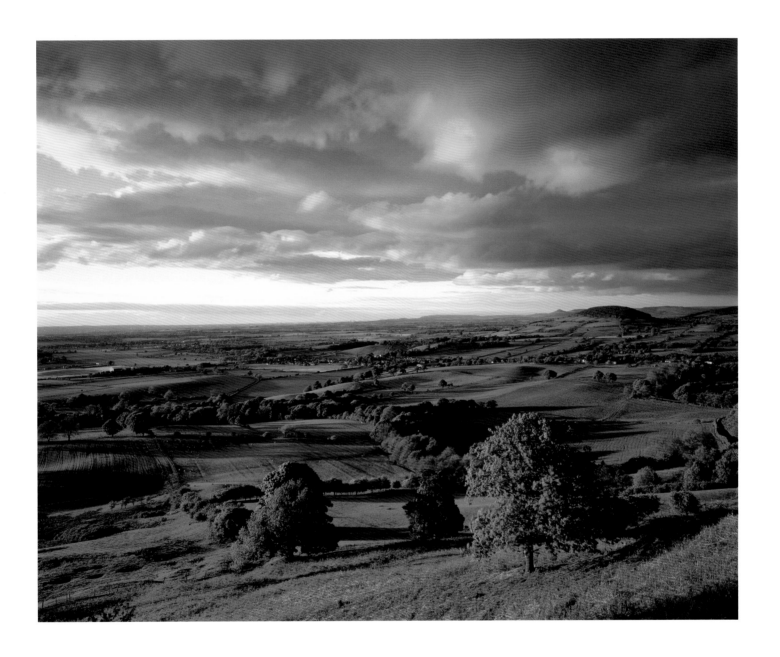

The temple of light

This extraordinary slot canyon, once a sacred site of the Navajo people, is now a place of pilgrimage for landscape photographers who visit from all over the world. When the brilliant Arizona sunlight blazes into the deep recesses of the canyon from a clear sky, rock which is lit indirectly by bounced light seems to glow. The predominantly reddish minerals within its sculpted walls are highly sensitive to the colour of light. In reflected sunlight the sandstone glows orange and red, but where only diffuse blue skylight penetrates the canyon it can turn purple or magenta. Modern colour transparency films such as Fuji Velvia enhance these colours, especially when long exposures are employed, as they inevitably are, due to reciprocity failure.

The fluid shapes, waves and crests of rock give the impression that solid stone has been frozen in the form of water. And despite its arid location, Antelope's appearance has evolved from watery beginnings. Firstly, it is part of the vast Colorado Plateau layer cake of rock. For 250 million years, shallow seas built up these deep sedimentary layers, while periodic 'desertification' brought sand dunes, eventually fossilized. Subsequent uplifting of the region provoked the rapid erosion still happening today. It is flash floods which have created Antelope, tunnelling it out from a fault in the rock which coincided with a water course in the desert. It is the beautiful offspring of an awesomely destructive force of nature.

Having introduced quite a number of people to Antelope Canyon, I know I'm not exaggerating when I describe it as one of the great natural wonders of earth. The awe it commands is not due to size, for nowhere is it more than 80 feet (26 metres) deep, but its beauty of form and quality of light exceeds in spiritual atmosphere any temple or church.

To do justice to this beauty is not easy. In the main image my spotmeter readings showed a difference of more than three stops in the left-hand and right-hand zones of the composition. The solution was a two stop ND hard graduated filter on its side, the ND influencing nearly half of the right-hand side. The filter acted as a bridge between the two exposure zones, enabling me to expose both correctly.

The hazards of slot canyons

Antelope offers two distinct canyons to explore, Upper and Lower. The main image was shot in the Lower Canyon, photographically the less challenging of the two, being shallower and more open to light. But steep drops, twists and turns make it a demanding environment to explore. It is also the more dangerous of the two. Eleven unfortunate European visitors lost their lives down here in September 1997, caught in a devastating flash flood.

Once a fee has been paid to the custodians, and a shuttle jeep ridden up 5 miles of dry wash, the Upper Canyon is easily accessible, being a flat walk along a sandy floor. Deeper and darker, it is a place of high contrast and dramatic possibilities. The smaller image on this page was shot here, looking almost vertically upwards.

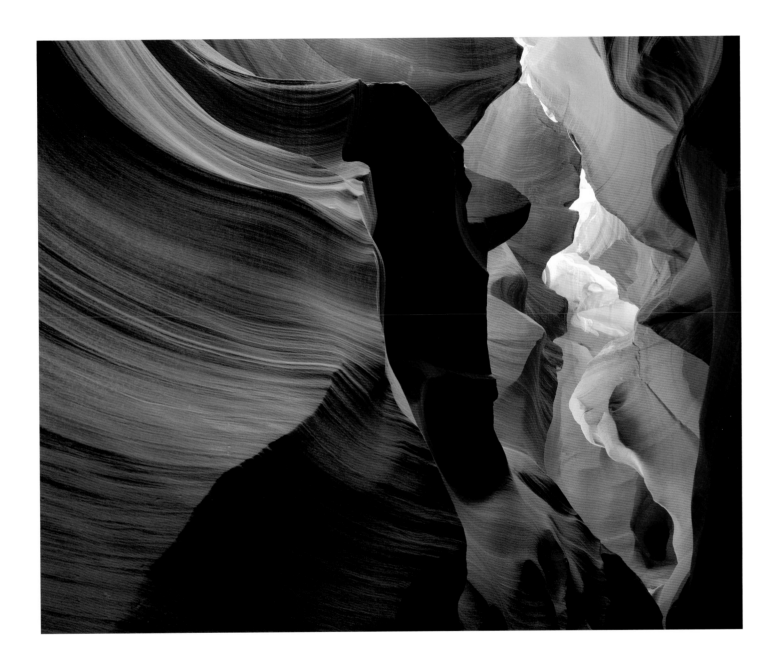

Contours in blue

There are places you visit and forget, and some you don't. Dunraven Bay remained filed away in some recess of memory for sixteen years before I returned there. It is an almost arrogantly spectacular beach, with a vast expanse of gently sloping sand, backed by sheer cliffs of multi-banded rock. At low tide, the sand is bordered by wave-cut platforms of limestone, broken by shelves, and scattered with hundreds of thousands of roundish, wave-tumbled stones.

While it is the kind of place I love, on this last visit there was a problem. Although it was the middle of January, the weather was simply too fine! Not a cloud in the clear blue sky on both days I spent there. This precluded a scenic approach simply because without clouds there was no atmosphere, no magic. And as I wandered the beach I felt that even with the winter sun low in the sky, the lighting on the foreshore was also too hard and brutal for detailed compositions.

Putting my preference for warm light to one side, I walked into the shadow of the cliff that protects the southeast edge of the bay, and there I found the wonder I was seeking. While the dry limestone reflected the blue sky, damp parts of the rock, and pools, picked up colour from the sunlit cliff at the back of the beach. The dry rock acted as a diffuse reflector, while the damp surfaces were specular (direct light) reflectors.

Although it took time to tune in, by the second day I had figured out what I wanted to do. Shooting unfiltered, I was able to combine two complementary colours, blue and yellow, which helped dramatize the curved, tide-beaten surfaces of the rock platform. The composition is concerned mainly with balancing all those intersecting diagonal lines. But it is the mysterious colour, borrowed from outside the image area, which is the magical ingredient.

Steady as she goes with telephotos

The main photo was made with a 300mm Fujinon telephoto lens that helped isolate the elements and achieve a slight compression front to back. Although 300mm is only comparable with an 85mm on the 35mm format, it is as tricky to keep steady as a 300mm on any format. All 5 x 4in view cameras are boxy, unaerodynamic objects, especially prone to wind vibration. I shielded the camera from the gusting wind using my body and outstretched jacket.

In this composition I needed maximum front tilt to ensure sharpness throughout. Tilt control makes the view camera perfect for shooting a flat surface at a steep angle, giving far superior quality compared with any rigid lens/film plane camera.

Shot the previous day, the smaller image is the work of someone still coming to terms with a new subject. Although not aesthetically disastrous, it lacks the coherence and completeness of the main image. It was shot with an 81B warming filter, whereas the main image is unfiltered to take maximum advantage of the blue cast of the sky.

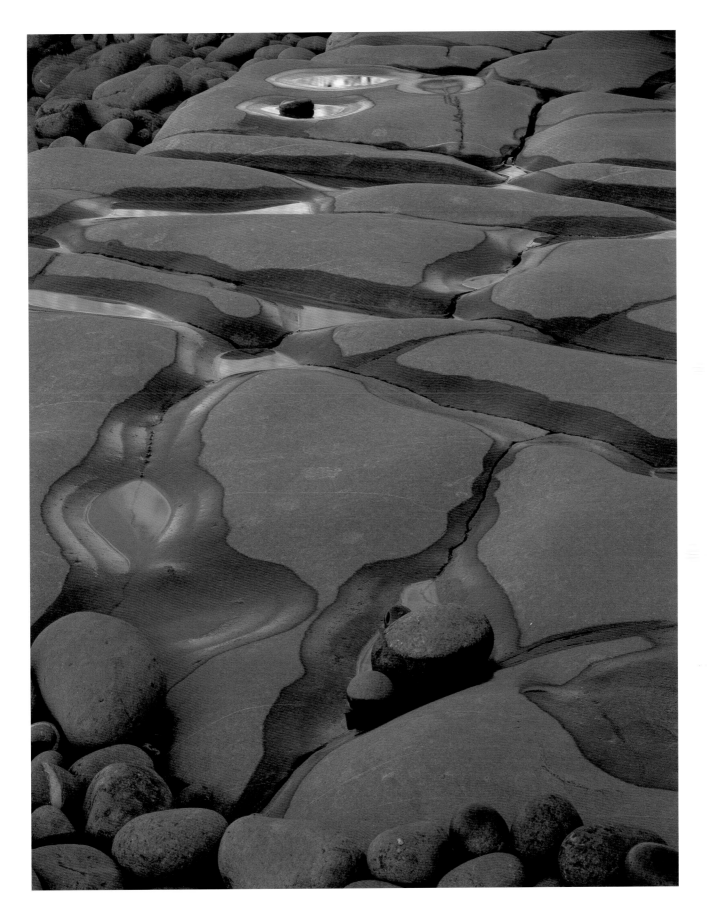

The point of return

We shall not cease from exploration
and the end of all our exploring
will be to arrive where we started
and know the place for the first time.

T.S. Eliot, 'Little Gidding', *Four Quartets*

Before I set off on assignment to some far-flung destination, one or two of my friends and neighbours enjoy mocking my (apparently) leisured lifestyle, 'Off on holiday again, Joe? It's all right for some!' Or when I am at home, which is most of the time, I am often asked, 'Where are you off to next?' There is an assumption that I must constantly travel abroad to far-off places, because exotic places make exotic pictures.

The truth is rather different. While I find new places stimulating, the process of getting there, the travel part, is often an ordeal. I do travel abroad, typically twice a year, which is less than many of my aforementioned friends. I make a point of seeing some wilderness every year, if I can. But mostly I am at home in Britain, and enjoy the landscape close to home in North Yorkshire as much as anywhere, mainly because I know it so well.

To adapt a well-known phrase, familiarity breeds content. Knowing a place means being better prepared. In an art form where timing and lighting are crucial, prior knowledge of territory hugely improves your chance of being in the right place at the right time. And if you know a place, you feel no pressure to do the standard view. On the contrary, you are more likely to seek out a fresh angle, a new perspective, a previously unseen detail. Depth of knowledge can inspire depth of expression and feeling, whereas unfamiliarity often results in a rushed, superficial interpretation. That, in a nutshell, is the point of return.

While I love the warm colours and monumental scale of America's desert southwest, I know I have little hope of emulating Michael Fatali, Jack Dykinga, or David Muench. This is their backyard. Perhaps if they were to visit North Yorkshire, the roles would be reversed. When I set out to shoot from home, I know that if conditions do not match my aspirations there's no pressure to expose any film. I know I can always go back. Once-in-a-lifetime trips abroad do not afford that luxury. The result is often pictures reflecting the compromises of someone desperate to shoot something, anything, as a record of the visit.

So landscape photography should not be limited to holidays or travel assignments, and there are two more good reasons for this. Firstly, our local landscape is something to cherish and celebrate in its own right. Secondly, I personally need to practise what I do in order to keep improving my technique and keep my ideas flowing. And besides, I just love taking pictures. If I felt I had to go off on a journey every time I needed to photograph, my life would not work.

Yes, travel broadens the mind, develops our knowledge of the world, and teaches us respect and tolerance for unfamiliar cultures and people. But perhaps best of all it lends perspective to our own home environment, and deepens our appreciation for the landscape in our backyard. Besides, when you get plenty of practice photographing the understated landscapes and unpredictable weather of northern England, dramatic travel locations are easy!

The edge of light

It is on and around edges where the landscape offers up its most powerful images. The edge of weather is a good example. The leading or trailing edge of a storm front or major weather system looks dramatic in itself, and often produces powerful effects of light and shade on the landscape. The edge between land and sea (or lake, or river) is another favoured zone for picture taking. But the greatest edge of all is the change from night to day, and from day to night. This might be called the edge of light.

The quality of light itself has an influence on our emotions and imagination, but one I suspect only photographers and artists are consciously aware of. I have always believed the light is as much the subject of the picture as the landscape, and when working with the edges of the day it sometimes *is* the subject. As a stage for light, the coast is the place, and near where I live the best bit of coast is Saltwick Bay.

I've visited Saltwick countless times, although on the first visit I almost didn't find it because the approach is so discouraging. Access is through a caravan and camping park, and the wild, windswept shore beyond it is utterly unexpected. Although rich in rocks, cliffs, sand, and even sea stacks, the most photogenic features of the bay are its wave-cut platforms, which reflect light brilliantly.

The main image was made at the end of a midsummer day, some 25 minutes or so after the sun had set. I had been searching all evening, trying to find some inspiration in the light and the rocky details. Nothing had really worked, but I knew the rising tide might bring a solution. My familiarity with the place meant I felt no great pressure. If the right moment came I would be ready.

The advancing water covered most of the rock platform, leaving a few big stones proud of the surface. As the sky began to turn pink I realized that the clouds, the colour and the reflected light *were* the image. A wide lens and a minimal composition expressed the sense of space and light that had eluded me earlier.

Less is more, and vice versa

Whereas the main image was shot at the last gasp of summer daylight, the smaller version here is a winter dawn, the opposite end of the day and the year. The silhouetted stones, sea stack and headland suggest that my main preoccupation was with the sky reflected in the wet rock of the beach. Light is also the main theme of this photo. However, the additional complexity of the composition confuses the issue. This is a case of more being less.

My passion for rocks probably got the better of me, and I have fallen into the trap of trying to shoot something, even though the elements are not resolved. Low tide has left the elements cluttered. It is not a terrible photograph, but it is not a good one. Shot before I had got to know Saltwick well, it helps confirm that returning to a place allows you to be more selective. Familiarity gives you an edge.

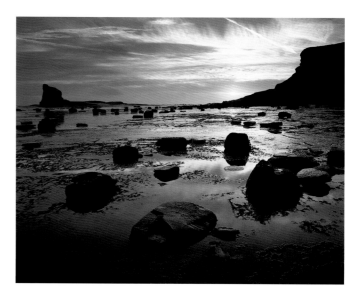

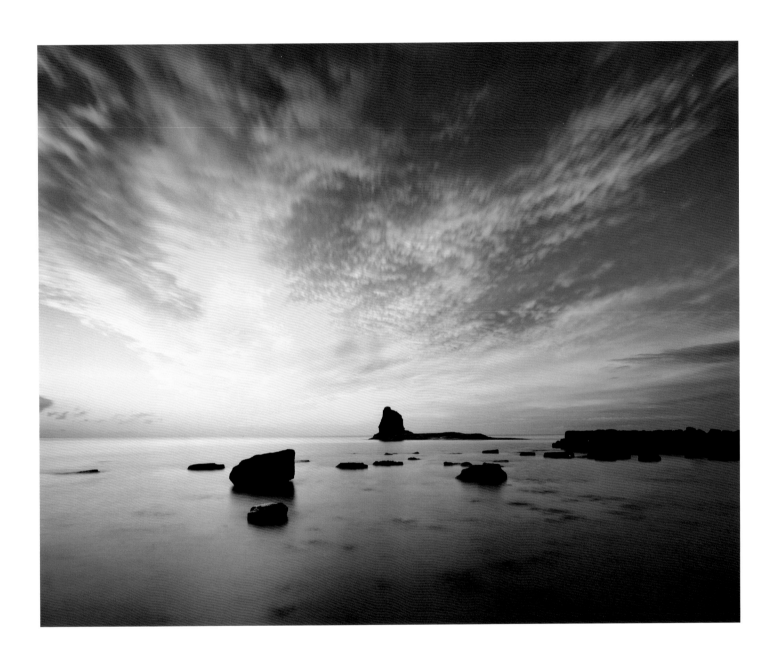

The Queen's Garden

At Bryce Canyon, geology has combined with the forces of erosion to create what is rightly regarded as one of nature's masterpieces. Part of the Colorado Plateau region of southwestern USA, the sedimentary rocks at Bryce are quite a bit softer than those found at its relatively near neighbour, Zion, and weathering is rapid. Surprisingly to those used to a temperate maritime climate, the most significant agent of erosion here is ice. It may be on the same latitude as North Africa, and become hotter 'n Hell on a summer's day, but at more than 2500 metres there are freezing air temperatures at least two hundred nights a year. Although Bryce is fairly dry this is no desert, and the rains and snow that fall make it a showcase for freeze-thaw, or frost wedging.

While geologists can explain the science of it, the old Indian legend tells of an ancient people who spent too long building and decorating their city. This upset their guardian spirit, Coyote, who punished their vanity by turning them all to stone. He then tipped their paints on top of them for good measure.

It wasn't the legend but the breathtaking wonder of the place that overwhelmed me on my first visit there. My initial impulse was to reach for the widest lens I had, to take it all in. The truth is that any perspective can work at Bryce, and it is one of the easiest places in the world to take a superficially interesting picture. I've even used the phrase, 'Any fool can take a dramatic picture from the rim of Bryce Canyon,' to challenge my delegates on workshops I have led there. It is easy to shoot, but not so easy to produce a picture that is original or personal.

On my last visit I made a conscious effort to see narrower, to use longer lenses and select details that emphasized the remarkable colours and glowing light that accompany the early morning. For the most part I excluded the sky. The far-off cliffs and mountains look blue through the effects of atmospheric distance, so the sky was not necessary as a source of colour contrast. The main image is of the so-called Queen's Garden district, with Sinking Ship Mesa beyond. It was made with a 400mm lens (equivalent to 110mm on the 35mm format), and no filter was needed.

Paul Simon contradicted

To paraphrase the song: Mama, perhaps you really should take my Kodachrome away.

One of the oldest photographs in this book, the small photo on this page was shot in June 1986. I used a Nikon and Kodachrome 64. The light was quite interesting, and the angry sky is typical of the thunderstorms that occur in this region on many summer days.

The weather and time of day are largely responsible for the colour differences between the two images, but the film itself is also a contributing factor. The fifteen intervening years have seen films become sharper, finer-grained, more consistent and stable, and as E6 films have improved, so Kodachrome has effectively been superseded. However, that is less significant than the experience I had gained as a photographer, and the fact that I had returned to Bryce on a few occasions, giving me the chance to refine my ideas and plan shots, rather than simply reacting.

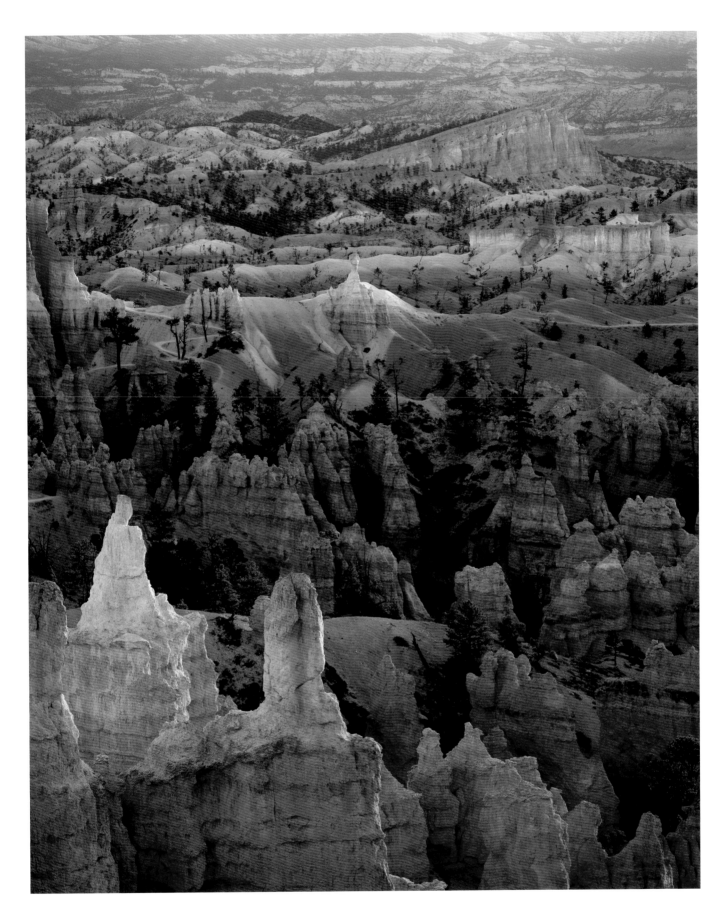

Gateway to the moors

Man-made objects are rarely the main feature of my landscape photos, but I make an honourable exception for this gate because of the splendid landscape backdrop, and for its inherent symbolism and slight sense of mystery. The wooden signpost, which I initially thought spoilt the simplicity of the picture, actually adds something to the narrative, and even to the composition once I had resolved where to place it against the background. The gate set slightly ajar invites us to walk into the picture, and perhaps down the footpath which follows the edge of the moor. The path runs past the gate, not through it, and it seems abandoned to the wild verge that surrounds and will eventually reclaim it.

This gate can be found on the Cleveland Way above Sutton Bank in North Yorkshire, and when I last walked out here one summer evening, the lighting conditions were ideal. The sort of cloud which often haunts the uplands of northern England remained over the moors, but had cleared to the west, allowing the sun to shine strongly for half an hour or so before setting. I had time to select my camera position critically, ensuring the signpost was sited so it showed up clearly against the background. I chose a 72mm super-wide-angle lens (similar to a 20mm on 35mm) which allowed me to include a full sweep of the path to the right without cramping the foreground or the sky. A two-stop ND graduate covered the top quarter of the frame to balance the sky to the foreground. I made my exposures as the wind blew so the grasses would be softened by motion blur, in contrast with the solid detail of the gate. To preserve correct perspective I employed a fair amount of lens drop on my view camera, and a little tilt as well, placing the zone of focus from foreground to the distant horizon.

Gateways may be symbolic, but meaning is something the viewer discovers in the photograph – it is not something the photographer can impose. What I can say is that this landscape, with its mixed farmland, moorland and wooded margins, is rich in clues to the history of its human occupation. I hope that the lighting on this wonderful evening serves to make any meaning or interpretation both deeper and clearer.

Original version, identical viewpoint

On a visit to Sutton Bank three summers earlier, similar cloud conditions prevailed but with softer light. On this occasion the polarizer and warming filter I used combined to produce colour quite different to that in the later version. The position of the camera, however, is almost identical in both images, for I found it impossible to resolve the composition from anywhere else. I dislike repeating myself, and did so here only because no better or equally good alternative could be found.

This spot is a favourite of mine, and I expect to revisit at other times of year and photograph it with snow, or with spring wildflowers, or with autumnal woodland beyond. However, it will be hard to improve on a late summer sunset, when the grass turns gold and the distant green slopes confirm the fertility and timelessness of a very English landscape.

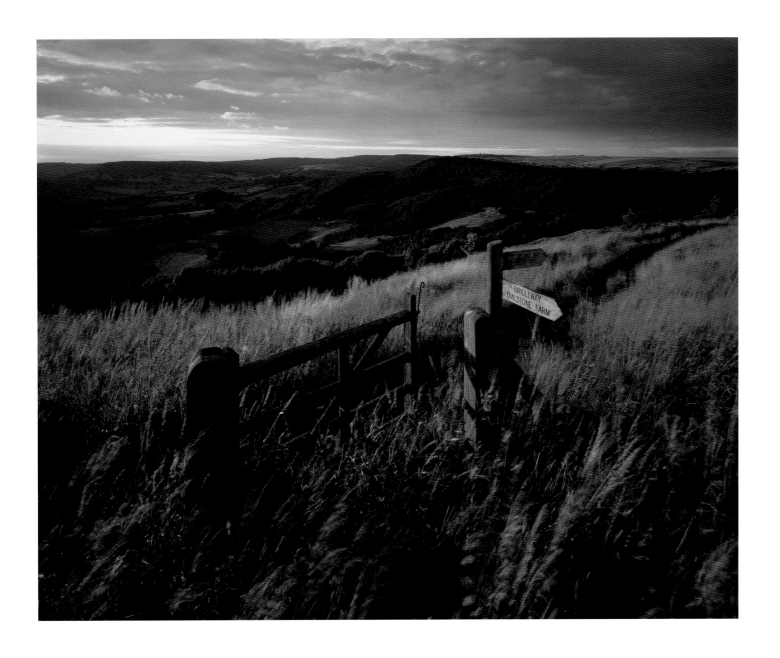

Inversnaid

This darksome burn, horseback brown,
His rollrock highroad roaring down,
In coop and in comb the fleece of his foam
Flutes and low to the lake falls home.

A windpuff-bonnet of fáwn-fróth
Turns and twindles over the broth
Of a pool so pitchblack, féll-frówning,
It rounds and rounds Despair to drowning.

Degged with dew, dappled with dew
Are the groins of the braes that the brook treads through,
Wiry heathpacks, flitches of fern,
And the beadbonny ash that sits over the burn.

What would the world be, once bereft
Of wet and of wildness? Let them be left,
O let them be left, wildness and wet;
Long live the weeds and the wilderness yet.

This poem by Gerard Manley Hopkins, composed when he was staying at Inversnaid, immortalizes Snaid Burn. The photo opposite, of Snaid Burn, was inspired by the poem, whose words hang framed in the hallway of Inversnaid Lodge.

The poem says much more evocatively than I could what I hope the picture is about. One thought, though: if Gerard Manley Hopkins had been alive today, would he have been a poet, or a landscape photographer?

World-class workshops

Inversnaid Lodge, run by André and Linda Goulancourt, is one of Britain's best-known photography centres. Photographers come here from around the world to take part in workshops led by Thomas Joshua Cooper, Paul Hill, Fay Godwin, John Blakemore and others. It has been my good fortune to lead workshops here too.

The small photograph (this page) is of exactly the same part of the burn, but shot a year later when less water was flowing. It was shot in extremely low light and the very long exposure (one minute) has pushed the film well into the zone of reciprocity failure, shifting the colour (unacceptably far) to green. Returning to places where one has made strong pictures in the past does not, unfortunately, always guarantee success!

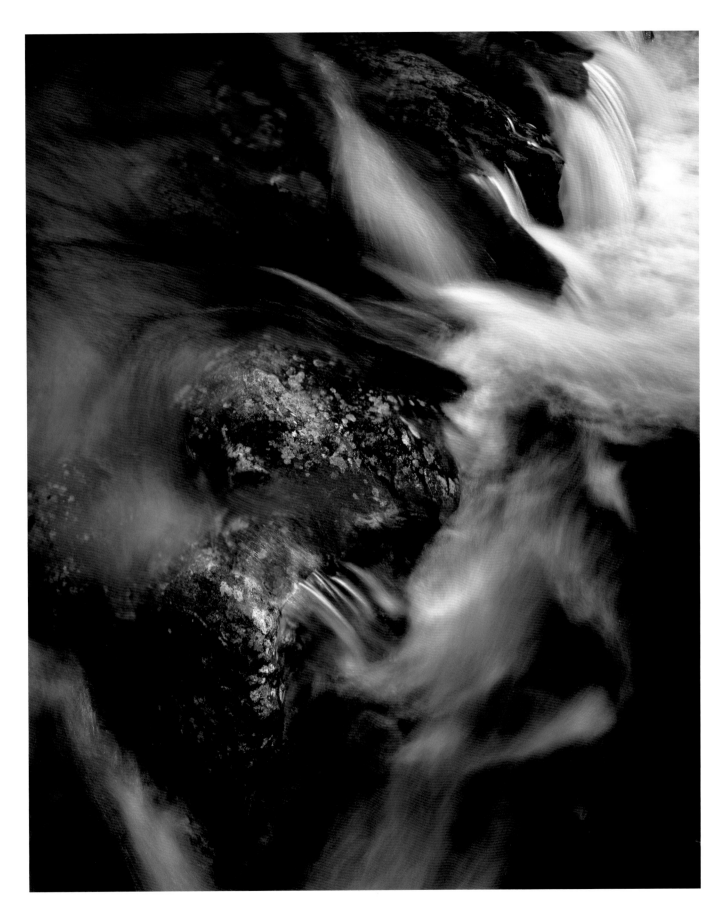

Endgame on the checkerboard

In 1982 I journeyed across America with university friend David Luallin in a yellow VW Beetle. Although I'd travelled widely by plane elsewhere in the States working as an assistant, this was my first land crossing. It was while we were in Arizona and Utah that I had the kind of life-changing encounters that made this journey a true rite of passage. One was in Zion National Park, where I ventured alone into Hidden Canyon and experienced a slick rock sandstone canyon for the first time. Although my photographs proved a major disappointment, failing to capture my emotional reaction to the place, I have never forgotten the sense of wonder I felt in that quiet, secret corridor of stone.

Zion remains a favourite location to which I have returned often. I think it is one of the most magical places in the world. The centrepiece of this semi-desert landscape is an awesome canyon carved through brilliantly coloured sandstone by the Virgin River. Since the river always flows, the canyon floor is a verdant oasis of oak, cottonwood, box elder and sagebrush, while mule deer and porcupine are among the wildlife residents. Upstream, in its northern reaches, the canyon walls converge to a point where the river fills the valley floor. This is The Narrows, a stupendous slot canyon hemmed in by 650-metre-high cliffs.

Beyond Zion canyon itself, the easterly, Mount Carmel, section of the park contains a surreal backdrop of steep-sided slick rock hills. The Checkerboard Mesa is this area's most famous feature. Late one cloudy afternoon, eighteen years after I'd first set eyes on Zion, the sun shone unexpectedly through a gap in cloud for a few seconds, transforming the scene I'd been contemplating. Could it happen a second time? Another gap in the cloud suggested it could, so I set up my tripod rapidly to see if I could play the endgame. A vertical 6 x 12cm format suited the subject, and just as I loaded the film back the sun appeared once more. I had time to make four rapid exposures before the sun was gone for the last time. Although I reacted to the first appearance of the sun, I anticipated and prepared for the second. In the eighteen years since my first visit, I had learned that it is light which reflects our emotions, and that sometimes the briefest moments create timeless images.

Slow, slow, quick, click, slow

I had attempted to photograph a different tree in front of the Checkerboard Mesa a few days before – the smaller image on this page. There was already too much shadow, making the outline of the tree unclear, and the lack of clouds produced a stark, two-dimensional effect on the skyline. The Mesa almost looks like a cardboard cut-out.

While the large-format camera is a relatively cumbersome and slow instrument to operate, light is often transient and fleeting, demanding quick responses and a clear vision. Making the right decisions under pressure is not luck, or what camera you use, but the result of hard work and experience. Which is why, when asked what shutter speed he had used to take a great photograph, a famous American photographer is alleged to have replied (through gritted teeth), 'Forty-three years and a thirtieth of a second.'

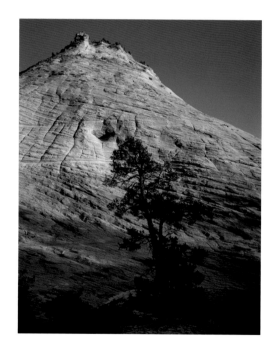

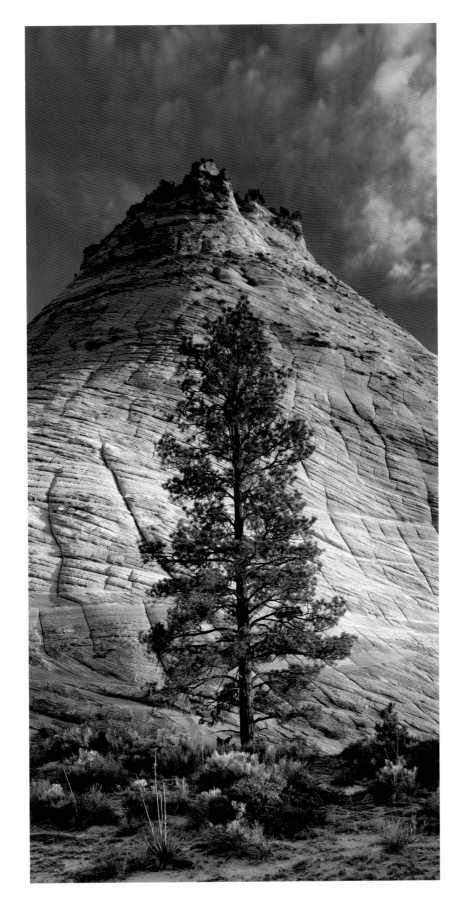

Soul city memories

Work has taken me to some varied places over the years, from mines to fish auctions, and from motorways to mighty cathedrals. Perhaps the strangest place I've ever worked was Père Lachaise cemetery in Paris, and stranger still is the fact that I've spent three weeks of my life within its walls taking pictures!

In 1982 I returned to England after nearly two years working as an assistant in the United States. I moved to London and not long after I got there, what seemed like a great opportunity arose, proposed by an American friend of a friend. The offer was to make the pictures for a really beautiful book. The catch? It was about a cemetery, and, oh yes, there was no publisher yet, therefore no money for photography.

But on the whole a rookie photographer does not turn down a book, and at the time I assumed the lack of a publisher was not a problem. So I spent two sunless weeks in early November exploring and shooting in this amazing place, where some of the immortals of French art and culture are buried, as well as a few non-Frenchmen such as Oscar Wilde and Jim Morrison.

I am not a morbid person by nature, yet I must admit I loved Père Lachaise. Its sculptural and architectural extravagance, softened by years of neglect and decay, make it both highly atmospheric and, to my eyes, profoundly beautiful. Carolyn Campbell, the writer who invited me to shoot the pictures, was full of enthusiasm for the photographs. But by summer of the following year no publisher had been found, and I filed away Père Lachaise into that category of life marked an 'experience'.

In 1997 Carolyn wrote to me saying that there was strong interest from an American publisher, but she would need a few more pictures (although there was still no photo budget). My affection for the place remained undimmed, and I returned for a week when the late-autumn Parisian sun shone. Accompanied by my partner, our two children, a view camera, and fifteen years of extra life and photographic practice, I revisited my working past, my photographic youth. In this cemetery, it is impossible not to reflect on your own mortality. As much as the image-making opportunities, it was contemplating the nature of life and death that made this, for me, such a poignant experience of the point of return.

Multiple errors from early years

The small photo here, a 35mm Kodachrome from 1982, illustrates the way my colour style has evolved since. It is completely unfiltered, so suffers from white sky, green cast due to reciprocity failure, and blue cast from the lack of sunlight. In the main image made late one afternoon in 1997 I exploited the late low sunlight to the full by the use of a warming polarizer. The rising front of the view camera allowed me to use a wide-angle lens without the occurrence of converging verticals.

Carolyn and I did not pursue a contract with that particular publisher, so the book has yet to materialize, and to this day I have yet to make a single penny out of the project. Perhaps in another fifteen years I will go back, and who knows, it might just be third time lucky. Meanwhile, if anyone out there wants to publish a virtually finished book, you know who to call.

Roseberry reflections

Roseberry Topping appears five times as a subject in this book and I make no apology for being fond of this, the hill that looks over the North Yorkshire village where I live. Its ironic local nickname is the Cleveland Matterhorn, which is funny because it is about 4500 metres lower than the Swiss version! But I am certain the residents of this part of North Yorkshire love Roseberry Topping just as much as the people of Zermatt appreciate their local landmark.

The great American photographer Joel Meyerowitz has published a book about St Louis, in which the city's famous arch appears, quite literally, in every picture. In some images it is the main scenic subject; in some, he has photographed close details of reflections in the arch; in others it is glimpsed unexpectedly in a street scene. The arch creates a link woven through this affectionate portrait of a city. For me, Roseberry Topping plays a similar role. I have shot close-up studies of its summit cliff face; I have photographed views from it; sometimes it fills the frame; at other times it is a mere punctuation on the distant horizon. Although I may be photographing gorse, or bluebells, a stand of trees, a flock of sheep, or a drystone wall, Roseberry's summit somewhere in the background gives a focus and an unmistakable identity to the landscape.

By English standards, the North York Moors is quite a dry upland, and there are very few stretches of calm water for shooting reflections (and ice details in the winter). This little farm pond is the only permanent water I know of near Roseberry, and it is too small to get far enough back so the hill would be reflected in it. Nevertheless, with this stand of trees it does form a charming subject. A strong sky is needed, for it is the sky and its reflection that fills most of the frame. This special autumn afternoon provided such a sky, while sheep liberally spread across the field in the middle distance helped create a pastoral atmosphere.

Polarized viewpoints

The small version of Roseberry on this page was shot (with a Hasselblad) at the end of a dry summer. These fields turn this colour only rarely, creating a mood reminiscent of Spain or Italy. Roseberry's profile is an instant reminder of its Yorkshire roots, however. Once again, sheep grazing this upland pasture lends a certain atmosphere that would be lacking without them.

A polarizing filter was used in both photographs here. In each case the blue of the sky is strengthened, and all colours tend to be enriched slightly. I take care not to over-use this filter. It is a great tool when a little subtle dramatization is needed, and when its use is not conspicuous. But I rarely use it when the natural colours are already strong from the sunrise or sunset, or when the sky is clear of cloud.

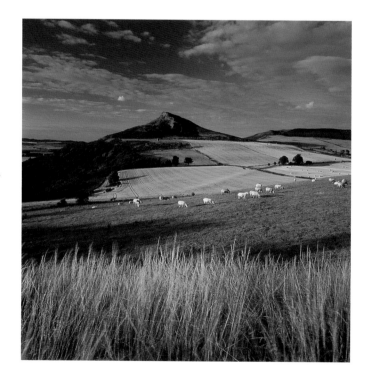

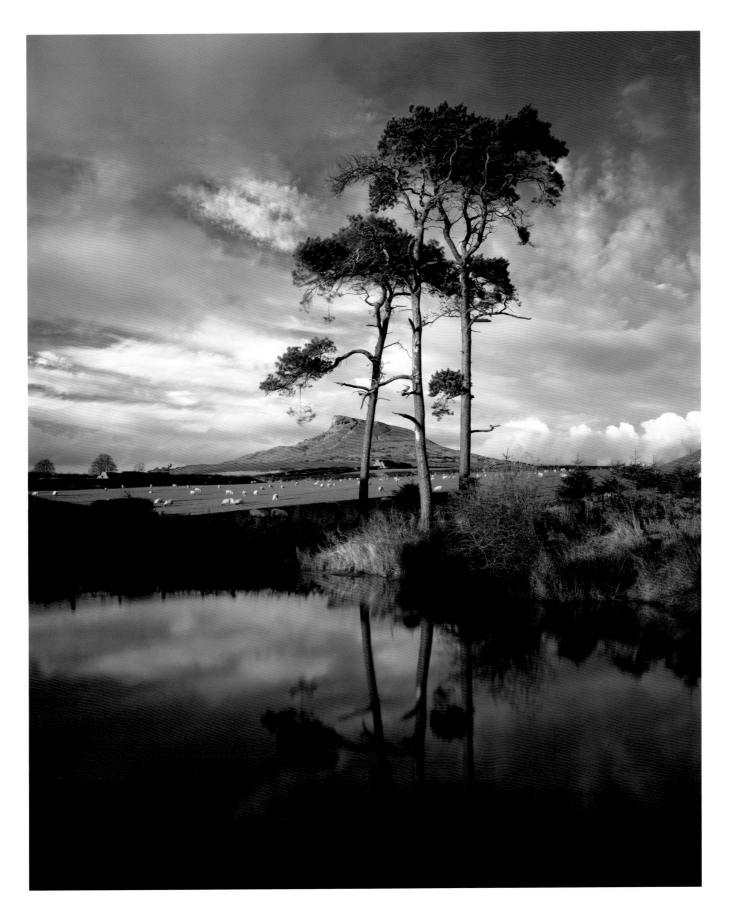

Staithes

Not long after I moved to North Yorkshire, I visited the fishing village of Staithes for the first time. I found the famous viewpoint at Cowbar and, like most people, I was enchanted by it. I also knew it to be an over-familiar cliché. I returned to Staithes a few times in the following years, hunting down every side street and alley for an original angle that would be as effective, but in vain. The only solution was to capture the classic view in outstanding light.

Which was what, exactly? I would want warm, low sunlight on the rooftops, and clouds over the North Sea for drama. At dawn I would be looking into the rising sun. Dramatic, but as I discovered on a couple of occasions, much too contrasty. So it would have to be evening light. As the line of sight of this viewpoint runs from west due east, any evening around the spring or autumn equinox could be ruled out. The sun would be going down right behind the camera, a formula for flat, unmodelled light. My efforts on midsummer evenings were too harsh. I became convinced it had to be winter.

The years went by, and in the meantime I moved formats to 5 x 4in. One January afternoon I ventured onto the North York Moors, where crisp snow had recently fallen. I was frustrated by lack of cloud. Unbroken blue sky is a pretty boring backdrop for a snowy landscape. But there were clouds in the east, brewing over the North Sea. Suddenly I remembered Staithes. Although I was reluctant to leave the snow, I knew I'd be unhappy with that blue sky. And as I approached Staithes, I could see that this was indeed the opportunity to fulfil what I had imagined years before.

Utilizing the drop front on my view camera I was able to look down on the buildings without perspective distortion. An inverted coral graduate was used over the lower half of the composition to warm up the desperately cold shadows. ND grads over the top half were used to balance the darkening effect of the drop front and the coral grad, as well as helping increase the natural drama of the sky.

This is one of the few photographs I have ever made that I am tempted to describe as definitive. What more could be done to improve it, I honestly don't know.

'Before and after'

The companion picture on this page was also shot in the winter, on one of my first visits to Staithes. Made with a wide-angle 40mm lens on a Hasselblad, perspective distortion is just one of the many imperfections which blight this photograph. I shot too early in the afternoon, and the sunlit cliff on the left unbalances the composition. Lack of clouds mean there is no ambient reflected light. The result? Hard, deep, blue-black shadows.

While it is depressing to ponder the abject incompetence of this picture, it does give cause for optimism. Not only does it make a handy 'before' shot to the 'after', it suggests I actually learned something in the intervening years!

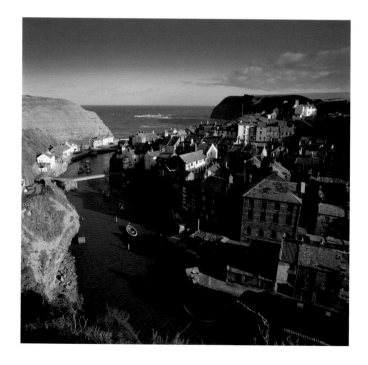

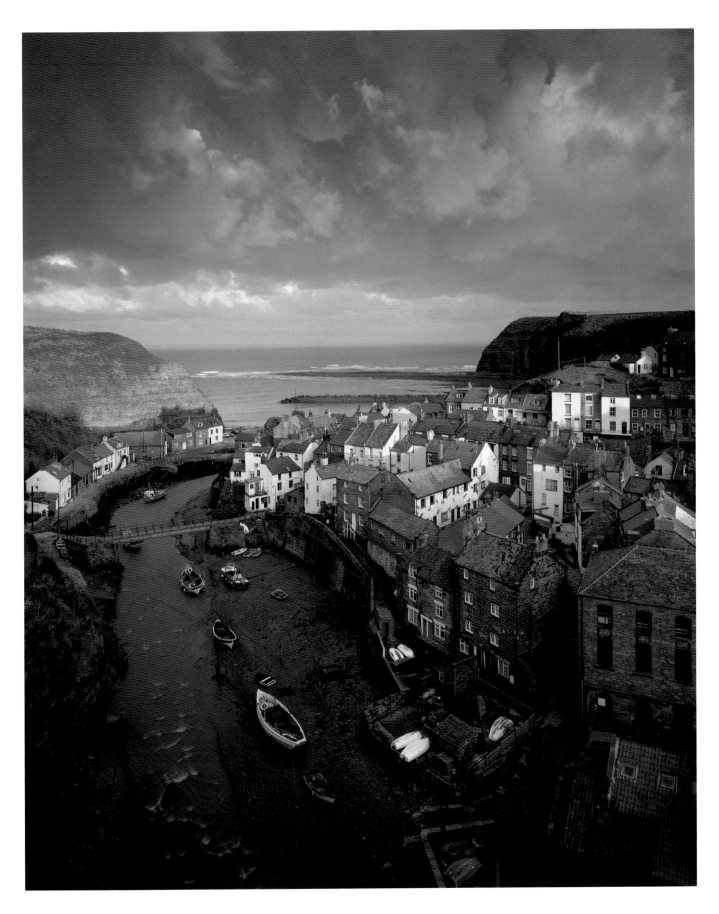

Jurassic park

The main photo (opposite) of the Rumps peninsula in North Cornwall brings back fond memories. This view opens up on a walk I must have done a hundred times since childhood. When my parents first brought my sister, brothers and me out here as kids, they told us the Rumps, with its obvious head, neck armour and forelegs, was a sleeping dragon. Although we knew it wasn't, we still felt a frisson of fear and excitement to think it just *might* be, and to me this place has never lost its magic. For my own children, a dinosaur has replaced the mythical dragon, and even the shrunken imagination of an adult can see a somnolent stegosaurus napping in the North Atlantic.

The walk perambulates around the National Trust's Pentire Farm estate. That this unique headland (with its remains of an Iron Age hill fort), and neighbouring Pentire Point, remain in such a natural state is entirely thanks to the National Trust. The land came up for sale in the 1930s, with the clear threat that it might be developed into a sprawling suburb of Polzeath, the small resort town that occupies the adjacent bay to the west. By purchasing the entire property, the National Trust has protected this landscape against such a fate for all time according to its charter, which is enshrined in legislation. The Trust has been particularly active in acquiring coastal holdings the length and breadth of Cornwall, and the fact that so many beautiful stretches of Cornish coast remain unblighted by ugly development is largely down to its efforts.

Of all the many times I have been out there, the light on the evening of the main image was as good as I've ever seen. To preserve as much of the gorgeous mackerel sky as possible, I opted for a super-wide 58mm (equivalent to 16mm on 35mm), which enabled me to compose a vertical more effectively. A polarizing filter enhanced the sky/cloud contrast, and a 0.6 ND grad balanced the exposure between sky and land. This was one of the very first landscape pictures I made with a view camera. Happy though I was with my results, it took another four years before I started using the 5 x 4in format regularly.

Photographic and ideological fulfilment

I submitted my results to the National Trust photo library, for which I have worked freelance since 1988. The image was subsequently used by the Trust as a poster entitled A Priceless View *to promote membership recruitment. It is also a pertinent reminder of what might have been lost. Without the Trust the Rumps might now be a picturesque caravan site, or worse.*

The alternative image (this page) was shot on a day with soft, hazy light. If the thrift in the foreground had been rather more abundant, thus giving more colour and detail, it might have been successful. As it is, my efforts to convey depth using the foreground rocks seem forced, and the idea lacks conviction.

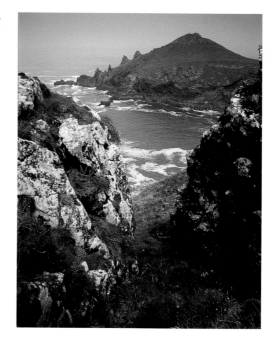

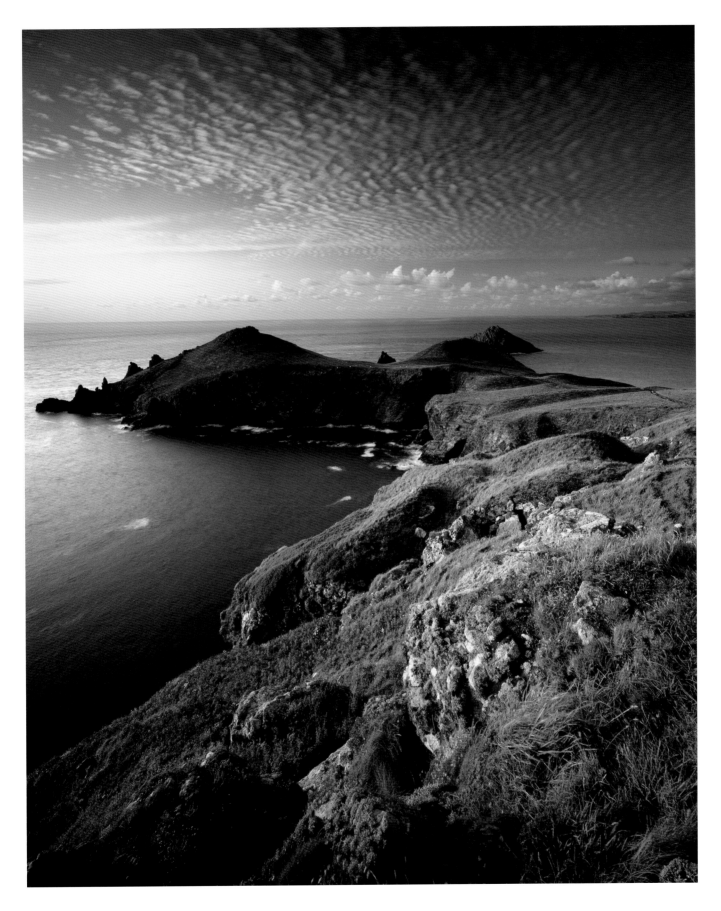

On the rocks

Scientists have shown us Earth is the aggregation of stardust, born from cataclysmic forces in a younger universe. Their discoveries form the first chapter in our modern creation story, one more awesome and majestic than those stories our ancestors dreamed up to explain their precarious and baffling existence. When the turbulence of the young solar system subsided the earth was revealed as a rocky planet, with unique properties that led, eventually, to the creation of life.

Whatever miracles of chemistry and physics combined to create water, and the gaseous atmosphere on which all life depends, Earth's rocky crust, and the minerals contained therein are no less vital. Some have proposed re-naming Earth 'Planet Ocean', but Third Rock from the Sun is just as apt. Even though nearly three-quarters of Earth's surface is covered with water, its crust, which makes up the continents, islands and the ocean floor, is rock, and this is the stage on which the drama of life is played out. And as a landscape photographer I have long been fascinated by it.

While rock and water may be the raw material of life, it is really the colour, form and sense of energy in rock that motivates me as a photographer. The geologist can unravel the mysteries of how different rocks were formed, but my own rock studies are motivated by a search for beauty, for inspiration rather than explanation.

With a temperate maritime climate and mostly modest topography, Britain's post-Ice Age environment of fertile soils and flourishing plant life masks the land's rocky origins. But there is bare rock here, on the coast, moor, and mountain, and these are the landscapes that inspire me most.

We often characterize rock as a discrete object, from the titanically large, like Gibraltar, to a hand-holdable chunk of rubble. In truth, pebbles, gravel, sand and even microscopically fine silt are also rock, just ground down into ever smaller particles by the relentless erosive forces of nature. It is a curious paradox that, given enough time, fluid, yielding water will break down and move solid rock after the processes of deposition, volcanism or metamorphism have given it birth. Glaciation, frost wedging (freeze-thaw), chemical weathering, flooding and perpetual tidal flows are all simply different guises for the power of water droplets working together. Wind, too, given enough time, can move mountains in the form of sand, but water and ice, driven by gravity and the energy of global weather systems, are the chief architects of erosion.

Water appears in many of the images in the following pages, and if it doesn't, its influence is visible in the shapes and surfaces of the land. Even in the rocky deserts of Arizona, Nevada and Southern Utah, it is water (usually in the form of sporadic flash flooding and frost wedging) that has carved these dramatic landforms. The weathering effect of water is often a beautifying process, smoothing and polishing, revealing mineral colour, cross-bedding planes, and igneous intrusions, and sometimes creating fantastic shapes through joint enlargement, as in slot canyons.

In geological time, even rock can melt away in the kitchen of creation, but in the span of a human lifetime it seems permanent, a symbol of eternal values in our human world of endless change. And by the sea, on the mountain, or in the desert, its shape, form and colour seem a suitable subject for the reflections of the human spirit.

Chamber of secrets

The swerving, swooping curves that characterize Antelope Canyon in northern Arizona present the photographer with infinite marvellous opportunities. There are no familiar reference points, no foreground and background, no distant church spire or mountain, no plants even. There is nothing here but rock. This absence of familiar content is a little intimidating, yet also exciting. Even a representational photograph can be remarkable, but Antelope also lends itself to a surreal or abstract approach. Either way, the idea surely is to capture light that creates a feeling, a mood, an emotion.

On my third visit to Antelope in October 2000, I edged slowly around a tight curve in the canyon and found myself beneath an overhang. Above me, the far side canyon wall was bathed in reflected light, suggesting the motions of flowing water frozen in stone, which is a powerful part of Antelope's appeal. Beneath the overhang were more fluid curves, although much darker. The broken line defining the right-hand edge of the overhang seemed to be concealing something. The light created a secret, mysterious atmosphere. I felt cocooned within a secret chamber of rock.

But now I had to face the challenge of turning these feelings into photographic reality. My spotmeter revealed the contrast range of the stone exceeded (by a stop and a half) the four and a half stops my film could reasonably record. I knew that white highlights, and any large area of black shadow, would create distracting 'holes' in the transparency. In any case, I could easily see detail everywhere. The trick was to persuade film to do the same, and I knew from previous experience that correct use of a graduated ND filter might work.

I selected a three-stop (0.9) ND soft graduate. This was used on its side, neutral density to the left, with the transition zone running vertically down the image centre. After careful fine-tuning of the filter position and a little recomposing to ensure the right weight of the various forms and shapes, I was confident the grad was invisible. My exposure was based on an average between the essential shadows, and the highlights now moderated by three stops of ND filtration. The filter formed a bridge between bright and dark zones, allowing me to fulfil my vision of this chamber of secrets.

Overhang overexposure

Later that day I found myself almost at the lowest point of the canyon, in a much larger, hall-sized space, beneath a vast ceiling. A wave of rock was emerging high up in the canyon wall and, by using the overhang as a framing device at the top of the composition, I could mask off a sunlit area beyond.

I was anxious to retain a touch of detail in the dark overhang, for I feared it would otherwise become a black cut-out shape. As a result, my exposure produced highlights which are nearly a stop too light, creating a weak result. I would probably have been better off had I used a light ND grad (perhaps a stop) to feather down the highlights, while retaining good colour lower in the composition, and just allowed the overhang to drop into black.

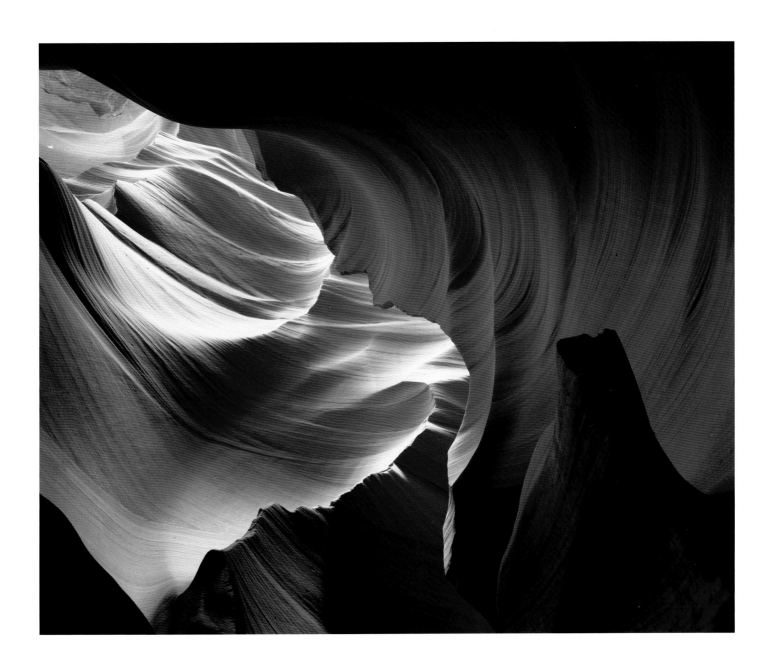

Greymare in gold

Few places have captured my imagination so comprehensively as Dunstanburgh Castle, a brooding relic of the Middle Ages on England's Northumbrian coast. It sits on an isolated outcrop of the Whin Sill, the same igneous dyke that underpins Hadrian's Wall. Almost surrounded by sea, the defensive qualities of the site can still be appreciated even though the castle was partially destroyed and left as a ruin several centuries ago. Never restored, its survival in the face of perpetual North Sea storms is a tribute to the strength of its original construction.

On the northwest side of the castle precinct, the beach is composed of tens of thousands of fair-sized basalt boulders. Above the level of the boulder field lies a sinuous, humpbacked stone platform called Greymare Rock. In one of my favourite angles of Dunstanburgh Castle, at high tide, it forms an interesting middle-distance feature in a relatively wide-angle view.

I have visited this spot many times and the version opposite is probably my favourite. I had arrived and set up with high hopes well before dawn, but cloud smothered the sunrise comprehensively, and there was none of the hoped-for crimson first-light colour. Even so, I did not lose hope, and around half an hour later the sun made a brief appearance through a gash in the cloud blanket.

I'd love to say I calmly made my exposures, packed up and walked away. But it wasn't quite like that. As soon as the sun appeared, the contrast suddenly went off the scale. Another ND grad was needed, staggered higher than the one already in place. Then I had to re-do my exposure readings, trying to juggle all the figures that included compensating for both ND grads and how they would affect the gold sky highlight, with the unfiltered foreground highlights on the black boulders. There was time to make just three quick-fire exposures before cloud swallowed up the sun once more. And I knew that of the three, only the last exposure had full sun on the foreground! When I did finally pack up and set off for breakfast, I was much more stressed and exhilarated than cool, calm and collected.

Sea-level alpenglow

A total contrast in style and mood is offered by the panoramic (6 x 12cm) version of Greymare Rock on this page. This picture was made on a beautiful summer evening. The sun had set some 30 minutes earlier, and a touch of 'alpenglow' can be detected in the cloudless sky, where the blue shadow of the earth can be seen above the horizon.

The 1-minute exposure ensures no detail is recorded of the moving waves on the shore. The motion-blurred water leaves a strange, misty atmosphere quite in tune with the mood of this medieval landscape. It only needs an armed knight mounted on a white charger silhouetted against the skyline to complete the image.

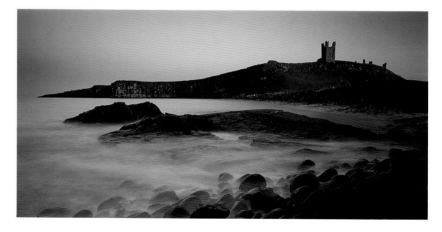

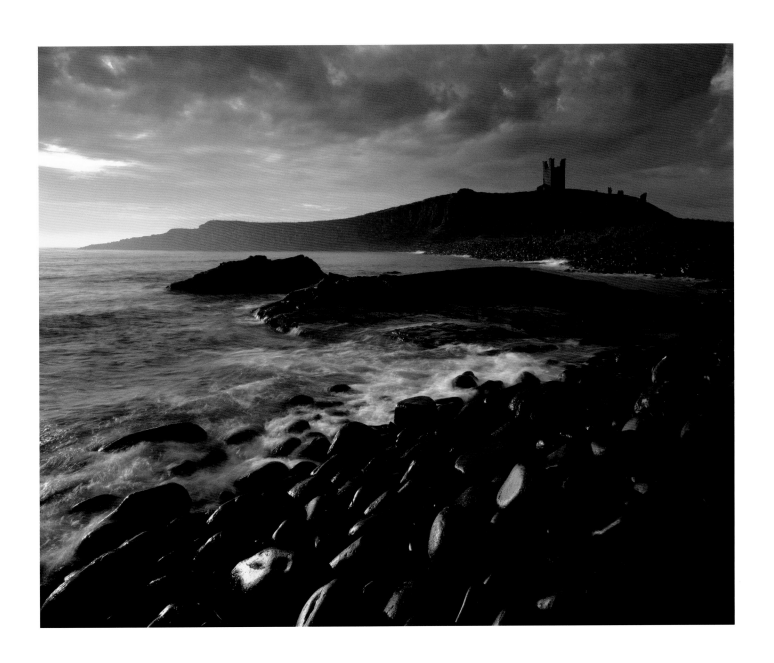

Metamorphics

When choosing a location as the base for a photographic workshop, I am acutely aware that, in Britain at least, we have a strong chance of poor weather throughout the duration of the course. If the only real photographic attributes of a place are a series of standard views which inevitably are dependent on good lighting quality, then I risk the possibility of many frustrated and disappointed delegates. So I prefer locations rich in detail – detail that can provide beautiful subject matter when the only light available is damp, soft and flat.

Certain British coasts excel in this respect, with varied and fascinating geology that is colourful and rich in tonal and textural contrasts. Great views are included too, but in the absence of good scenic light, there is still exciting subject matter to explore. Sandy Mouth is an outstanding example.

With such a name, you might expect wall-to-wall sand castles, donkey rides, souvenir shops and ice cream, especially as it is only a few miles north of Bude, a popular holiday resort in North Cornwall. In fact, the sands at Sandy Mouth are only revealed at low tide, and since the National Trust owns all the land behind it, the single commercial enterprise in the area is a low, stone-built café tucked in beside a car park, well away from the beach itself. This is a predominantly rocky shore, with vertical cliffs facing directly west over the Atlantic.

The metamorphic rock in the main image underwent a tortuous process of creation. Originating through sedimentary deposition, it was then squeezed, super-heated and folded before appearing on this Cornish seashore to be pulverised by the ocean. Well within the intertidal zone, it is subject to the relentless pounding energy of waves twice a day, year in, year out

This is a study of the apparently random results created by the unruly power of nature. The corner-to-corner diagonal structure of the composition helps bring order. But it is the combination of drying surfaces and soft light – enhancing the colours and subtle textures – that makes it special.

Beyond the picturesque

Given the impressive scale and spectacular nature of Sandy Mouth's cliffs, I am surprised that my favourite rock study there (opposite) is of such an intimate detail of the foreshore. The photograph on this page shows a section of the base of the cliff, which is typical of the rock strata in this area. Yet somehow this shot, with its obvious use of the diagonal bedding planes, lacks the detail, depth and life that the main image demonstrates.

Abstract studies of natural phenomena are not easy to do well, but are always a worthwhile challenge. It is an opportunity to concentrate purely on the formal issues of picture-taking – line, tone, shape, texture and so on – without any figurative distractions. This kind of visual exercise is good training that informs what we do on more traditional landscape subjects.

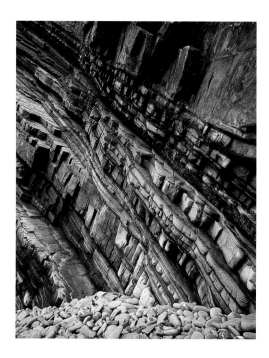

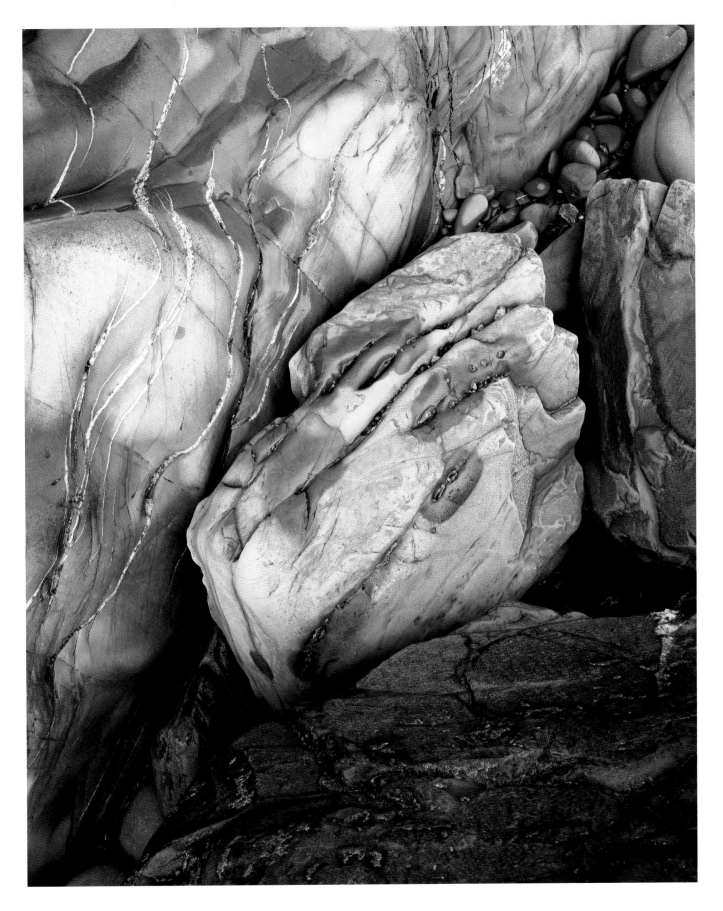

Stone circle

Northern Ireland has one world-famous piece of scenery – the Giant's Causeway – which attracts tens of thousands of visitors each year. Yet few of them go on to enjoy the equally spectacular coastal wonders which await discovery elsewhere in the province. One of these is Fair Head on County Antrim's northeast corner, where a moorland plateau is fringed by vertical, dolerite cliffs, nearly 200 metres above sea level. On seven or eight visits I have yet to see more than three other souls.

A very long day preceded my most recent visit. An early start at home in North Yorkshire was followed by a five-hour drive to Stranraer in southwest Scotland, and then two hours on a ferry. On arrival at Larne, fine weather prompted me to drive one and a half hours to Whitepark Bay, on Antrim's north-facing coast, which I knew would be beautiful in the evening light. I worked for three hours, finishing well after sunset. By the time I'd cooked and eaten some supper, and driven over to Fair Head for dawn the following morning, it was past midnight. With the weather forecast quite promising, I set my alarm for 3.45 a.m.

My basic camper van allows me to stay close to my dawn locations. After barely three hours sleep I looked out onto a changing sky, clear over the northeast horizon, but with broken cloud piling in from the west. Within twenty minutes I was down on the rocky shore that flanks Fair Head, but cloud quickly covered the rising sun. I would have to be patient.

As I wandered north I was transfixed by a boulder which, from a certain position, seemed perfectly spherical. The lichens, textures and colour of the scene would work in the soft light, and I set up my 5 x 4in view camera accordingly. In my first two exposures I employed an 81D colour-balancing filter, but suddenly the sun began to appear. I removed the 81D, and shot four exposures as sunlight and passing cloud shadow briefly transformed the scene. Shortly after, the cloud thickened up decisively and I was soon back in the van eating breakfast, then catching up on sleep. This was a time to be grateful for deteriorating weather!

Lines of sight

If I know beforehand the compass bearing of my main shots, I aim to work at a location when the sun is rising or setting perpendicular to that direction. For example, the spherical boulder shot at Fair Head has a line of sight on a northwesterly bearing. The sun had not long before risen above the northeast horizon. Shining from my right, it provides ideal modelling light for landscape.

Little can compare with the sight of the sun rising or setting over the sea when conditions are right. A coast which faces due south will see neither sunrise or sunset during the summer, but enjoys both during the winter. A coast facing due north experiences the opposite condition. That is why, for me, Antrim is a summer coast.

The small photograph was taken on my very first trip to Antrim, in 1989, with a Plaubel 69W Proshift.

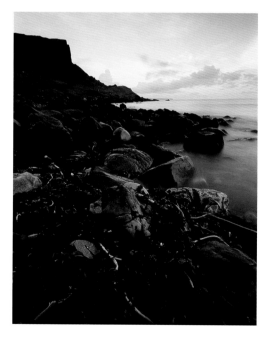

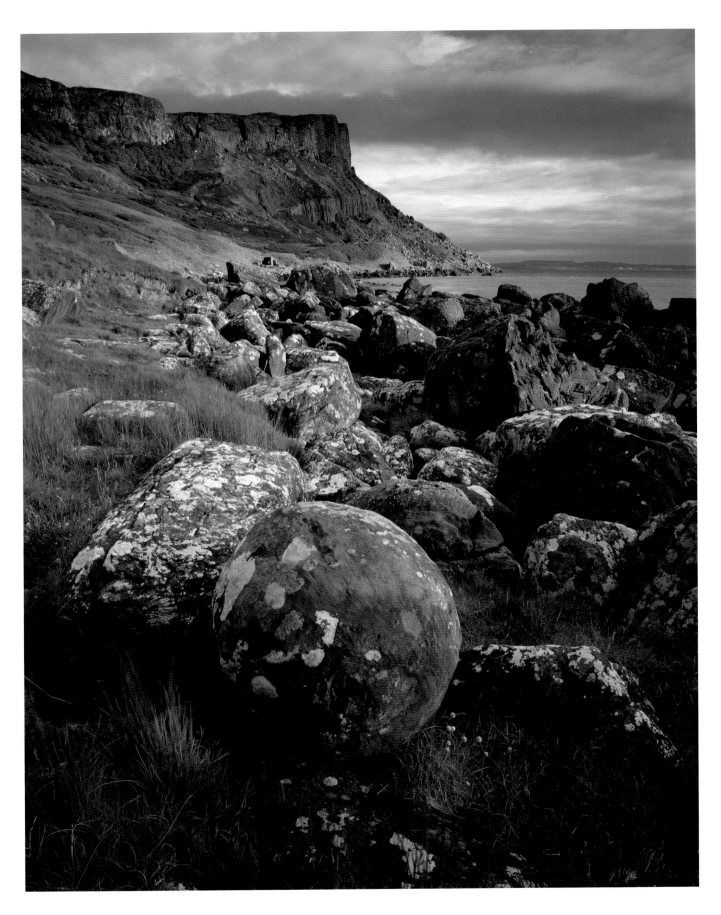

Badlands, good landscapes

A vast desert territory that occupies a sizeable chunk of Southern Utah, Grand Staircase-Escalante is one of the most recently designated of America's National Monuments. The few roads that cross it are unpaved and primitive, so they are bumpy at best and impassable, even by four-wheel drive, at worst. Consequently, the region is almost free of human habitation. Attempts by pioneers to settle here have all been thwarted by rocky terrain and lack of water. In every sense, this is a truly hostile, awesome wilderness.

Still, Route 89 crosses a part of the southern Grand Staircase, making this area at least quite accessible. From the road I have walked into the Rimrocks on a few occasions. This is a classic example of badlands: dry terrain where the rock is so soft it is sometimes described as mudstone. In spite of its dry climate, the rain that does fall here is usually delivered in brief but massive downpours. The soft rock, partly composed of salt, literally dissolves under each onslaught. Harder rocks which have been broken up during earlier periods of erosion lie scattered. Where they lie they shelter the softer stone below, and the result is that they become perched, raised up above the landscape as, over the course of hundreds of years, the surrounding rock is washed away. These features, commonly called hoodoos, eventually collapse and the whole erosion cycle starts afresh.

Not only can badlands produce fascinating, surreal forms, the rock itself is also often highly colourful. Not far from the formations in the photographs are striped cliffs, indicating the presence of constantly changing mineral concentrations during the process of deposition. The predominantly red rocks in the photos are iron-rich, but from my point of view it is the raking afternoon sunlight that makes the picture, rather than the colour of the rock. Set against a sky darkened slightly by a polarizing filter, the strong sense of depth comes from a combination of tonal and colour contrasts. In the sparklingly clear desert air, this creates an illusion of tactile reality, inviting the viewer to hop through the edges of the frame and take the imagination for a walk.

Twilight afterglow

The first afternoon I ventured into the Rimrocks, accompanied by my friend Chrissie, was a cloudy one. We had a productive time scouting, but the soft, grey light did not suit the subject, and my efforts were limited to a few frames of black and white.

We were just beginning the walk out when I realized that, although the sun had gone down, the thin cloud was breaking up rapidly, as if it had been waiting for nightfall before revealing the desert to the sky. The sun's refracted rays flooded back from below the horizon, and the thinning clouds turned pink in a glorious afterglow. Illuminated by the clouds, the landscape also lit up briefly, giving me just enough time to shoot a few frames with my Horseman 6 x 12cm camera. One of these is shown on this page.

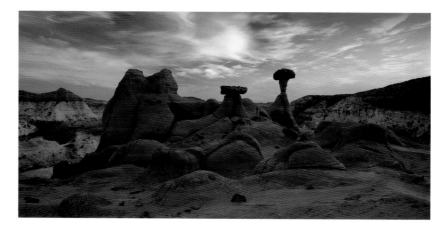

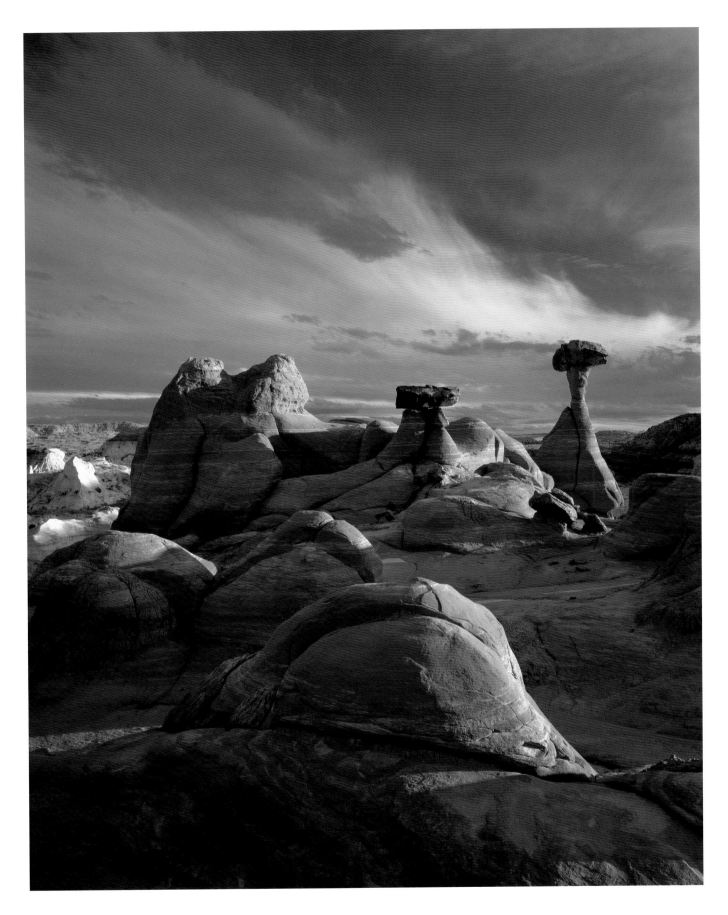

Stepping stones

Where the North York Moors meet the sea, the coast faces predominately north and east, which means the bays and beaches there are mostly dawn locations, especially during the summer. At these times, sun rising over the North Sea warms the cliffs and produces magical lighting if conditions are fine.

The high cliffs of most of this coast deprive its beaches of afternoon sunlight, so for most of the year this dilutes its appeal for afternoon and evening photography, and also inhibits its popularity with tourists. But in the height of summer the evening sun is so far to the north that it can be seen setting over the sea in the northwest. At Saltwick Bay, a mile or so east of Whitby, this can create spectacular lighting opportunities. The headland of Saltwick Nab to the west and the lonely sea stack of Black Nab to the east define the limits of the bay. While the soft centre of the bay is sandy, wave-cut rock platforms underlie the headlands. These platforms are composed of a dark, sedimentary rock which makes an excellent reflector when wet. Wide, shallow pools cover much of this wave-cut rock at low tide. Thousands of large rocks, some resulting from cliff falls and some from long-since abandoned breakwaters on the shore, lie randomly scattered over these platforms.

In this photograph the sun had already set perhaps fifteen minutes earlier. The foreground shadow detail was extremely dark, but I was determined not to lose it. With a huge contrast range to record I was obliged to resort to two neutral density graduated filters. Each had its transition zone in a different position, a technique I describe as staggering graduates. An 81B warm-up filter was used to moderate the excessive blue of the light.

Although the very shallow water looks flat calm, there was a fair breeze and the clouds above were constantly changing, shifting reflections and the weight of the composition as they did so. It is very difficult to predict the perfect moment, the one superior to all others, and it is inevitable that in conditions like these I will shoot several exposures, in this case about six. Of these, the version opposite is the one with the best cloud position.

Movement stilled by long exposure

The first time I tackled this theme at Saltwick was also in midsummer a few years earlier. On that occasion I used a Horseman 6 x 12cm rollfilm camera. The tide was approaching fast as the exposure was made, but detail of the waves has disappeared during the minute or so that the shutter was open. The subsequent impression of stillness is reinforced by the completely clear evening sky.

I have always had a soft spot for the original photograph and still do. The gentle mood and subtle reflections on the stones appeal to me. But, like most landscape photographers, I am addicted to the drama which clouds bring to a scene. It is this, and the greater simplicity of its foreground, which makes the main photograph my favourite of the two.

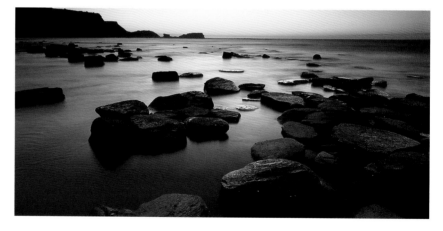

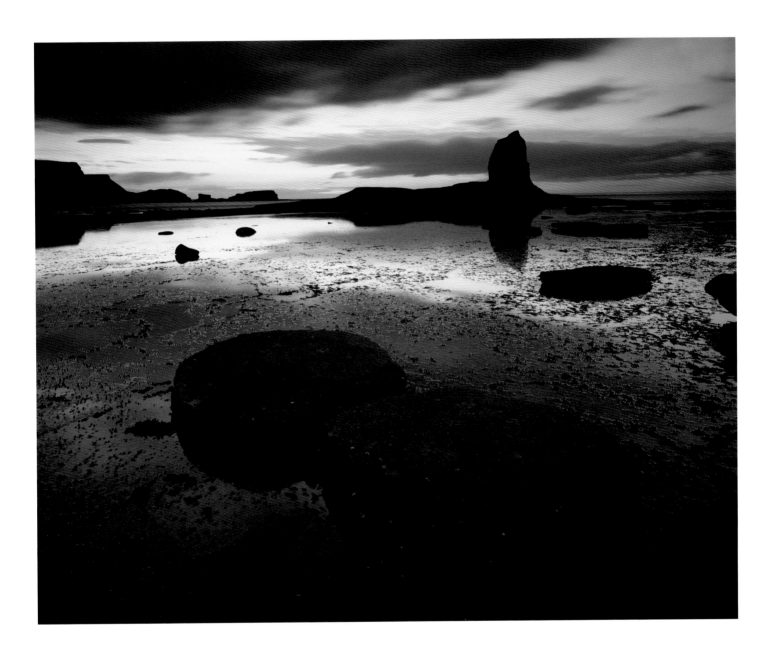

Holy Island shore

As a child I spent countless hours by the seaside, building sand castles, exploring rock pools, and playing games with my brothers, sister, cousins and friends. I am sure my passion for coastal subjects originated in the deep joys of childhood. The space and light of the seashore, the sound and fury of the waves, the familiar cry of the gulls and the tang of salt in the air are all inseparable from my childhood memories.

Although I still love exploring rock pools and the seaweedy crannies of the intertidal zone, seaweed itself is not the easiest subject to photograph. So discovering this handsome branch of stranded kelp on the shores below Lindisfarne Castle was a good opportunity. I organized the composition around the sinuous line of the main stem. The dark mat of the main frond formed a crown, while the rocks provided the colour, detail and the contrast needed for a sense of depth.

It may all look simple enough but, as is so often true of nature details (or 'portraits'), it took ages to position the camera until I was completely satisfied with the compositional balance. Occasionally I am asked if I move anything in these studies, the clear implication of the question being that to do so would be cheating, to be somehow unethical. The answer is, yes, I do move things, perhaps taking out something distracting here, tweaking the position of something else there. I do my best to keep such interventions to an absolute minimum, because obvious manipulation would undermine the exercise. It must still appear to be the product of natural forces, not a studio still life.

My adjustments aim for a clarification of the idea. On the seashore, the random effects of the wash of the tide could theoretically leave these elements anywhere in relation to one another. If I am confident that nature might have arrived at this configuration anyway, I am comfortable. So long as I respect the possibilities of chance, I see a little arrangement as analogous to taking extra care with composition. Some will always disagree with any manipulation whatsoever on the grounds that it is not strictly natural, but my view is that whatever works, works.

Castle and causeway

Lindisfarne Castle is the focus of most people's interest when they visit Holy Island. Originally a sturdy fortress on an isolated crag, the small photo gives some idea of the defensive value of the site. It was beautifully restored in the early twentieth century by architect Edwin Lutyens, and is now in the care of the National Trust.

Holy Island itself has a remarkable history, and was one of the original sanctuaries of early Christianity in Britain – hence its name. It is linked to the mainland by a causeway that is swamped (twice daily) by the high tide. It is exciting (if a little foolish) to return to the mainland at the last possible moment and watch the tide closing off the causeway behind you. This predictable act of nature compels many visitors to watch, fascinated, witnessing a tidal equivalent of the Old Faithful geyser!

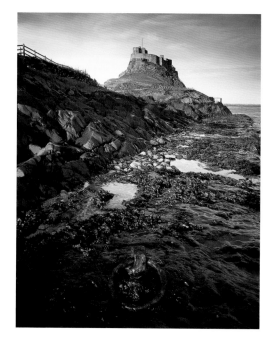

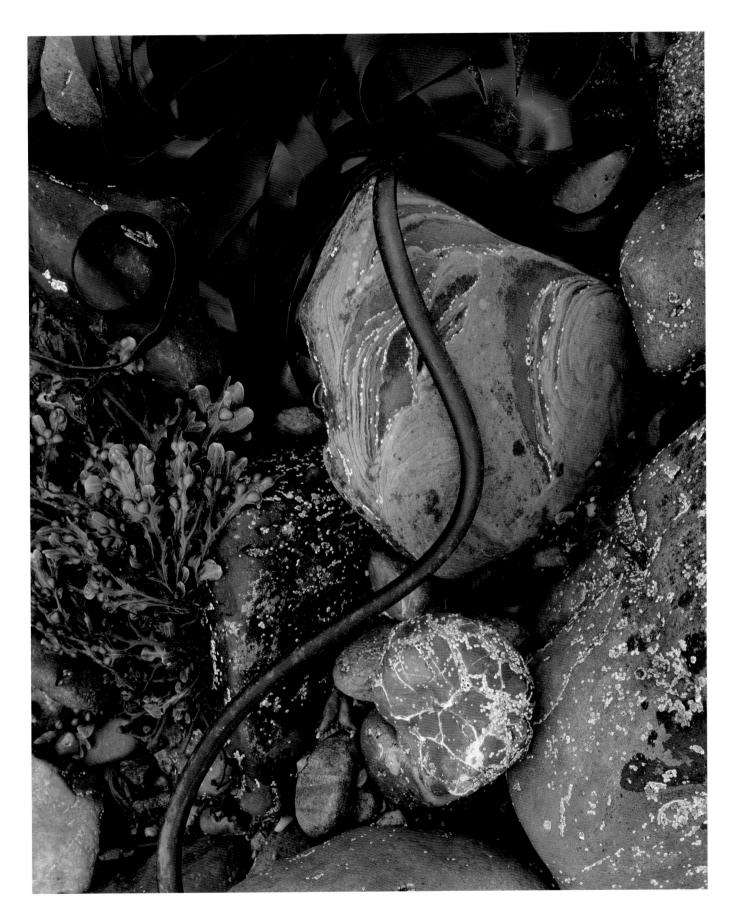

Iron coast evening

The Cleveland coast is the nearest seashore to my home. Facing mainly north, and within sight of the industrial skyline of Teesside, this is no idyllic Riviera, but a hard, windswept land of sea cliffs, where steel mills and oil refineries compete for attention with raw nature.

The industrial heritage of the region was built on the minerals locked up in the local geology. And at Saltburn, the one Cleveland seaside town that has some resort-like pretensions, the spectacular cliffs that defend its eastern shore are rich in the colour of iron. I have always liked the shape of Hunt Cliff from Saltburn. A vertical nose buttressed by a steep diagonal scree (or talus) slope, it looks like a side of the buttes in Monument valley. On a fine midsummer evening, the warmth of the setting sun helps reinforce that impression, so this is the time of day (and year) I usually choose for my photographic expeditions there.

With a low or falling tide it is a great walking beach. Large areas of smooth sand retain enough water to provide reflections, while beneath Hunt Cliff a rock platform scattered with huge boulders fallen from the cliff itself and extensive seaweed beds complete a varied intertidal zone.

Offshore cloud beyond the cliff profile is the special extra element that makes the main photograph. The foreground rock was not essential here. I could have filled the foreground with reflection by moving forward and right a few paces. Or I could have shot with a longer lens and gone in tighter on the cliff face, possibly giving an effect with added drama and impact. But I trusted my compositional instincts, judging that the simplicity of the rock, with its long shadow, and the reflections broken by dry areas of sand made the best solution.

Although many different options were available to me I stayed loyal to my wide-angle lens, and emphasized space, depth and texture, as well as the intimate detail in the foreground. Given the subject matter and the light, then, if I have a style, this photograph is as good an example of it as any.

Early version, ugly light

I have walked at Saltburn many, many times, but the small photo on this page was made on one of my first visits here. The basic idea that is fully developed in the main image is just emerging in this early version. The encroaching tide does help clarify the foreground, but although quite dramatic, the colour of the light is a shabby grey that does not reflect my feelings for the place.

A Hasselblad was used, hence the square format, and although in many situations the square can be limiting, in this case it suits the composition well. The diagonal line of the clifftop and the placement of the egg-shaped boulder in the immediate foreground work as well as or better than the related elements in the main picture. It is a shame the same cannot be said for the colour.

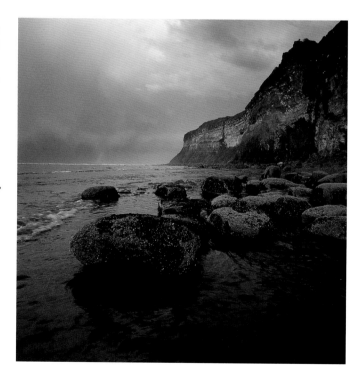

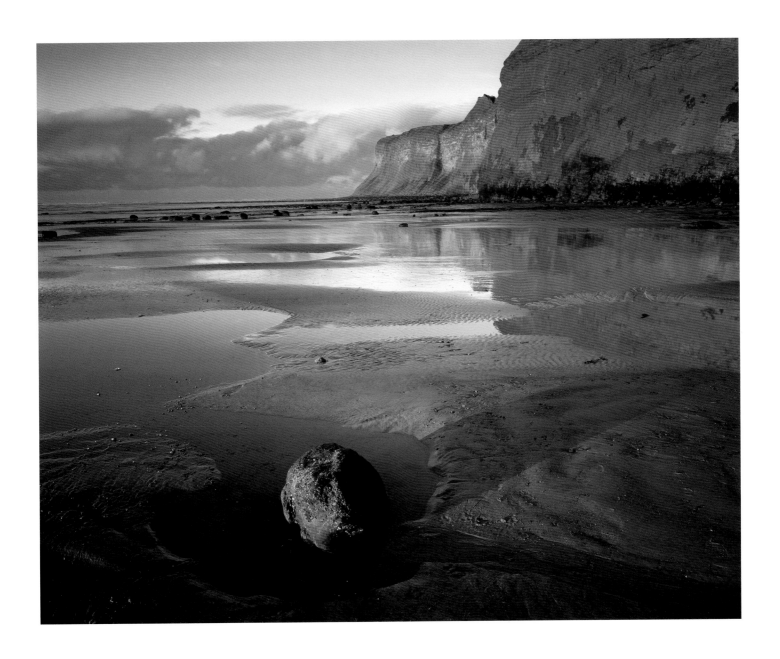

Living stone, I presume

A mere 50 miles from the neon fantasy money-magnet that is Las Vegas, the Valley of Fire is a rocky desert wilderness of no material value but great beauty. Set above the western shores of Lake Mead, where the Hoover Dam has captured the Colorado River, it is protected by the state of Nevada as a park.

The spacious visitor centre welcomes day trippers taking a break from the fun and games of Vegas, providing information, refreshments and toilet facilities, but few venture into the landscape itself. This could be because there is no obvious feature, no mountain or mighty canyon, no vertical cliffs or rushing waterfall. A rocky desert without such a focal point must be quite hard to sell or package. For every Ayers Rock, Matterhorn, Yosemite or Yellowstone, it is good to find a magical wild place that is relatively unknown. The popular honeypot landscapes attract their huge numbers of visitors because they are indeed so beautiful and impressive. But for the photographer, visiting them comes at a price. In such a landscape it is hard to escape the burden of great images shot by others, which may have influenced us to visit in the first place. This baggage may prevent us seeing for ourselves.

Valley of Fire may possess no clear focal point, but within its rocky ridges and rifts and low rugged hills can be found colour and detail to match anything on the Colorado Plateau. Its sedimentary rocks have been heavily folded and twisted, and sandwiched within soft formations are sheets of harder rock, producing the fins and blades that appear in the main photo opposite. Baked by day and frozen by night, the rapid erosion caused by violent temperature fluctuations keep these rocks in a state of constant change. In the warm, low sunlight at the beginning and end of the day it really is a landscape of living stone.

I have stood at famous dawn and dusk viewpoints in various American national parks and monuments, flanked by a forest of tripods. By comparison, the relative solitude in the Valley of Fire represents a kind of freedom.

Blue sky aversion technique

The small photo on this page was shot on a day completely lacking in cloud. On cloudless days it is often impossible to use the sky without the horizon line looking like a cardboard cut-out. So I looked for options that avoided the sky altogether. The warm colour around the rock window contrasted well with the blues (reflected from the sky) in the background. Unfortunately, the sunlit grasses are slightly out of focus and are too bright, and the idea remains unresolved.

In the main picture the sky and the yellows in the foreground make an attractive colour contrast, and the diagonals give a strong sense of perspective. The wispy clouds are essential, softening the horizon and adding depth where it is needed.

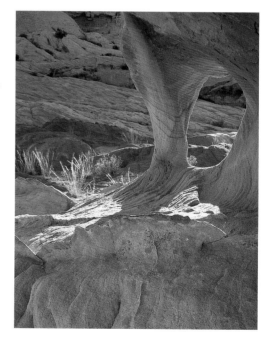

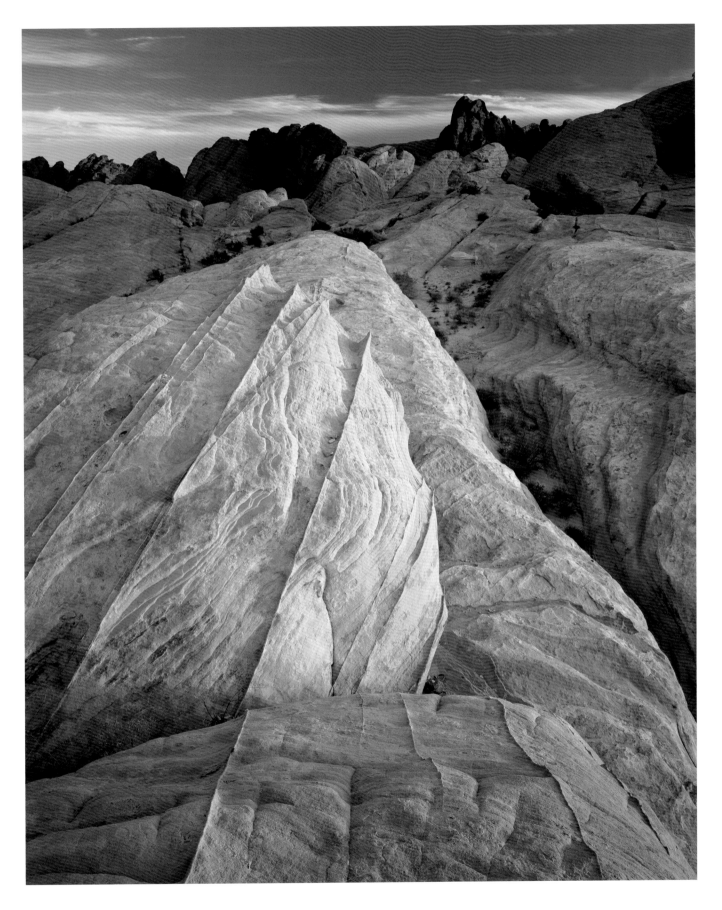

Days of wonder

First and foremost, this chapter is about some of the wonderful places and some of the special days which have given me inspiration. But it is also about the philosophy that guides me, and is responsible for my personal style, such as it is. Before I attempt to describe that philosophy, let me first say what it is not. It is not about being clever, or following the latest photographic trends. It is not about exploiting the latest breakthroughs in technology. It is not about confrontation, or seeking a shock reaction. It does not involve the pursuit of commercial success for its own sake. What I aspire to is to celebrate the beauty of landscape, and emphasize its importance to the human spirit.

I intend to make images that are real, beautiful, and natural. I strive to be a faithful witness, and I work within the tradition of photographic documentary truth (what you see in the photo is what was there at the time). The creativity, beauty and wonder of the natural world are infinite, and these are the subjects of my work, not the ego of the photographer. By accepting the discipline and technical limitations imposed by a documentary approach, I do not get involved in the tricks and cunning manipulations required in commercial photography. I believe that would undermine my sense of wonder.

Wonder is not a reaction reserved for Everest or the Grand Canyon. I see wonder in a wildflower or a rock detail, as much as in a mountain range. Although I prefer wilderness and wild margins, agricultural landscapes can inspire me too, especially those which suggest a harmony between man and nature, such as Tuscany, the Pyrenean foothills, or the English Lake District.

Dramatic wilderness already enjoys wide photographic exposure, and I imagine most people in the developed world have seen pictures of Namibia, Macchu Picchu, or Torres Del Paine in a million magazine travel articles. The challenge for me is not just to focus on these five-star locations, but to celebrate the less spectacular scenery in my own neighbourhood. The photographs I have taken near my home are a source of discussion and pride locally, for by photographing something with love and care we attribute value to it. The virtuous side effect of this is that local pride is a great practical asset in environmental conservation. If our work can play some small part in encouraging people to value their own region, then it is not wasted or self-indulgent.

Ultimately, I believe landscape photography is a spiritual concern. Photographers have long used the phrase 'spirit of place' or 'spirit of the land', and even 'spirit of the wilderness'. But to me the spirit of a place lives or dies according to how we humans respond to it. It is how we feel about places that gives meaning to their spirit, and if we care enough about a place we will protect its beauty and its biodiversity. Wherever the landscape remains free from industrialized agriculture, we encounter that spirit in the vitality of nature's endless cycles of growth and decay. And we can feel or see it in the intimate details of a beach, a copse, or an ancient hedgerow, as well as in the overwhelming power of a storm, or in the still beauty of a moonlit night.

Now more than ever, the present and future good of humanity depends on the ecological health of Earth, this wonder-planet that is our common home. And now more than ever, we assimilate information visually. By identifying with our environment, and by focusing our attention on the beauty that inspires us, photographers can contribute positively to the debate about the future direction we should take, and what really matters.

Arctic light

To most Americans (including the *Star Trek* fans) Alaska is the true 'Final Frontier'. Even in boomtown Anchorage, where half of all Alaskans reside, wilderness begins at the city limits, and moose grazing the central reservation of the city ring road is a common sight. Everything about Alaska is big, apart from its human population. Big mountains (including Denali, highest mountain in North America), big snowfalls, big mosquitoes, and, unfortunately, big reserves of oil.

In 1989 the most controversial ecological disaster in history followed the grounding of oil tanker *Exxon Valdez* in Prince William Sound. Local fish, marine mammal and bird populations were devastated by the resulting oil spill, but it could have been much worse had tidal flows not flushed much of the slick into the Pacific Ocean.

Two years later I was out there as part of a Raleigh International youth development expedition. I took part in a three-week kayaking voyage, helping the National Forest Service survey the impact of the oil on the marine environment. We found the local wildlife populations recovering well, which was expected. Less expected for me

was the impact the Alaskan wilderness would have on my imagination. Having been there, the world would never look the same again.

Although we spent time elsewhere in Alaska crossing glaciers and climbing mountains, it was the awesome grandeur of Prince William Sound which moved me most deeply. Travelling by kayak puts the paddler close to nature in every respect, close to the dangers of the water, as well as to its beauty. Carrying our food, camping on the storm shingle above the high-tide line each night and out of touch with the outside world, we were completely dependent on our own resources. In such circumstances, your civilized cocoon melts away and you become part of the landscape, part of nature.

It was the undisturbed perfection of the islands that impressed me the most. The sublime beauty of the wilderness struck me as paradise, the original Eden. Walking through the pristine sub-Arctic rainforest of the islands was a joy, but tinged with guilt, for each footstep in the deep muskeg mosses left a scar that would take years to heal.

An ice time in Alaska

In 1998 my friend Steve Burge, a veteran of the 1991 expedition, was running a programme of kayaking tours in Prince William Sound. I joined him and three companions for ten days paddling over the midsummer days of June. Encounters with bears, humpback whales and sea eagles were among the catalogue of wonders on that tour. But the first evening on Growler Island, photographing beached icebergs in the Arctic light remains a cherished memory.
Shortly after the small photo was taken, the sun disappeared behind cloud. The totally blue light that remained was softer and more mysterious than before, creating a perfect stage for the right actor. Steve manoeuvred his craft into the right spot, and in the subdued light and flat water kept it rock steady for the four-second exposures. In tune with the place, at ease with the situation, he is a man at home in the wilderness.

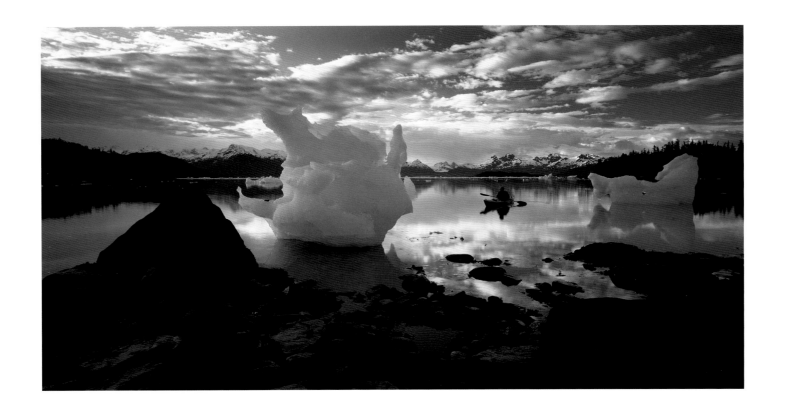

Enchanted forest

In Britain the majority of woodland is managed either for recreational access or forestry. In this semi-natural state it is still a pleasant environment for walking, and springtime in British bluebell woods can be stunningly beautiful. With thoughtful stewardship a mixed or broadleaf woodland is a diverse habitat, and a good place for wild animals such as foxes, badgers, squirrels, rabbits, deer and so on, as well as many species of bird. Even a managed woodland can still be a great way to get close to nature.

Whereas Britain's human population has been shaping its landscape for the last 10,000 years, men have only lived in New Zealand since AD 800 when the first Polynesians (now the Maori) arrived. Although the vast majority of its two main islands is now occupied or farmed, there are still significant areas of wilderness, and much of that is temperate rainforest. My first aim on a recent visit to New Zealand was to see my brother, who lives in Dunedin, but exploring some of the South Island 'bush' came a close second.

I chose to walk part of the Routeburn Track, a classic long-distance trail in Fjordland. The walking is quite demanding in terms of the climbing and distances involved, but with a well-defined trail to follow and civilized huts to stay in overnight, it was an easy way to experience the wilderness. The trail passes through pristine rainforest, where the vegetation is so thick and impenetrable that in many places off-trail hiking would be difficult without a machete.

During the four days of walking it was always either overcast or raining, the weather being true to its habitat. The soft lighting was a real bonus for picture-taking. Chaotic, abundant vegetation creates a contrast nightmare when sunlight shines through it – unless that sunlight is moderated by mist, and that was a treat I was denied on this trip.

The structure of the main picture hangs on a few essential elements – the foreground tree, the fern plant, the stream and the background of massed mossy trunks. In the distance a clearing allows light to penetrate beyond the trees, and this adds a subtle depth. Every surface seems covered in moss, creating a very ancient, fairytale atmosphere. This is the nearest thing I've seen to an enchanted forest.

The ultimate walk in the woods

The small 6 x 12cm photograph shows the context of much of the Routeburn Track, high up in glaciated valleys, with steep peaks towering above. While most of the rainforest is unbroken, there are a few open areas of meadow and marsh. The clearing in the photo is known as the Orchard, although the small trees for which this place is named were not planted, nor are they fruit-bearing.

The trail, while easy to follow, is primitive and almost impossible to spot from above. Popular as it is with hikers, it appears to avoid damaging the landscape in any way, while giving access to those who are prepared to work hard for the experience. It looks like a model example of wilderness access management.

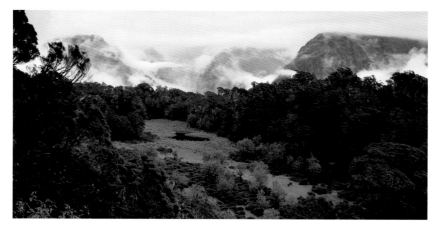

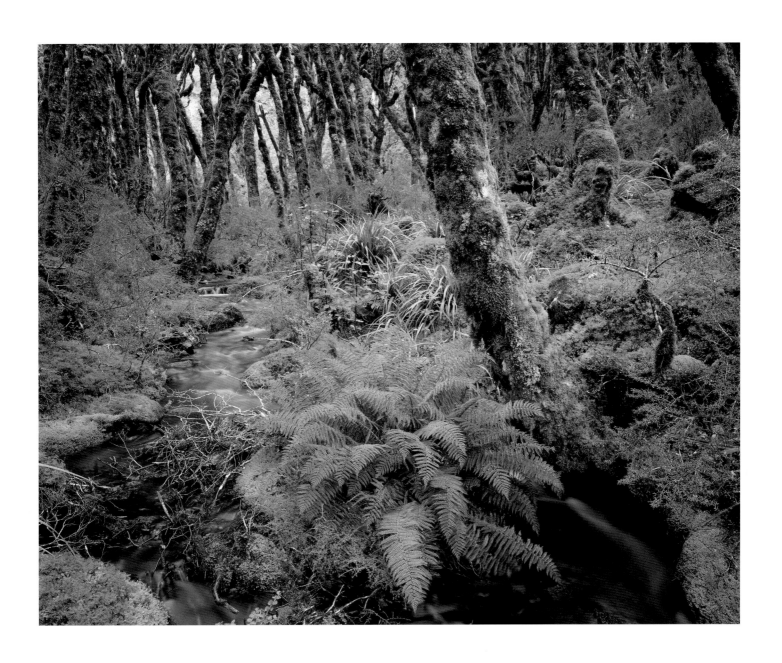

Mewslade Bay

When I was at the lab looking at the transparency of the image on the right, a familiar voice remarked from over my right shoulder, 'What planet have you been on then?' It was photographer David Tarn, another landscape specialist. When we cross paths in the lab, David and I normally trade anecdotes and a few good-natured insults, and I knew this comment was as close as he would ever get to being complimentary! It was a fair indicator that the image was something special.

So where is this extraordinary place, this lost world? It may come as a surprise, but the answer is South Wales, not far from the urban sprawl of Swansea. Outdoors-loving Brits are resigned to the fact that, on these overcrowded islands, most of the countryside is agricultural, a tamed landscape for producing food and harvesting timber. But our coast still has the power to shock, surprise and delight with its wildness. Here at Mewslade Bay, vertically tilted limestone cliffs have created a beach that is both fearsome and fantastic.

I have no doubt that the depth of sand on the beach varies greatly according to unpredictable local influences, storms and so on, but when I visited Mewslade Bay it was at a level which exposed thousands of sharp limestone fins just above the surface. As a parent, the thought of children playing here made my blood run cold. And for swimmers and surfers it would be incredibly hazardous, too. But as a photographer it is a kind of heaven. Strange and surreal forms provide myriad opportunities, and the beautifully smooth sand is a perfect foil for rocks sharp-edged enough to cut paper.

In the main picture, lack of cloud was disappointing, but arguably the simplicity it brings helps balance the extremely rich detail of shore and cliff. A polarizer helped deepen the sky blue and intensify the colour of the reflection. No other filter was used. This proved an especially challenging shot to focus on 5 x 4in. In the end I decided something had to give so I have sacrificed sharpness at the very top of the cliff. This is because the wedge-shaped zone of focus I had placed through the foreground to a third of the way up the cliff face (using lens tilt) was not deep enough to include the clifftop.

Clear hazards of hazy light
The following evening I returned to Mewslade Bay to find it was still sunny, but rather too hazy. Everything I tried just looked flat and cold. The only shot I managed that was not a complete failure is shown small on this page. Shot into the light with a warming filter and ND grad to balance the sky, it makes positive use of the haziness to convey depth.

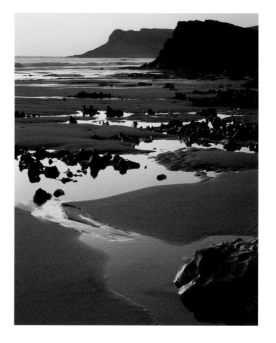

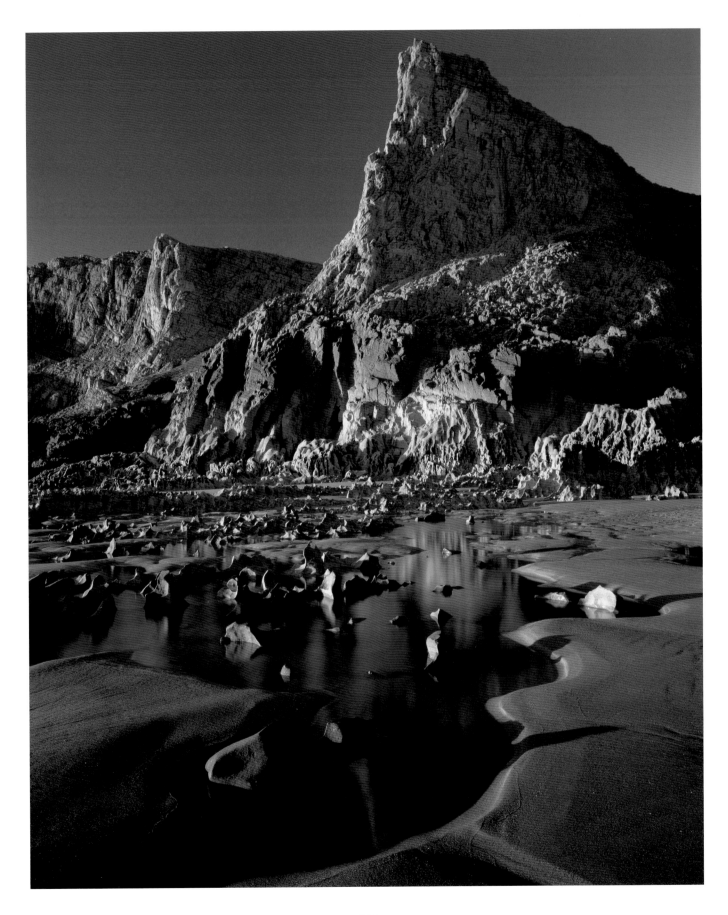

Wall Street

The classic view of Bryce Canyon from its rim is one of the great icons of the American landscape. Yet the bizarre towers, spires and turrets of multicoloured rock are so remarkable it is almost intimidating. It is hard to escape the conclusion that any photograph we make of it, however fine, will fail to do justice to the original.

Bryce is not itself a canyon but a break, the edge of a high plateau whose most dramatic section faces the rising sun. From Sunrise Point to Bryce Point, this unique landscape is sometimes called the Bryce amphitheatre. However, innumerable miniature canyons divide the rock formations themselves, and Bryce can be explored by hiking the trails that follow the canyons and dry washes that lie below them. This mature Douglas fir tree is on the Wall Street trail, so-called because pioneers saw a fanciful similarity between these mighty rock walls, and the fledgling skyscrapers that had sprung up in the financial district of New York City. Trapped within steep cliffs, the tree's unlikely presence in such an extreme environment seems to symbolize the power of living things to thrive in hostile conditions.

In October 1997 I had a 6 x 6cm Hasselblad with three lenses, and a Horseman SW 612 with a 90mm lens only. In its context, the Douglas fir was an obvious vertical panoramic, so the Horseman was selected. When I arrived just before midday the sun was harsh, and there was too much light on the canyon wall at the back. But analysis of the sun's position and its future course held promise. Waiting gave me time to think hard about the final arrangement of the tree within the rock walls. My not-very-wide angle 90mm could not include the entire tree, so I contented myself with its lower section only, 'enclosed' by the canyon walls. (This is the smaller image on this page.)

As the sun moved westward across the sky it gradually left the (east-facing) cliff behind the tree and lit instead the back of the trunk, and a rock wall which reflected red light back into the shadow side of the Douglas fir. The scene had transformed into one of glowing terracotta textures. I made my exposures, and watched as the sun kept moving. Soon the tree had become a dark silhouette again and the moment had passed.

Justified on super-wide

While I was happy with the results of my encounter with the Wall Street Douglas fir, the lack of a super-wide lens had limited the scope of my interpretation. The following October I was back at Bryce with a small group of fellow photographers, and this time I was shooting 5 x 4in. But a panoramic format still seemed well suited to the subject, so I selected a 6 x 12cm roll film back. In the Utah sunlight the effect repeated itself with unerring predictability, enabling me to make the main picture in virtually identical conditions.

A 58mm lens (on 6 x 12cm this is equivalent to around 21mm in 35mm terms), with its much wider angle of view than the 90mm, enabled me to include the entire tree from base to canopy.

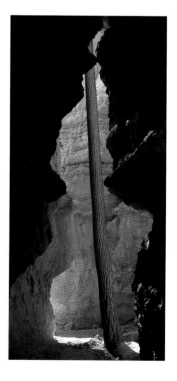

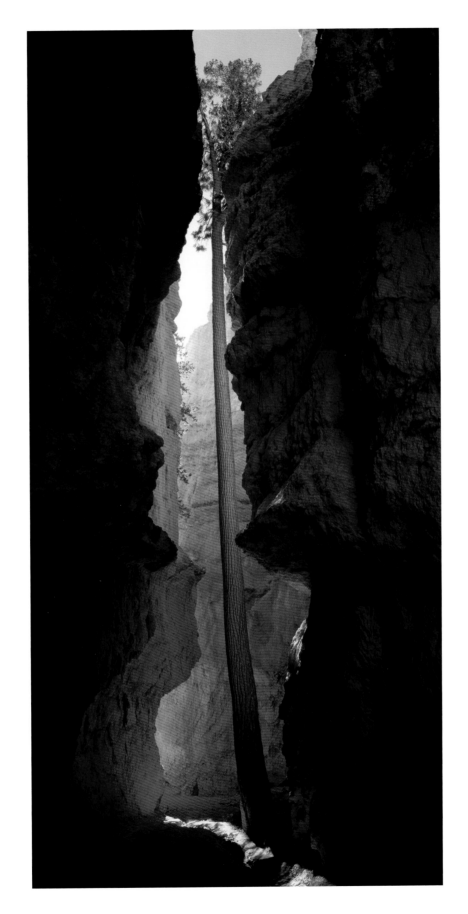

No place like home

Most people associate their home with some sort of landmark or feature. It might be a cathedral, a bridge, or even a factory chimney. Rural dwellers may have a particular view, a river, or stand of ancient trees that denotes home. Whatever it is, something about this landmark inspires reassurance and local pride, and spotting it on a return journey after time away kindles a strong feeling of 'home at last'.

For residents of the villages that cluster around the northwest fringes of the North York Moors, that landmark is undoubtedly Roseberry Topping. This curious little cone-shaped hill is not high, but its profile is so distinctive and unmistakable in a land of whale-backed ridges, it is inevitably a focus of attention in the landscape.

Standing only a mile and a half from where I live, it has encouraged me to be out practising my craft. I know it can always serve a useful role in the composition, either as a focal point on the distant skyline, or as a subject in its own right. When the light is interesting I am always happy to wander out knowing I may add to my Roseberry Topping collection.

Late spring is my favourite time to photograph Roseberry. The mixed broadleaf woodland of Newton Wood forms a broad skirt on its western slopes, and although bracken is a dominant and problematic ground-cover plant in the woods, it does nothing to disrupt the wild bluebell population which flourishes here before the bracken hits its summer stride. Ungrazed meadow opens out on the wood's upper slopes, and bluebells thrive here too, along with stichwort and other wildflowers. With yellow gorse blooming just below Roseberry's upper slopes, this archetypically English landscape can look quite varied in colour for a few weeks in May. By the second week in June, green will have all but taken over.

In the main image, a field of oilseed rape in the lowlands beyond the Topping adds another colour dimension, as does the evening sunlight on the west-facing cliffs of the summit. And a sky that appears to have been custom-fitted for the occasion helps set off this unspectacular, yet wonderful landscape.

Filling the frame

The smaller image on this page, shot a few years before the main one, was made in the early morning, although at the same time of year. This means that Roseberry's cliff face is in deep shadow, which is regrettable, but then this is an altogether more experimental composition.

The branches in the foreground belong to a low-growing oak tree, and I have arranged them within the frame to crowd out most of the sky except that immediately around Roseberry. I suspect the main reason for this was that the sky was not very exciting, and I was looking to keep it to a minimum without losing the focus provided by the hill itself. Shot with a dedicated 6 x 12cm panoramic camera (Horseman SW612) it also illustrates the way format has affected my approach to composition.

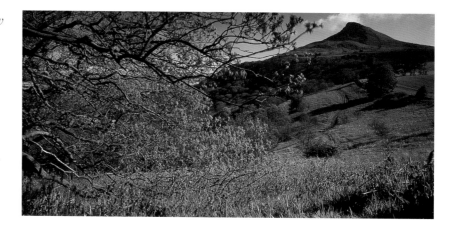

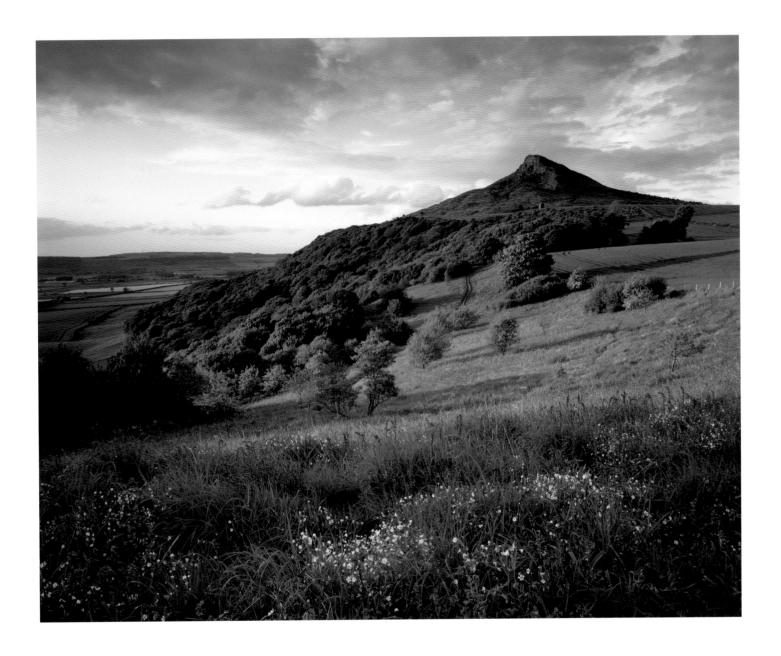

Bedruthan sunset

The gigantic seastacks of Bedruthan Steps make it a candidate on anyone's list of the most spectacular beaches in Britain. Vertical cliffs rise rampart-like around the shore, and access is possible by one route only, an extremely steep staircase which descends from the National Trust property of Carnewas.

Nevertheless, the beauty of the site, in particular the superb sand, makes it a popular destination for anyone with enough enthusiasm to descend the vertiginous staircase. It is a real goldmine for photography, and although I have visited many times, I know I have yet to uncover more than a tiny fraction of its potential.

One of my most memorable experiences here was with a photographic group I brought down one very close, humid day in late spring. The clouds built up quite unexpectedly, and suddenly we were caught in a devastating cloudburst. After a while it became clear the rain was not going to relent. I was worried that some members of the group might get chilled once soaked through, so I rounded everyone up and we headed back up the stairs to the clifftop. Having checked to ensure the whole party was safe I made my way back across the beach for the last time. I found myself splashing through a couple of inches of water. It was not the rising tide, but freshwater cascading off and through the cliffs – the whole beach was awash. I was soaked through, but to experience nature's power through this sudden storm was exhilarating and memorable.

On another evening I came down the staircase to find the beach completely covered by the tide, as it is twice every day. I had nothing else to do, so waited as the sun dropped into the ocean and the tide also began to fall. Now I was able to walk on the sand again, though the coves around the corner remained cut off. My patience was rewarded with a gorgeous late sunset and the most magical part about it was being on that spectacular shore completely alone. There were no traces of human life, just freshly washed sand, stark rocks and the light. The photograph opposite records my memory of that evening.

Good location for a lie-in

The 6 x 12cm format photo on this page shows the standard view of Bedruthan Steps, complete with sunshine, blue sky, and puffy white clouds. As an overview, this gives a fair idea of the potential of the place as a photo destination. The composition does its best to utilize the strong diagonals within the scene, but the lighting is too ordinary for my liking.

Facing due west, Bedruthan is a rock solid 'don't waste your time at dawn' location, for the beach does not emerge from shadow until at least two or three hours after sunrise. So this part of Cornwall is one place where you don't need to feel guilty about having a lie-in!

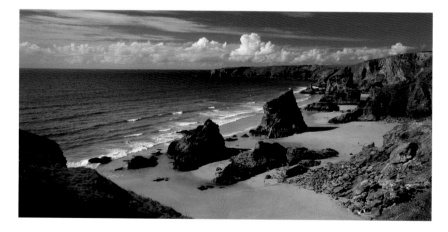

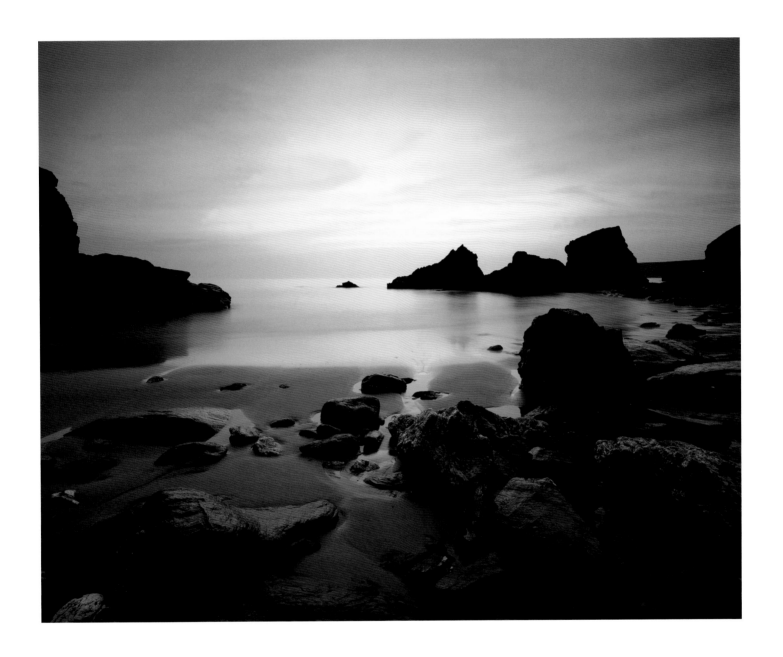

River Etive

Appearing in the second chapter, an alternative version of this view, shot at the opposite end of the year, proves I am very fond of Rannoch Moor! With its glaciated mountains, numerous beautiful lakes, peat-bog moorland and severe weather, this place retains a sense of real wilderness, in spite of being crossed by the A82 trunk road.

The River Etive and its many tributaries that drain this vast moorland are particularly magical. I have spent days just following the course of several of these beautiful streams, observing their sinuous twists and turns, sudden drops, falls and rapids, as well as the occasional calm, flat stretch of quiet water. In different weather conditions and at different times of year they can change character completely, from gently bubbling brook to raging bully. To me they are the defining features of the landscape, the central nervous system through which this place can best be seen and understood.

The main photograph here was made on a midsummer morning. I was en route north to Skye, and had stayed overnight on Rannoch. My travelling companion, David Ward, and I met up at 3.30 a.m., as you must if you want to experience dawn this far north in the summer. In spite of the season it was bitterly cold. Snow could be seen dusting the mountaintops. Broken cloud cover encouraged us to live in hope, but dawn came and went without an appearance from the sun. We agreed the river was our best chance of catching something, and we split up to avoid starring in each other's pictures.

Around an hour after sunrise the sun did finally light up the landscape and, just as importantly, the clouds above. It was the reflected colour in the clouds (above me, not in the photo) that provided the luminosity in the foreground, and prevented the rocks from looking cold and harsh. I would have liked a little cloud wreathed around part of Buachaille Etive Mor (the sunlit mountain) just to increase the sense of depth and atmosphere, but it would be hard to improve on the cloudscape itself.

Downstream, David too had captured this passage of light, creating a stunning image in his own unique style. We met up again shortly afterwards, and explored for another couple of hours before breakfast at 8.00 a.m., having already done a good half-day's work.

Seasonal colour variation

Shot in March, the 6 x 12cm image here shows the same landscape in its post-winter clothing. It was a very mild winter that year, and the snow had already retreated to high altitude, but the moorland colours form a pleasing harmony with the stones in the river and the raw buttresses of the mountain.

The 6 x 12cm version was also shot quite late in the morning in mixed sunlight and cloud. The colours of this image are partly due to a warming filter (81B) as well as the post-winter tones of the terrain. In the main photo it is the sun that provides warmth on the mountain, and an essential contrast to the summer greens of the landscape.

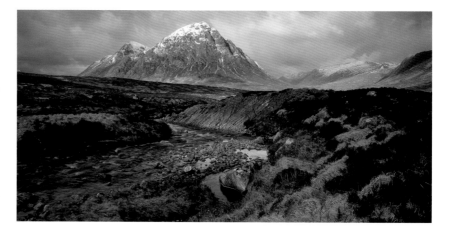

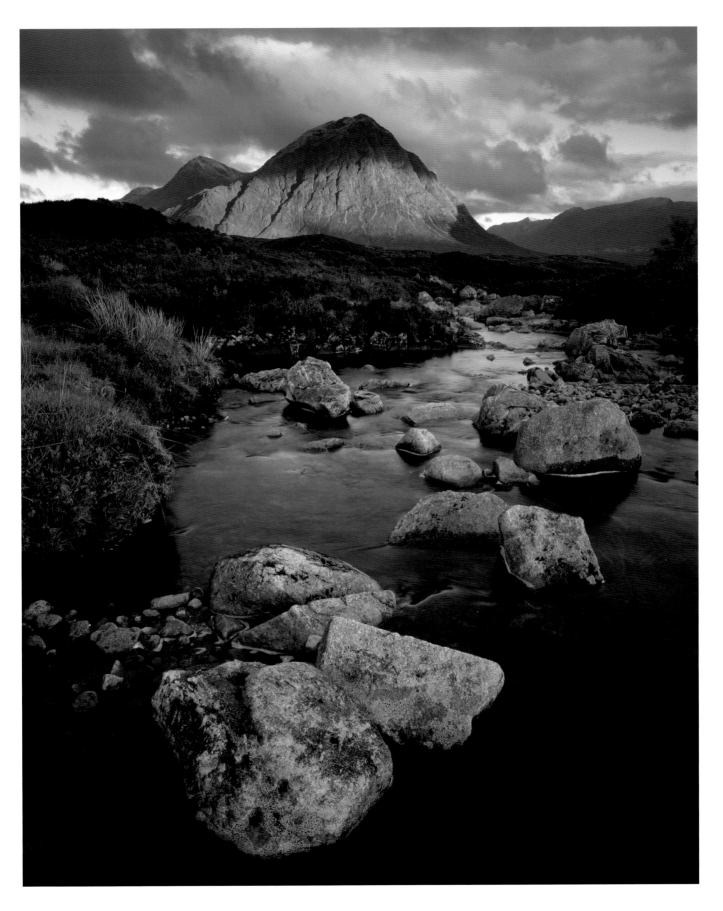

Friendly Beaches

Australia's island state of Tasmania lies south of the mother continent, a rocky fortress surrounded by the notorious Southern Ocean. Consequently, its climate is radically different from much of that experienced by the hot, dry mainland. The damp maritime climate and abundant vegetation, may lead most Australia-visiting Europeans to feel that 'Tassie' is insufficiently exotic to be worth a visit.

So, fortunately, Tasmania remains largely free of industrial tourism. This makes it an especially rewarding destination for a photographer. While the dryer eastern half of the island does support agriculture and a fair amount of forestry, the wet and mountainous west remains largely unspoilt wilderness. The mountains are not necessarily that high, but they are ancient and rugged, and shelter some unique and spectacular ecosystems.

For anyone as passionate about coastline as I am, Tasmania has plenty more to offer. Especially outstanding is the Freycinet Peninsula on the east coast, with its red granite cliffs and mountains, and beautiful white sand shorelines, including Wine Glass Bay, said to be one of the world's most beautiful beaches.

A little further north, facing east over the Tasman Sea towards New Zealand, Friendly Beaches is a great dawn location. My friend Cameron, a Tasmanian photographer, and my guide for this tour, drove us there in time for the earliest light before sunrise. There was a fabulous pink and lilac pre-dawn glow. The sun appeared through clouds soon after rising, and the cloudscape itself was breathtaking. No polarizer was needed here, just a neutral density graduate to balance exposure. The sky continued to change, and it was not until the sun became too bright on the sand, at least an hour and a half after rising, that we stopped shooting. With so many sheets of film exposed this would prove an expensive morning for both of us. But to experience such beauty is a privilege beyond price. The pure air and the unspoilt landscape were like a glimpse of the dawn of time.

Chaos behind the camera

Photographing on sand is a hazardous business. Cameras, lenses, tripods and film are all vulnerable to its abrasive character. Another hazard is the unintended footprint. On beaches I rock hop whenever I can, or walk in the shallow water. The snapshot of Cameron and our tripods gives an idea of just how hopeless it would have been had we not taken care when initially scouting for an interesting foreground. It also reveals the value in shooting really early after sunrise. The main photograph has a warmth and richness of colour which is absent from the smaller picture, taken an hour or so later.

There is something magical about the tidal flows on a sandy beach. It is reassuring to think that although our footsteps might be there for up to ten hours, they will inevitably melt away in the next high tide, restoring the atmosphere of wild perfection.

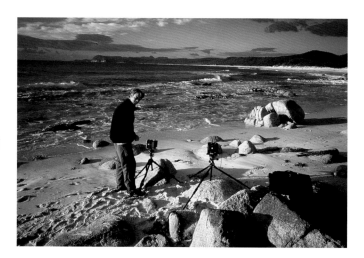

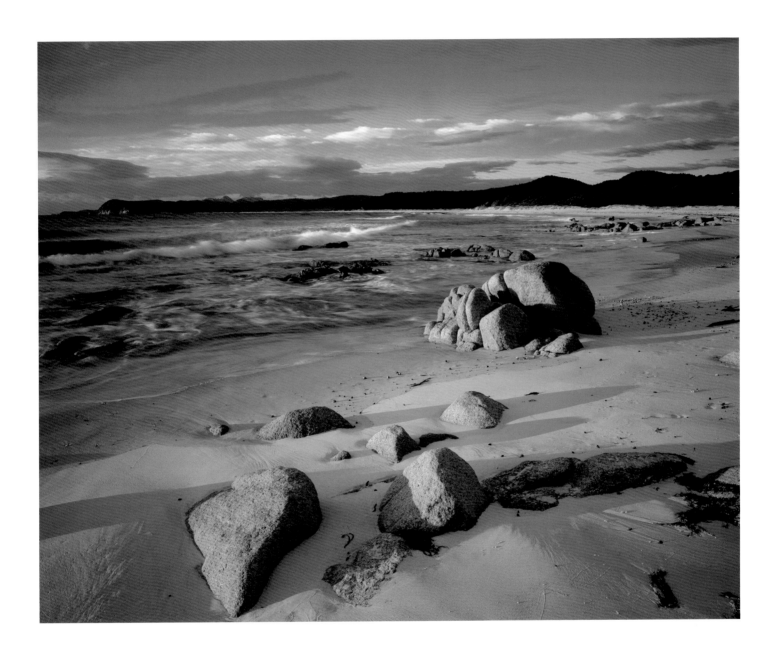

Go the distance

Part of the appeal for me of being a landscape photographer is the physical challenge, as well as the sense of adventure. I never wanted a desk job, and whenever I have to spend a whole day in the office, editing, or dealing with business, the lack of fresh air and exercise leaves me more tired than if I'd been out on the hill. I've never been to the gym, but being used to carrying 20 kilos of camera gear up hill and down dale, the gym is a lifestyle choice I probably wouldn't make.

Many photographers are reluctant to venture too far from the comfort of their cars, and this is another incentive to explore further into the back country, to go the distance. It is always more fulfilling to discover wonders off the beaten track than to repeat the well-known lay-by view, however spectacular it may be.

The Left Fork of the North Creek of the Virgin River is definitely off the beaten track. Its most dramatic section, the Subway, is around 5 miles from the nearest road, and the trail, such as it is, involves numerous stream crossings, rugged terrain and some exposed sections that will upset anyone fearful of heights.

But for those who make the effort, the reward is a glimpse of one of nature's most remarkable creations, a canyon the shape of an inverted keyhole, and cascades whose beauty surpasses imagination. The Subway is not for the claustrophobic, and after I'd spent four hours within its tunnel-like chamber I was ready to leave. In that time I'd explored as far as I could, and taken only two photographs.

Made in mid-November, the main photograph depends fundamentally on two different sources of light, and the delicate pinks of maple leaves which have floated down from high up in the canyon. The main light source is the (partly cloudy) sky above, whose cool, soft tones reveal detail and texture in all but the deepest recesses of the Subway's overhang. A south-facing cliff reflected in the shiny wet surfaces of its walls lights the Subway's tunnel. By this late in the year I had expected early winter rains to have washed out the autumn colours, so the leaves were a special bonus.

Trail to the Subway

On my first adventure into the Left Fork of the North Creek I took a small group with me. The distance proved too much, and after about 4 miles we were forced to turn back, a little way short of our destination. Even so it was a wonderful day, and I shot a couple of images, including the one on this page which shows the cottonwoods in their characteristic mid-October colours.

The main image was shot three years later, when I ensured I would not miss out a second time by leaving the trailhead before dawn, and by travelling alone. I carried 2 litres of water, two packets of trail mix, warm clothing, and 50 feet of rope in addition to my full camera outfit. No stroll in the park then, but it was definitely one of the most memorable days of my life.

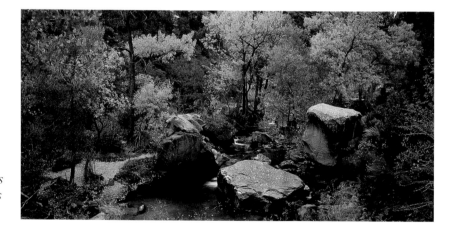

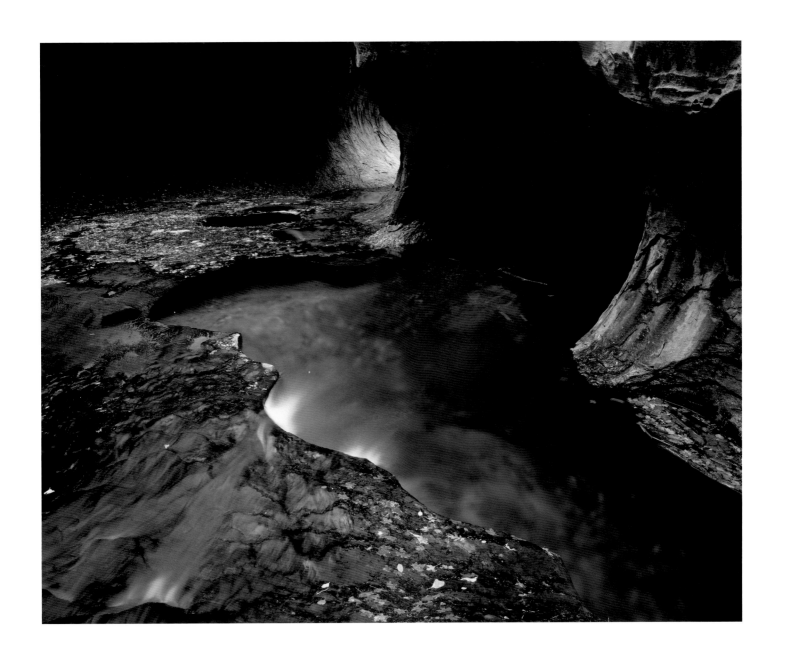

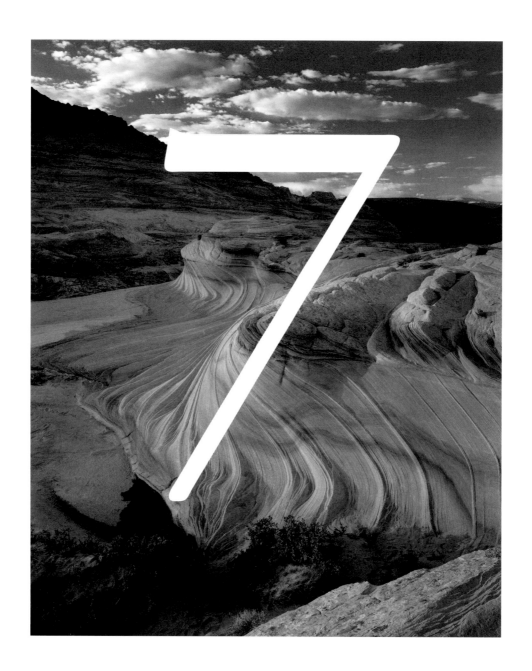

Friends and heroes

No creative individual can claim to be truly original. All have influences, reference points, guidelines, masters and heroes. I am no exception. As a keen student of the medium I have marvelled at the pictures and absorbed the writings of many of the great photographers who have interpreted the landscape. On the following pages I acknowledge a few of those whose images, written words and friendship have helped shape my work.

As far as I know, none of my heroes or friends has risked their life to save others, or even done military service. Even so, landscape photography is no faint-hearted undertaking. 'A warrior with his camera' was how his comrades described Frank Hurley, the photographer on Shackleton's legendary *Endurance* voyage of 1914–16 to the Antarctic. Fortunately, few have ever been forced to endure the almost unimaginable suffering that befell Hurley and the rest of Shackleton's team. But all the photographers described on the following pages have taken countless risks in the pursuit of their images. Crumbling clifftops, surging unpredictable tides, desert heat, mountain cold, physical isolation and sudden storms are all hazards faced by anyone seeking great light and inspiring landscapes. Accepting these dangers and hardships requires courage, if not out-and-out heroism. Then there is the rising before dawn, the forced marches, the long antisocial hours, and not least the 20–30 kilos of equipment that typically has to be carried. A certain amount of self-sacrifice comes with the territory.

Strong-willed, independent-minded and sometimes suspicious of our contemporaries, the solitary working life can perhaps make landscape photographers vulnerable to feelings of isolation. But for all our undoubted individualism, we share common values and ideals. Collectively we promote the cause of environmental protection and we celebrate the natural world. By identifying how others have influenced me, I want to emphasize that we are not as isolated as we may feel, and that together we are a positive force, not a self-indulgent irrelevance.

So what is the practical application of our photography, what benefit can it contribute beyond keeping us creatively challenged? I would point to the lives of two of my heroes – Ansel Adams and Peter Dombrovskis. Both these wonderful artists put their work to the service of nature conservation. Adams in America and Dombrovskis in Australia each made a difference, inspiring the protection of wilderness through National Park and Monument designation (Adams), or mobilizing opposition to dams which would have brought wholesale wilderness destruction (Dombrovskis). Both also made images of the small and beautiful details of nature, celebrating the vitality of ordinary things that thrive in and around our homes, not only scenes of monumental grandeur. The world is a better place for their images and the wilderness they helped preserve, and their example remains a beacon I strive to follow.

The more technological and urbanized our world becomes, the more we need to reconnect with nature, to remember we are part of it, not apart from it. Through the vision of individuals, landscape photography can be a universal language that reflects our yearnings, and our common humanity.

Monument Valley

Sports fans like to sit around and debate about who was The Greatest. In the landscape photographer's pub, most would agree that distinction falls on Ansel Adams. He was the Pelé, the Bradman, the Mohammed Ali – a giant among landscape photographers. Adams was a leading member of the short-lived f/64 group that emerged in America in the 1930s. These individuals believed in the power of photography to describe the visual world with supreme accuracy. They ridiculed the painterly, impressionistic approach, which some had used in pursuit of artistic status for photography. They believed photography was a new art form, reflecting the technological world developing around them.

For me, as for many, it all began with Ansel Adams. The power and beauty of his original prints overwhelmed me when I saw them for the first time in the late 1970s. His photographs of Yosemite, especially, seemed to transcend documentary facts, and illustrate a mythical, heavenly place suggesting how the world ought to be. At the time, Adams' reputation was not as secure as it is now. I remember one critic's sarcastic description, 'an upmarket postcard photographer'. A cynical, ironic modern art world had little time for work that was monumental, hopeful, romantic, beautiful. But Adams' work will live on long after his critics have been forgotten.

Widely remembered as a man of relentless energy and sharp intellect, Adams was not content to communicate with his photographs alone. He helped promote photography as an art form, working with Steiglitz in New York at The Photographer's Place. He refined the exposure/develop/print sequence of film into an understandable scientific structure called the Zone System, which is still widely used by photographers today. And, perhaps most importantly, he was a tireless campaigner for wilderness preservation. He was a founder member of the Sierra Club, and used his images to inspire support for environmental protection. The huge tracts of national park throughout Alaska are there in part due to Adams' efforts in fighting for them. US presidents sought his advice on nature conservation, and there is now a wilderness reserve in the Sierra Nevada named after him. By any standards he is a monumental figure.

Shadows of a legend

Like many landscape photographers, I owe a huge debt to Ansel Adams, but I have only been to Yosemite once, and that was a very long time ago. No photograph I took there could begin to approach standing as a tribute to Ansel Adams. Instead, Monument Valley makes a neat metaphor for the scale of his influence as a landscape photographer.

In the main image I have tried to avoid the Monument Valley cliché and concentrate largely on these rimlit foreground stones, relegating the towers, buttes and mesas to a supporting role in the distance. I used a roll film back on my Ebony 5 x 4in camera.

The small image (right) taken in 1986 was shot at dusk on 35mm Kodachrome. The foreground rocks are the very same ones that appear on the cover of Ansel Adams' only book of colour landscapes.

Mists of time

While I was a student, one of the photographers I most admired was John Blakemore. This British photographer walked away from a hectic life in advertising photography to concentrate on his own artistic work. A series of his landscapes was published in an Arts Council of Great Britain book that made a deep impression on me. All shot on large-format black and white film, they are mainly of mountain streams and rocky beaches in Wales. Blakemore's vision was intense, dark and mysterious. His landscapes avoided every hint of human existence, as if photographed before man walked the earth.

The light in which Blakemore preferred to shoot, and the demands imposed by using slow film (for superior tonal scale) on large-format necessitated the use of long exposures. When moving water is involved this invariably produces strange results, for the film cannot record detail in the water. Instead, a softening mist is traced through the area where the water has passed. John Blakemore used this technique to remarkable effect, and in my opinion his water time-exposures are among the most powerful ever made.

The literal nature of colour film can make long exposures with water look strangely unconvincing, and generally speaking I believe it's an approach better suited to black and white. But occasionally it is unavoidable. At Sandy Mouth in North Cornwall one evening, I found myself concentrating on rocks, rising tide, and the remnants of pink twilight above the horizon. The seawater was covered in a layer of foam, typical of the Cornish coast in windy weather. I felt the foam would distract from the main focus of my composition, which was reflected light on the foreground rocks. But depth of field demanded an aperture of f/22½ and, with the resulting shutter speed of 20 seconds, I knew any foamy detail in the water would disappear as the sea ebbed and flowed during the exposure.

The result is a by-product of technical photographic necessity. Sometimes it really does not work. But here the starkness of the rocks and the lack of recognizable landmarks complement the misty water. Even though 25 years have passed since I first saw his work, John Blakemore's images haunt my feelings for certain landscapes, especially those with a primal, timeless quality.

Sandy Mouth, rocky shore

The Cornish coast north of Bude runs due north–south. Facing west over the Atlantic, it is a superb afternoon/evening location throughout the year. Four miles to the north of Bude is the National Trust beach of Sandy Mouth, so named because of the beautiful banks of golden sand exposed at low tide. At high tide it is in fact a very rocky environment indeed, as can be seen from the photograph on this page.

The steep cliffs at the back of the beach are composed of stunningly photogenic metamorphic rock. Under heavy assault from the powerful Atlantic waves, these highly eroded ramparts are a treasure chest of graphic textured forms.

Mesa Arch

In 1986 I was given *Nature's America*, a book of photographs by David Muench. For the several years that followed I wasn't able to visit the States, and it was a precious reminder of the incomparable American West, where my desire to become a landscape photographer was really forged. Back in 1986 I was still a 35mm user, but it seems no coincidence to me that David Muench's photographs are all made with a 5 x 4in view camera. His deep-focus, richly coloured images seem to leap off the page. The wealth of detail and tonal depth of his work pointed in the direction my own path would eventually lead.

Nature's America covers most of the United States, but with the exception of some ancient native American structures (kivas) and rock art (petroglyphs), the images are exclusively of wilderness. Naturally enough, the great states of the west and southwest feature most strongly, and one of David Muench's favourite locations is Canyonlands in Utah, a vast National Park centred on the confluence of the Green and Colorado Rivers. Most of Canyonlands is accessible only to intrepid travellers, but a few roads do penetrate quite deep into its rugged territories, allowing the less adventurous a glimpse of one of the planet's wildest places.

One such road crosses the Island in the Sky, a peninsula-shaped high plateau, buttressed by 300-metre-high cliffs. An easy trail leads to Mesa Arch, which frames a sensational view into the canyon of the Colorado. By any standards it is an extraordinary sight, but it has an ace up its sleeve that makes it unique and magical. At dawn the rising sun reflects red light from the cliff below onto the underside of the arch. The resulting warm glow on the light sandstone is so unexpected, and so hot, that the arch almost seems to be on fire. This fiery glow is no rare phenomenon, but an almost daily event because of southern Utah's fine weather. Consequently, it is a popular spot. The last time I took a group there we had to wait until the twenty-seven German tourists who arrived before us had vacated the best positions. There cannot be many dawns in the year when there is not a group of photographers present to capture the scene.

Afternoon alternative

In the main photograph I set out to compose a portrait-shaped image, partly because on my previous visit I had made a panoramic (6 x 12cm) horizontal. I knew the sky framed within the arch would be too bright to hold much detail, but by including the sky above it I would have the complementary colours sky blue and rock orange within the frame, albeit not quite next to one another. A super-wide-angle (58mm) lens included all the elements I wanted, and helped provide the depth of field required. The foreground rock is only about 3 feet from the camera.

There are many rock arches in this area that are larger and more beautiful than Mesa Arch, but none frames such a phenomenal backdrop. The alternative version on this page was shot in late afternoon light, and is improved by some dramatic shadows on the giant rock towers in the distance.

Ravenscar

Landscape photography is usually a solitary occupation, and it is easier to stay focused if you are alone. Still, I am no loner and it's good to have a trustworthy companion with a sense of humour, especially if you're somewhere off the beaten track. I've spent more time out on the hill with David Ward than any other landscape photographer. If we set out together we often explore in different directions, sometimes ending up at the same spot, and usually meeting up for the walk back to wherever our vehicle is parked.

Such companionship is good for both personal security and creative inspiration. David's close-up work is outstanding, and he is a mine of information on life, the universe and everything, as well as being a dealer of wisecracks with few equals. We both like the same sort of light and subject matter, but invariably find quite different ways of interpreting them. Naturally, I like to check on what he is doing, and vice versa. A glimpse of the image in the other's viewfinder sometimes provokes the rebuke, 'You absolute b———-d.' It is

delivered with respectful appreciation, and met with pride, for this is a token of high esteem.

In the 1980s David did a series of walking books around Britain, one of which was on the North York Moors. A double-page spread from that book of Robin Hood's Bay inspired my first visits. My David Ward tribute therefore is an image of Robin Hood's Bay, looking towards Ravenscar, shot on a summer dawn.

The intertidal zone at Robin Hood's Bay is an impressive series of uptilted, sweeping rock ledges, which harbour a varied assortment of aquatic environments. Although highly beneficial for marine biodiversity, this complex content is tricky to photograph in a clear, rather than chaotic, fashion. In this case I adopted an approach David uses with his workshop students, the well-known KISS principle – 'Keep It Simple, Stupid'. The barnacle-covered central boulder, with sand ripples flickering towards it, gives a strong, simple theme to the lower half of the picture. Beyond it, the beds of seaweed, sea, cliffs and sky recede in a pattern of (relatively) horizontal zones.

Light turn-off

Because the cloud cover was uniform there was little incentive to include much sky, but I included enough to just frame the line of the cliff that sweeps around to the distant headland of Ravenscar. The early sun, which appeared only briefly, is the vital element that brings the landscape to life and energizes the colours.

Just how important the sun was can be judged by the small picture on this page. Shot a few minutes before the main photograph, the cold tones and lack of modelling on the sand ripples are disappointing. Having set up the composition initially for the horizontal format, I changed my mind shortly after this exposure was made and switched to a vertical. This allowed me to crop out the distracting stone on the right, and to include more of the sand ripples in the foreground.

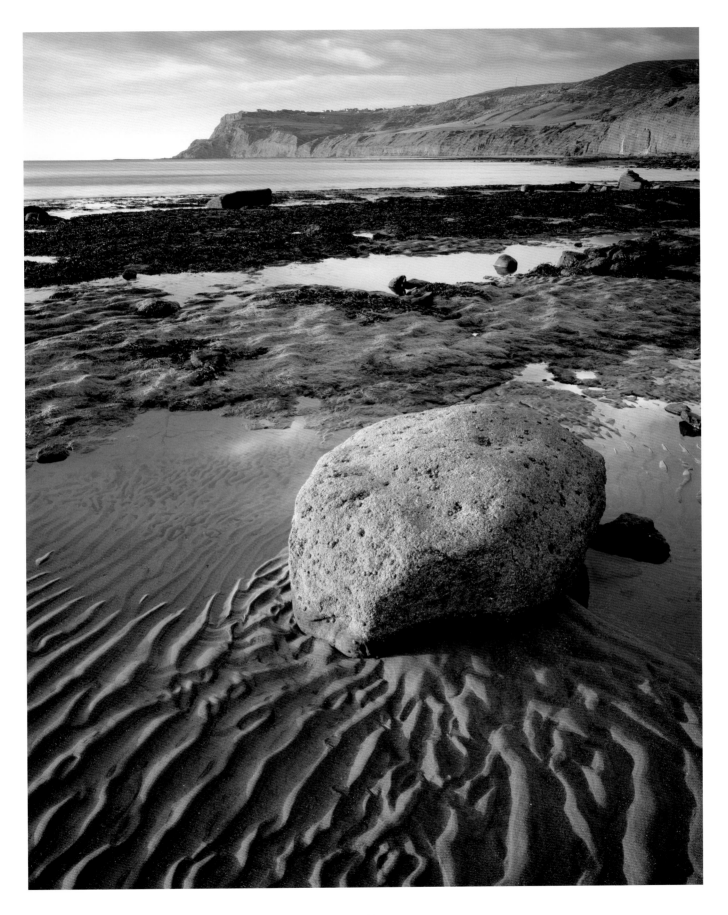

A civilized landscape

No British landscape photographer is better known or more respected among his peers than Charlie Waite. Like all the photographers featured in this chapter, Charlie is an innovator with a distinctive, original style, and he has led the way in the British landscape world with his series of books.

While Charlie would be a legend for his photographs alone, in recent years he has set out to popularize the art of landscape photography in Britain by other means. He is an ever-present contributor to the photo magazines, in which he takes readers out into the landscape, sharing his experience and vision, and offering his encouragement and critical insight in the finished articles. He has his own photographic holiday and workshop company, Light & Land, which has now helped hundreds of people improve their photography and deepen their appreciation of landscape.

He is always in demand as a speaker on the club circuit and, in spite of a punishing schedule, manages to deliver enough lectures to entertain and enthral hordes of camera-club members each year. Trained as an actor, Charlie is truly the great communicator of landscape photography, who can hold an audience spellbound with his images and anecdotes. Charlie's encouragement, kindness and friendship have meant a great deal to me personally. Ever since we first met in 1986, his thoughtful advice and personal endorsement have helped me on the landscape photography journey.

Although Charlie Waite has travelled and photographed worldwide, I always associate him with Tuscany. His style is distinctive for its geometry and sense of design. With its serried ranks of cypresses and parasol pines, rolling ridges and numerous medieval hill-top towns, Tuscany's civilized landscape is the natural domain of Charlie's camera.

Light & Land's most popular holiday destination is Tuscany, and the hotel it uses is outside San Quirico d'Orcia, a few miles from where the main photograph here was taken. In the distance can be seen Monte Amiata, the highest point in southern Tuscany. In such a cultured landscape it is possible to believe that man and nature really can live in harmony.

The slow cities

The small image is taken beside a winding road outside Montechiello, a subject made famous by numerous car advertisements and a million Tuscan postcards. The dominant greens indicate it was shot in May, when Tuscany is still damp from spring rains.

This part of Italy has endeared itself to me recently by the declaration of several of its historic towns that they are citta lente – *slow cities. The restaurants serve 'slow food', and the pace of life is unhurried and relaxed. This is a deliberate repudiation of the McDonald's culture, and the hectic, instant-gratification society.*

I see the view camera as the photographic equivalent of citta lente, *inviting the user to slow down, think, and receive, rather than snap and grab.*

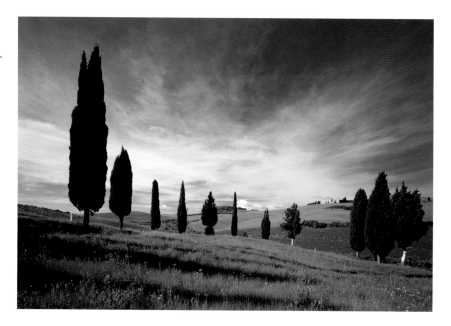

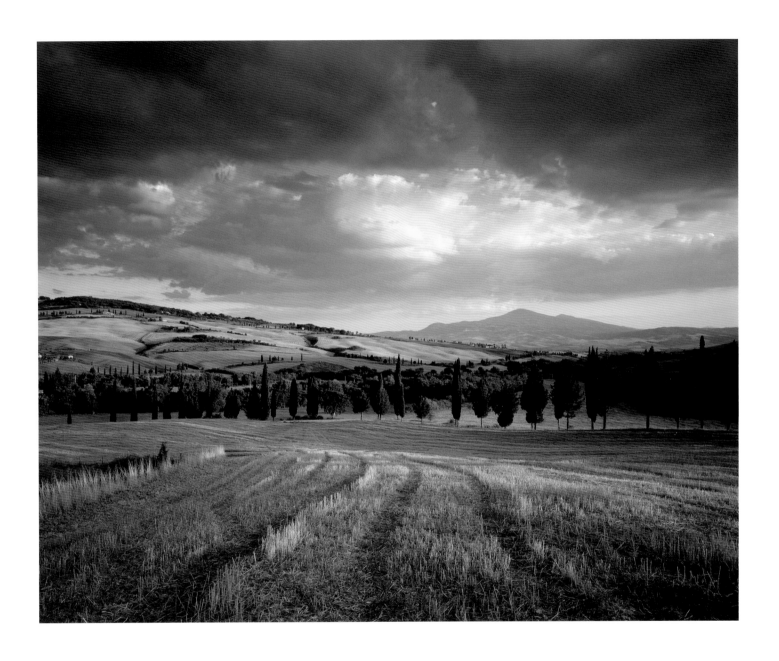

*T*ime and light

Of all my friends who are photographers, I have spent more time discussing aesthetics and technique with Nick Meers than anyone else. I still remember a conversation we had in which he explained his own philosophy of shooting landscapes, 'Time and light, Joe, that's what we deal with. What subject matter, what a privilege that is. Think of that, time and light.' He's right, of course, it is a fantastic privilege – one I hope I will never take for granted. This conversation helped crystallize my own perspective on the foundations of landscape photography – timing, lighting, and composition (TLC).

Nick is a much-published photographer who, like me, has worked for the National Trust for more than a decade. He has long used the panoramic 6 x 17cm format, but was frustrated enough with the limitations of the cameras available to build his own, incorporating the tilt and shift movements of a view camera. Using this instrument he created the image of Dunstanburgh Castle that inspired my own efforts here. The conventional angle on Dunstanburgh is from the south, a view immortalized by one of England's greatest-ever landscape painters, J.M.W. Turner. But Nick took it from the northwest, the Embleton side, using the boulder field in the foreground.

Living only an hour and a half or so from the Northumberland coast, I have come to know and love it well. Of all the castles for which the area is renowned, the ruin of Dunstanburgh makes, in my view, the most inspiring photographic subject. Low-lying land around it means it enjoys good light at the beginning and end of the day throughout the year. In the main photograph, Nick's angle, the very first rays of dawn make the picture.

The basalt boulders are here encrusted with almost-white barnacles. I knew what to expect, and had set up well before dawn. Be there and be ready, as the saying goes. The rising sun turned the boulders pink, briefly, before vanishing into the vast blanket of cloud encroaching from the west. The period of useable light was less than a minute. As is so often the case, there is no substitute for being in the right place at the right time for the right light. Time and light, no question!

Anti-vibration improvisation

From the south, Dunstanburgh Castle presents its partially intact curtain walls and vast drum-turreted gatehouse in the view made famous by J.M.W. Turner. The foreshore is full of rockpools, and harbours a healthy marine environment due to the high water quality in this relatively sparsely populated stretch of coast. A long lens was used, drawing the castle into the composition.

Like all coastlines, this is a windy place and, with no cliffs to provide lee-side shelter, it seems to be equally windy whatever the direction. The only technical solutions I know to the problem of wind vibration are to keep the camera low by spreading the tripod legs, to shelter the camera with your body (works fine, unless you are shooting into the wind!), and to use a wide-angle lens. I frequently use all three techniques at Dunstanburgh.

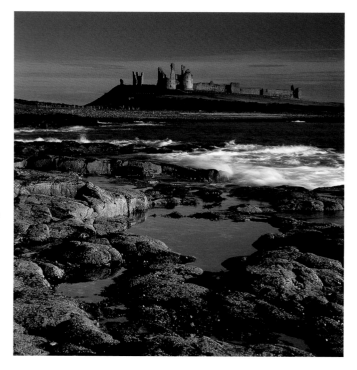

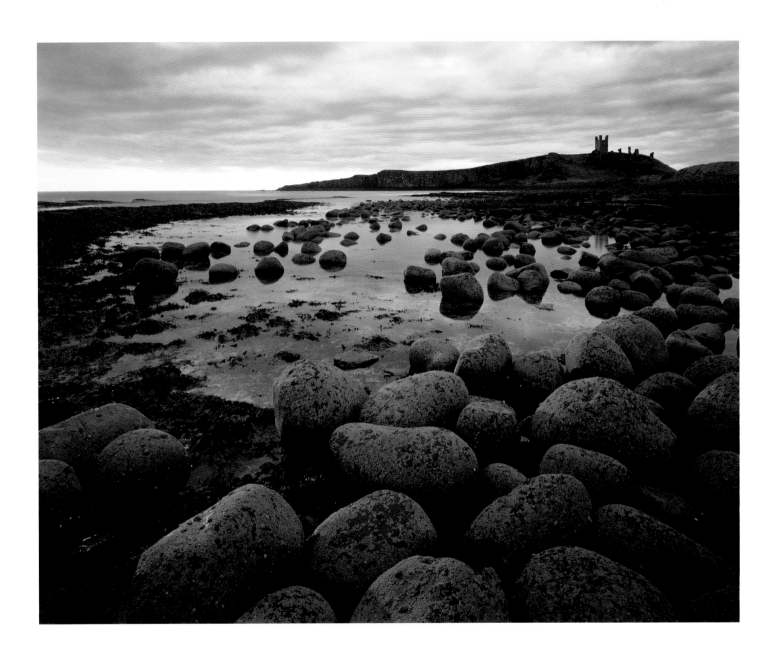

Crest of the wave

When I first saw Michael Fatali's photographs at his Springdale gallery outside Zion National Park, Utah, I experienced a strange mixture of emotions. On the one hand, I felt joy to see spellbinding colour prints of canyon details and desert vistas positively glowing on the walls in front of me. On the other hand, I felt deflated and depressed to think that here was someone whose work was on an altogether higher plane. I realized how limited my own pictures were by comparison. Fatali works on 10 x 8in and, combined with his wonderful eye for light, composition and colour, the exquisite technical quality of his photographs surpasses imagination. His original Ilfochrome prints really are unlike anything else you have ever seen.

It took me a while to overcome the shock of seeing Michael's work. I bought some of his posters, and still have them framed at home. For me they remain a benchmark of colour landscape photography. Of course, my depression didn't last long, while Michael Fatali's work remains a joy, and continues to inspire me to do better. I have subsequently been fortunate to meet Michael on a few occasions. He is still a young man who believes the best is yet to come – quite an alarming prospect for fellow landscape photographers!

Michael Fatali was not the first photographer to venture into Antelope Canyon, but he was the first to fulfil its photographic potential. Although thousands of photographers have been there now, his images are still the best. In this alone he is an innovator. But he has spent most of his photographic career exploring the backcountry of the Colorado Plateau, in search of unknown wonders.

Among them is a quarter of the Paria-Vermilion Cliffs wilderness whose exact location photographers do not declare. In that place, the slick rock language which flows through the 250 million-year-old layer cake of the Colorado Plateau reaches a unique eloquence and beauty. The main photograph shows one small corner of this area, a swirling wave of sandstone, touched here by the last rays of evening sunlight. Proud though I am of this photograph, it is Michael Fatali's image of this wave that hangs on our bedroom wall at home.

Working hard to see the wilderness

I was joined by my friends David Ward, Phil Malpas and Clive Minnit for a three-day adventure into this part of northern Arizona. Carrying all our equipment and enough water for each day in the desert did our fitness levels a lot of good, but most of the time we were so distracted by the scenery that we didn't notice the exercise. The small image on this page is one of several fabulous vistas we discovered.

Although America's great national parks and monuments are marvellous, they are to an extent packaged and civilized by roads and trails, so they are not a true wilderness experience. That is not an accusation that could be levelled at the Paria-Vermilion Cliffs. No paved roads, no made-up trails and a minimal daily permit policy preserve its stunningly wild atmosphere.

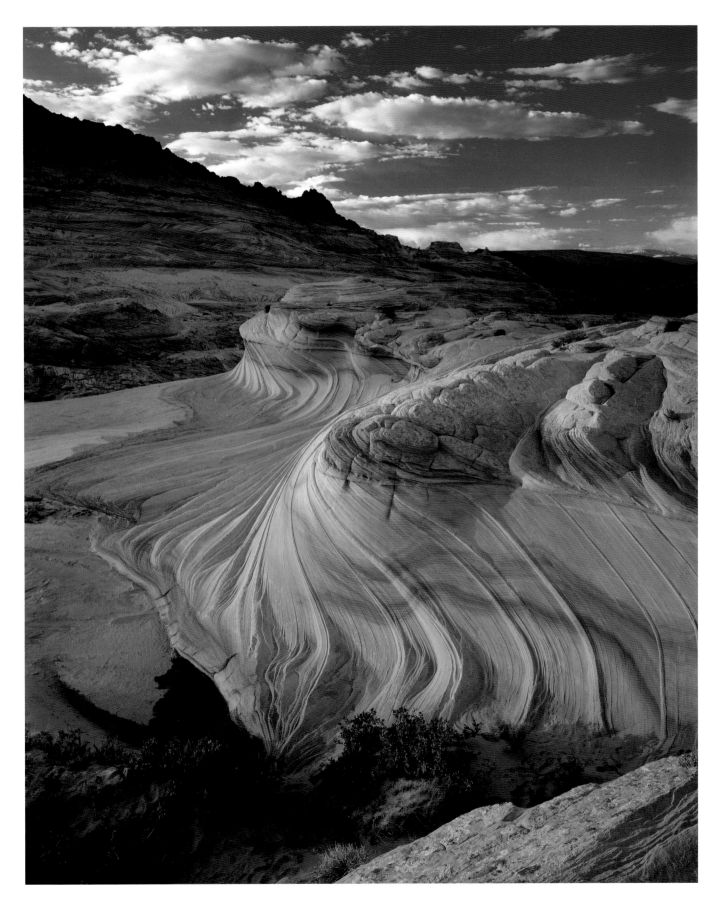

Elgol

Paul Wakefield's work has inspired me ever since I first saw his collaborative books with Jan Morris, published by Aurum in the 1980s. At the time I was a struggling young photographer, but Paul was setting standards for travel-book photography that remain unsurpassed to this day.

If anything, Paul's photos were too good for travel books – too moody, too personal, too unlike the blue-sky, fluffy-white-cloud blandness required at the time. My guess is they were mainly bought by fellow photographers who, like me, never read more than a couple of sentences of the big-name author's text, but wondered at the photographer's masterly portrayal of Wales, Scotland, and Ireland. Paul's photographs often depicted these landscapes in the threatening weather we know is typical of these Celtic fringes of Europe. That makes them all the more convincing and powerful.

In his Scotland book, Paul Wakefield's photograph of the Cuillin ridge from Elgol is one of my favourites. It is certainly the reason I visited there on my first trip to Skye. This was when the main photograph was taken. For March this was a day of pretty fine weather by Skye standards, and although there were a number of rain showers, there were sunny breaks until quite late in the day, when the cloud descended. In the main picture that process has already started, with the high peaks of the Cuillin ridge already obscured. However, the sun is shining on the rock wall to the right of the image, and the colour and texture there redeem the situation.

But without the circular boulder surrounded by swirling water, the rock wall would be too dominant. Foreground elements elsewhere are also significant, echoing forms and lines in the rock wall and the distant mountains. Nevertheless, the boulder is the key element, the anchor around which the composition revolves. Fortunately, the late afternoon sunlight provides a highlight, and enough sculptural modelling, to ensure the boulder remains the central focus of our attention.

Monochrome colour

When I returned to Skye the weather was the usual mixed bag, and the afternoon I revisited Elgol was particularly disappointing. I went to the place of the round stone, and was attracted by some thrift growing among the rocks, just above the high-tide line. Subjects with texture and subtle colour often work better in soft light, so, using the boulder again as a visual device, this time at the top of the composition, I attempted a tightly framed nature study.

I chose to shoot on ISO 100 Provia F, with its neutral colour palette, rather than Velvia. Although Velvia is an excellent choice for many flat light applications, it can shift to green with subjects of subtle colour made on a long exposure. A standard 150mm lens (similar to a 45mm lens on 35mm) draws the scene without distortion. The result is a very restrained and cool image of coastal flora.

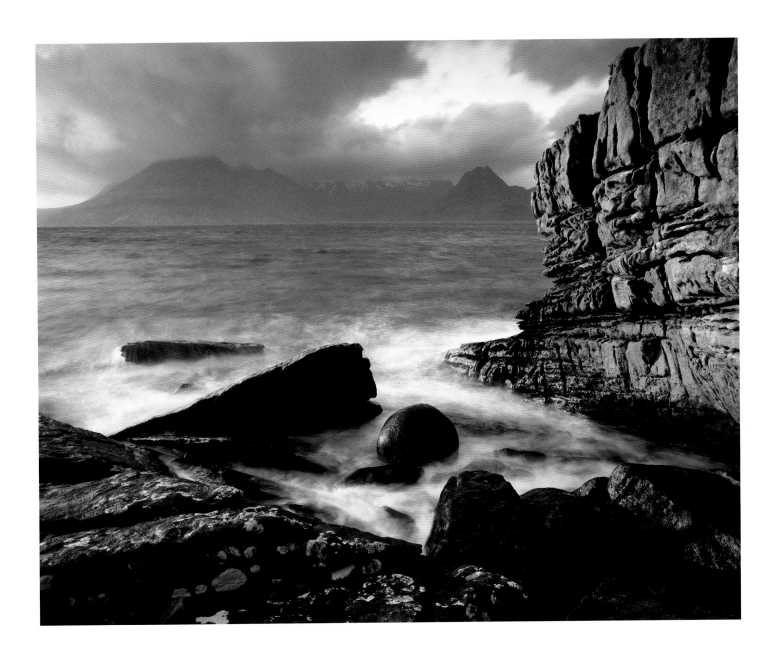

On the mountain

In Australia's island state of Tasmania, Peter Dombrovskis is a household name. The first Australian invited to exhibit solo at the International Photography Hall of Fame in Oklahoma, Peter's work is now beginning to receive the worldwide attention it deserves. He died in 1996 at the age of fifty-one while photographing in the Western Arthur range of Tasmania's southwest wilderness, but the quantity and quality of his work would represent more than a long lifetime's achievement for most of us.

Evidently, Peter was a softly-spoken, understated man, and his work echoes his personality. Most of his photographs appear to be have been shot in misty or overcast light – very little light at all in some cases! Yet they have an amazing depth and vitality, and many have a profoundly spiritual quality. The majority of his images are close-ups, nature studies, portraits of the rocks, shells, trees, flowers and plant life that make up Tasmania's unique wilderness environment. Arguably, soft light tends to suit such textural subjects, but it was really Peter's ability to see things clearly, and with deep passion, that makes his photographs so unique.

While fellow photographers marvel at the Dombrovskis low-light technique, we can all appreciate and admire Peter's work in nature conservation. A self-taught photographer and bushman, Peter used his deep knowledge of environmental issues, along with the inspirational impact of his images, to campaign effectively for the protection of Tasmania's remaining wilderness areas. When the Franklin River dam scheme was concocted in the late 1970s, Peter found himself at the forefront of efforts to oppose the plan. His image Rock Island Bend, a magnificently evocative photograph of the Franklin River, is widely credited as the icon around which the Australian public united. On July 1 1983, the High Court Of Australia declared the Franklin River dam scheme illegal, and within a month all the earth-movers were withdrawn, leaving the wilderness intact.

Backyard of a hero

My favourite book of Peter's is called On the Mountain. *It is a photographic portrait of Mount Wellington, the huge, sprawling volcanic plateau that looms over Hobart. Since he lived at Fern Tree, halfway up Mount Wellington, this was quite literally the landscape in his backyard. For me it was a place of pilgrimage.*

A legacy of the mountain's volcanic origins, dolerite columns flank the east-facing edge of the summit plateau. At more than 1300 metres high, and exposed to the full force of Southern Ocean storms, this rugged environment nevertheless harbours a diverse natural ecosystem. Since a road leads to the top it would be wrong to describe the mountain as a wilderness, but it is still largely wild and unspoilt.

The small photograph, made at dusk the night before the main image, shows the dolerite glowing in the twilight. In the distance can be seen the peninsulas and islands which enhance Hobart's magnificent setting.

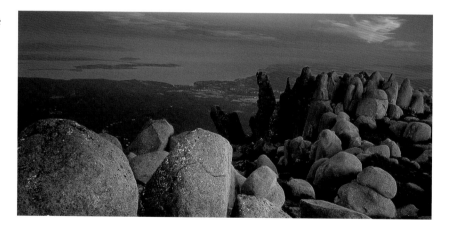

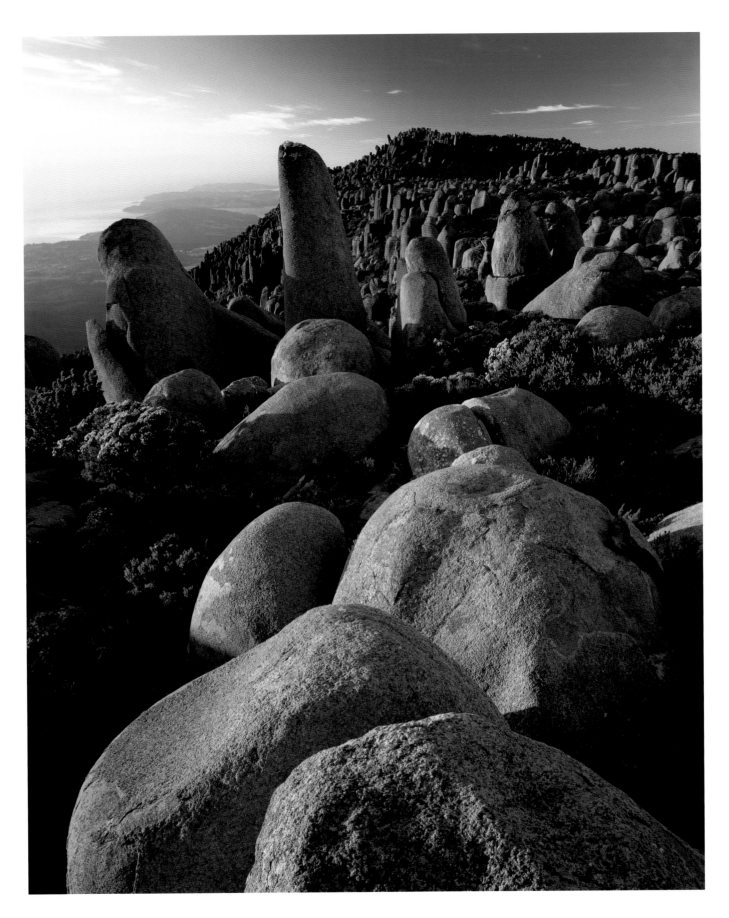

Light wait equipment

Ah yes, wait for the light. We also chase it, and anticipate it. But what we carry is not lightweight!

The pioneers of landscape photography required dedication and physical endurance to carry titanic loads into some of earth's remotest places. From the early American surveyors like Carleton Watkins and Timothy O'Sullivan, to Ponting and Hurley who accompanied Scott and Shackleton to the Antarctic, early photographers truly suffered for their art. Ansel Adams carried his 10 x 8in camera into the Yosemite back country, and more recently Peter Dombrovskis regularly hauled a 90-pound pack into the Tasmanian wilderness, much of it survival gear, rather than cameras. Be in no doubt, this was not lightweight equipment.

I am fortunate by comparison. My pack rarely weighs more than 20 kilos, and modern carbon fibre tripods provide superb support at little more than half the weight of traditional aluminium or wooden equivalents. If I am out for half a day or longer I also carry food and water and, where sensible, waterproof clothing. Speaking of clothing, thermal undergarments and fleece are my preferred apparel for working, thanks to the comfort they provide in a wide range of conditions. Being warm, dry and as comfortable as possible allows me to stay focused on the photography. By the sea I almost invariably wear rubber Wellington boots so I can stay dry in up to a foot of (salt) water. In desert conditions, it's rafting sandals.

I have used a 5 x 4in sheet film camera almost exclusively since 1997. The shape of this format corresponds to those most commonly used in publishing. It is unobtrusive and unremarkable, and I find it suits my style, encouraging me to concentrate on the landscape, not on how I'm going to squeeze it into the shape of some extreme format. My preferred camera is currently an Ebony SW45. A non-folding field camera, this model is remarkably quick and easy to set up – important if you work in fast-changing light. Over the years I have used dozens of different cameras and formats. All have merits (and limitations) and all are simply a means to an end. Viewing the image upside down on the ground glass screen works well for me, and 5 x 4in provides more than adequate quality for exhibition printing. Much as I would love to use 10 x 8in, the extra weight and bulk would slow me down and inhibit my freedom of movement. I find the 6 x 17cm panoramic format gimmicky and restrictive, although I enjoy looking at pictures by photographers who use it well. I do occasionally use a 6 x 12cm back on my 5 x 4in.

I generally carry five lenses with me at any one time. Typically, these might be 72mm, 90mm, 150mm, 210mm and 300mm, which covers super-wide to short telephoto. (Attribution of specific focal lengths can be found in the Technical Information section.) The manufacturers include Nikon, Schneider, Rodenstock and Fuji, and I am certain when my images are less than perfectly sharp, the fault is mine, not that of any of the lenses. I use a hand-held meter, either a Pentax digital spotmeter, or a Minolta spotmeter F. These instruments enable the photographer to judge placement of tone on the film with real accuracy. They

encourage me to take control and responsibility for exposure in a way no automated system can. This is both a more rewarding and ultimately more accurate practice than any other exposure system I know.

Filters play a vital role in my work, enabling me to produce on film what I see before me, or what I can visualize in my mind's eye. I don't want to see the filter – indeed, if filtration is obvious in the result, I consider it a failure – and so filter quality, as well as good technique, is vital. I use Heliopan polarizers, but all my other filters are made in England by Lee. These manufacturers produce truly neutral ND graduates, consistent colour-correction and light-balancing filters, and an excellent system filter holder. I carry at least eight ND grads of different densities and hardness, many warm-ups, a blue filter, two polarizers and four Lee filter holders. I keep a filter step ring permanently attached to each lens, to save setting-up time.

I have never hand-held a 5 x 4in camera, and though I know it is possible, I can't see myself trying it! Therefore I regard a tripod as crucial, the foundation on which my technique is built. I generally use a Gitzo carbon fibre 1348 tripod, with a Manfrotto 410 head. I also occasionally use a lighter Mountaineer model for some travel assignments, and a heavier Manfrotto 075 for long-lens work.

Most of the photographs in this book were shot on Fujichrome Velvia. Although now a comparatively elderly product, this film remains the preferred choice of most landscape photographers, with strong yet natural-looking colours, superb sharpness and ultra-fine grain. I usually give one third to two thirds more

exposure than its nominal rating of ISO 50 would suggest, and I find the quick-load back and film system convenient in the field. I also use Fujichrome Provia F, which has excellent colour balance for delicate neutral subjects, and only suffers reciprocity failure in extremely long-exposure situations.

Much of this book was written, quite literally, with a pencil on the backs of many envelopes. True, in the end the information was transferred to a laptop computer for editing and organizing, but the point is that in this age of extraordinary technologies it is not the technology itself that matters, it is what we do with it. For me a pencil and a scrap of paper is often more convenient than a computer. The bulky view camera, little changed in design for 150 years, and traditional film technology remain, for me, a better way of creating photographs than any automated digital capture system. I am a pragmatist, however, and as soon as the quality, convenience, price and all other aspects of operating digital make it superior to film, I will not be influenced by sentiment. As I write this, that day still seems a long way off, but some unexpected breakthrough in chip design could prove me wrong.

It is one of photography's pleasures to use equipment of such good quality that its performance can be taken for granted. The right tools allow us to focus completely on the work at hand. Discussion about cameras, lenses and all the other technical paraphernalia of our profession is inevitable when photographers get together and talk. But none of that is really half so interesting as what we do with it.

Technical information

Old Man of Storr, Trotternish, Isle
of Skye, Scotland
Ebony 45S field camera
Nikkor-SW 90mm f/4.5
Lee 0.6 ND grad, Lee 81B
Fuji Velvia
1 sec @ f/22 $^1/_2$

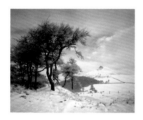

Arklet Water, Inversnaid,
Trossachs, Scotland
Ebony SW45 field camera
Nikkor-W 150 f/5.6
Lee 85C
Fuji Velvia
20 secs @ f/22 $^2/_3$

Roseberry Topping, North
Yorkshire, England
Ebony SW45 field camera
Nikkor-SW 90mm f/4.5
No filter
Fuji Velvia
1/2 sec @ f/22

Botanical Gardens,
Fuerteventura, Canary Islands,
Spain
Ebony SV45U field camera
Nikkor-W 210mm f/5.6
No filter
Fuji Velvia
1 sec @ f/32

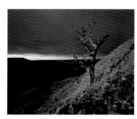

Hawnby Hill Crag, North York
Moors, England
Ebony SW45 field camera
Nikkor-SW 90mm f/4.5
No filter
Fuji Velvia, pushed one stop
4 secs @ f/22 $^1/_2$

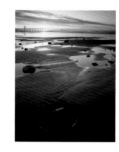

Saltburn, Cleveland, England
Ebony SW45 field camera
Nikkor-SW 90mm f/4.5
Lee 0.9 ND hard grad
Fuji Velvia
4 secs @ f/16 $^1/_2$

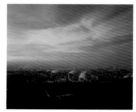

Wilton and Teesmouth, Cleveland,
England
Ebony SW45 field camera
Nikkor-W 150mm f/5.6
Heliopan polariser
Fuji Velvia
22secs @ f/16

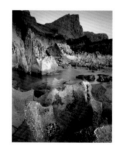

Mewslade Bay, Gower, South
Wales
Ebony SW45 field camera
Nikkor-SW 90mm f/4.5
Lee 0.6 ND hard grad
Fuji Provia F, pushed 2/3
30 secs @ f/32

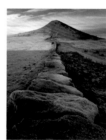

Roseberry Topping, North
Yorkshire, England
Ebony 45S field camera
Nikkor-SW 90mm f/4.5
Heliopan polariser,
Lee 0.6 ND hard grad
Fuji Provia
4 secs @ f/32

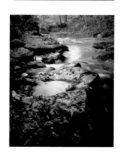

May Beck, North York Moors,
England
Ebony SW45 field camera
Nikkor-SW 90mm f/4.5
Heliopan 81EF, Lee 0.3 ND hard
grad
Fuji Velvia
8 secs @ f/22

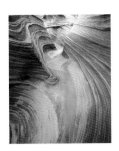

Paria-Vermilion Cliffs Wilderness,
Northern Arizona, USA
Ebony SW 45 field camera
Schneider Super-Angulon XL
58mm f/5.6
Lee 81B
Fuji Velvia
3 secs @ f/22 ¹/₂

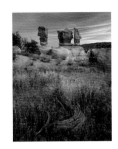

The Devil's Garden, Grand
Staircase - Escalante Wilderness,
Utah, USA
Ebony SW45 field camera
Nikkor-SW 90mm f/4.5
Heliopan polarizer,
Lee 0.45 ND hard grad
Fuji Provia F
1 minute @ f/22

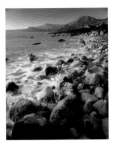

St Aldhelm's Head, Purbeck,
Dorset, England
Ebony 45S field camera
Nikkor-SW 90mm f/4.5
Heliopan polarizer,
Lee 0.6 ND hard grad
Fuji Velvia
1sec @ f/22 ¹/₂

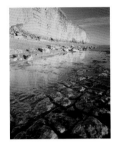

Burton Bradstock, Dorset,
England
Ebony 45S field camera
Nikkor-SW 90mm f/4.5
Heliopan polarizer,
Lee 0.3 ND hard grad
Fuji Velvia
1 sec @ f/16 ²/₃

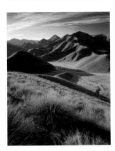

Lindis Pass, Central Otago, South
Island, New Zealand
Ebony SW45 field camera
Nikkor-SW 90mm f/4.5
Lee 0.6 ND hard grad
Fuji Velvia
1/2 sec @ f/32

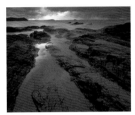

Stepper and Trevose Heads from
Pentire, North Cornwall, England
Ebony SW45 field camera
Nikkor-SW 90mm f/4.5
Lee 81B, Lee 0.6 ND hard grad
Fuji Velvia
1 sec @ f/22

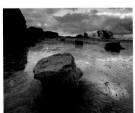

Saltwick Bay, North Yorkshire,
England
Ebony 45S field camera
Nikkor-SW 90mm f/4.5
Lee 0.75 ND hard grad
Fuji Velvia
1 sec @ f/32

Cliff Ridge and Roseberry
Topping,North Yorkshire, England
Ebony SW45 field camera
Nikkor-SW 90mm f/4.5
Lee 0.3 ND hard grad
Fuji Velvia
1 sec @ f/22

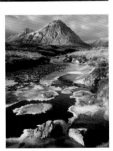

Buachaille Etive Mor, Highland,
Scotland
Ebony 45S field camera
Nikkor-SW 90mm f/4.5
Lee 0.3 ND hard grad
Fuji Velvia
1/2 sec @ f/22

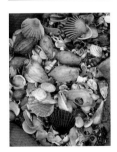

Clifton Beach, Hobart, Tasmania,
Australia
Ebony SW45 field camera
Rodenstock Apo Macro Sironar
120mm f/5.6
Lee 81D
Fuji Velvia
2 secs @ f/22 ¹/₂

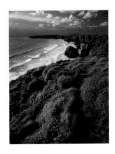

Carnewas, North Cornwall,
England
Ebony SW45 field camera
Nikkor-SW 90mm f/4.5
Heliopan polarizer,
Lee 0.45 ND hard grad
Fuji Velvia
1 sec @ f/22

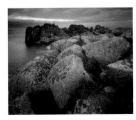

Le Gouffre, Plougrescant,
Brittany, France
Ebony SW45 field camera
Schneider Super-Angulon XL
72mm f/5.6
Lee 85C, Lee 0.9 ND hard grad
Fuji Velvia
8 secs @ f/22

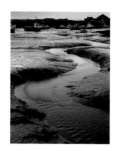

Paddy's Hole, Redcar, Cleveland,
England
Ebony SW45 field camera plus
Ebony extension back
Nikkor-W 210mm f/5.6
Lee 0.3 ND hard grad
Fuji Velvia
15 secs @ f/22 $^1/_2$

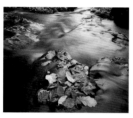

Falling Foss, North York Moors,
England
Ebony SW45 field camera
Rodenstock Apo Macro Sironar
120mm f/5.6
Lee 0.3 ND hard grad
Fuji Velvia
4 secs @ f/22

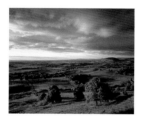

Swainby, North Yorkshire,
England
Ebony SW45 field camera
Schneider Super-Angulon XL
90mm f/5.6
Lee 0.6 ND hard grad
Fuji Velvia
1 sec @ f/16 $^2/_3$

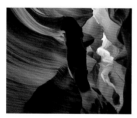

Antelope Canyon, Page, Arizona,
USA
Ebony 45S field camera
Nikkor-SW 90mm f/4.5
Lee 0.6 ND hard grad (on its side)
Fuji Velvia
22 secs @ f/22 $^2/_3$

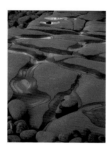

Dunraven Bay, Glamorgan, South
Wales
Ebony SW45 field camera plus
Ebony extension back
Fujinon-T 300mm f/8
No filter
Fuji Velvia
1 sec @ f/22

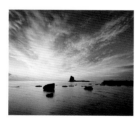

Saltwick Bay, North Yorkshire,
England
Ebony SW45 field camera
Schneider Super-Angulon XL
72mm f/5.6
Lee 0.3 ND hard grad
Fuji Velvia
11 secs @ f/22

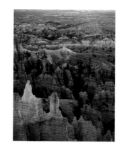

Bryce Canyon National Park,
Utah, USA
Ebony SW45 field camera plus
Ebony extension back
Fujinon-T 400mm f/8
No filter
Fuji Velvia
1 sec @ f/22

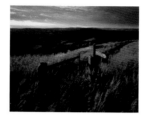

Sutton Bank, North York Moors,
England
Ebony SW45 field camera
Schneider Super-Angulon XL
72mm f/5.6
Lee 0.6 ND hard grad
Fuji Provia F
1 sec @ f/22

Snaid Burn, Trossachs, Scotland
Ebony SW45 field camera
Nikkor-SW 90mm f/4.5
Heliopan polarizer
Fuji Velvia
1/2 sec @ f/16 $^1/_2$

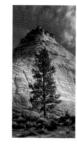

Checkerboard Mesa, Zion
National Park, Utah, USA
Ebony SW45 field camera
(Horseman 6x12 roll film back)
Nikkor-SW 90mm f/4.5
Heliopan polarizer
Fuji Velvia
4 secs @ f/22

Père Lachaise cemetery, Paris,
France
Ebony 45S field camera
Nikkor-SW 90mm f/4.5
Heliopan polarizer
Fuji Velvia
8 secs @ f/22

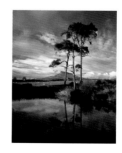

Roseberry Topping, North
Yorkshire, England
Ebony SW45 field camera
Nikkor-SW 90mm f/4.5
Heliopan polarizer,
Lee 0.3 ND hard grad (on its side)
Fuji Velvia
1 sec @ f/16

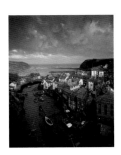

Staithes, North Yorkshire, England
Ebony 45S field camera
Nikkor-SW 90mm f/4.5
Lee coral 1 grad (inverted),
Lee 0.75 ND hard grad,
Lee 0.45 ND hard grad
Fuji Velvia
4 secs @ f/16 ¹/₂

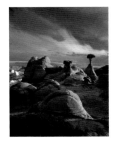

Rimrocks, Grand Staircase-
Escalante National Monument,
Utah, USA
Ebony SW45 field camera
Nikkor-SW 90mm f/4.5
Heliopan polarizer
Fuji Velvia
1/2 sec @ f/22 ¹/₃

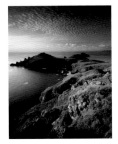

Rumps Peninsula, North
Cornwall, England
Ebony 45S field camera
Schneider Super-Angulon XL
58mm f/5.6
Heliopan polarizer,
Lee 0.6 ND hard grad
Fuji Velvia
4 secs @ f/16

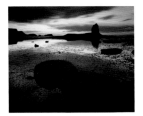

Saltwick Bay, North Yorkshire,
England
Ebony SW45 field camera
Nikkor-SW 90mm f/4.5
Lee 81B, Lee 0.6 ND hard grad,
Lee 0.45 ND hard grad
Fuji Velvia
15 secs @ f/22

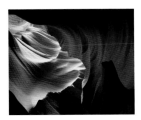

Antelope Canyon, Page, Arizona,
USA
Ebony SW45 field camera
Nikkor-SW 90mm f/4.5
Lee 0.9 ND soft grad (on its side)
Fuji Provia F
30 secs @ f/32

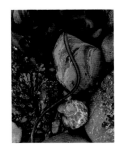

Holy Island, Northumberland,
England
Ebony 45S field camera
Nikkor-SW 120mm f/8
Lee 81B
Fuji Velvia
8 secs @ f/32

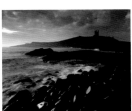

Dunstanburgh Castle,
Northumberland, England
Ebony SW45 field camera
Nikkor-SW 90mm f/4.5
Lee 0.6 ND hard grad,
Lee 0.75 ND hard grad
Fuji Velvia
1/2 sec @ f/22

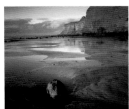

Hunt Cliff, Saltburn, Cleveland,
England
Ebony SW45 field camera
Nikkor-SW 90mm f/4.5
Lee 0.45 ND hard grad
Fuji Velvia
1 sec @ f/22 ¹/₂

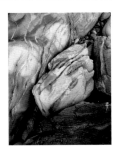

Sandy Mouth, North Cornwall,
England
Ebony 45S field camera
Nikkor-SW 120mm f/8
Lee 81B
Fuji Velvia
8 secs @ f/22 ¹/₂

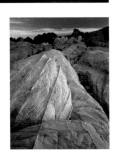

Valley of Fire State Park, Nevada,
USA
Ebony SW45 field camera
Nikkor-SW 90mm f/4.5
Heliopan polarizer,
Lee 0.3 ND hard grad
Fuji Velvia
4 secs @ f/32

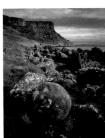

Fair Head, County Antrim,
Northern Ireland
Ebony SW45 field camera
Nikkor-SW 90mm f/4.5
Lee 0.6 ND hard grad
Fuji Velvia
1 sec @ f/22 ¹/₂

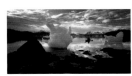

Growler Island, Prince William
Sound, Alaska
Horseman SW612 panoramic roll-
film camera
Rodenstock Grandagon-N 90mm
f/6.8
Heliopan polarizer,
Lee 0.6 ND hard grad
Fuji Velvia
4 secs @ f/16

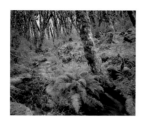

*Routeburn Track near Lake
Mackenzie, Fjordland, New
Zealand
Ebony SW45 field camera
Nikkor-SW 90mm f/4.5
Lee 81D
Fuji Provia
8 secs @ f/22*

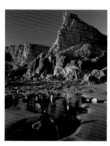

*Mewslade Bay, Gower Peninsula,
South Wales
Ebony SW45 field camera
Nikkor-SW 90mm f/4.5
Heliopan polarizer
Fuji Velvia
8 secs @ f/32*

*Wall Street, Bryce Canyon
National Park, Utah, USA
Ebony 45S field camera
(Horseman 6 x 12cm rollfilm back)
Schneider Super-Angulon XL
58mm f/5.6
Schneider ND centre filter
Fuji Velvia
4 secs @ f/22*

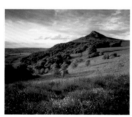

*Roseberry Topping, North
Yorkshire, England
Ebony SW45 field camera
Nikkor-SW 90mm f/4.5
Heliopan polarizer,
Lee 0.6 ND hard grad
Fuji Velvia
4 secs @ f/22*

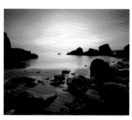

*Bedruthan Steps, North Cornwall,
England
Ebony 45S field camera
Schneider Super-Angulon XL
58mm f/5.6
Lee 81B, Lee 0.6 ND grad
Fuji Velvia
8 secs @ f/16 1/2*

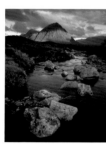

*River Etive, Rannoch Moor,
Highland, Scotland
Ebony RSW45 field camera
Schneider Super-Angulon XL
90mm f/5.6
Lee 0.6 ND hard grad
Fuji Velvia
1 sec @ f/22 1/2*

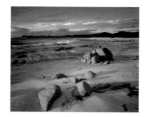

*Friendly Beaches, Freycinet,
Tasmania, Australia
Ebony SW45 field camera
Nikkor-SW 90mm f/4.5
Lee 0.45 ND hard grad
Fuji Velvia
1 sec @ f/22 1/2*

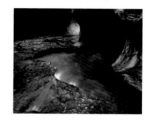

*The Subway, North Creek of
Virgin River, Zion National Park,
Utah, USA
Ebony SW45 field camera
Nikkor-SW 90mm f/4.5
Lee 10 magenta (long exposure
colour correction filter for Fuji
Velvia), 15 secs @ f/32*

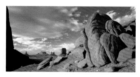

*Monument Valley, Utah, USA
Ebony SW45 field camera
Nikkor-SW 90mm f/4.5
Heliopan polarizer
Fuji Velvia. 1 sec @ f/22 1/2*

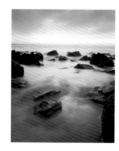

*Sandy Mouth, North Cornwall,
England
Ebony SW45 field camera
Nikkor-SW 90mm f/4.5
Lee 0.6 ND hard grad
Fuji Velvia
20 secs @ f/22 1/2*

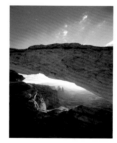

*Mesa Arch, Canyonlands National
Park, Utah, USA
Ebony SW45 field camera
Schneider Super-Angulon XL
58mm f/5.6
Schneider ND centre filter
Fuji Velvia
4 secs @ f/22 2/3*

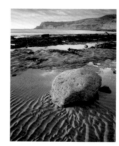

*Robin Hood's Bay and Ravenscar,
North Yorkshire, England
Ebony SW45 field camera
Nikkor-SW 90mm f/4.5
Lee 0.45 ND hard grad
Fuji Velvia
1 sec @ f/22 2/3*

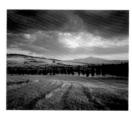

*Val d'Orcia, Siena, Tuscany, Italy
Ebony SW45 field camera
Nikkor-SW 90mm f/4.5
Heliopan polarizer,
Lee 0.6 ND hard grad
Fuji Velvia
4 secs @ f/22*

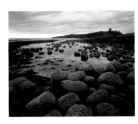

Dunstanburgh Castle,
Northumberland, England
Ebony 45S field camera
Nikkor-SW 90 mm f/4.5
Lee 0.75 ND hard grad
Fuji Velvia
4 secs @ f/16 ²/₃

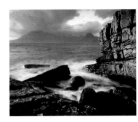

Elgol, Isle of Skye, Scotland
Ebony 45S field camera
Nikkor-SW 90mm f/4.5
Lee 0.6 ND hard grad
Fuji Velvia
1/2 sec @ f/22

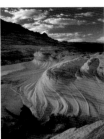

Paria-Vermilion Cliffs Wilderness,
Arizona, USA
Ebony SW45 field camera
Nikkor-SW 90mm f/4.5
Heliopan polarizer,
Lee 0.6 ND hard grad
Fuji Velvia
8 secs @ f/22

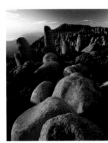

Mount Wellington summit,
Tasmania, Australia
Ebony SW45 field camera
Nikkor-SW 90mm f/4.5
Heliopan polarizer,
Lee 0.3 ND hard grad
Fuji Velvia
4 secs @ f/22 ²/₃

Acknowledgements

Many people have directly or indirectly contributed to this book. I would like to thank:

Piers Burnett of Aurum Press for having the confidence to commission this book;
Eddie Ephraums, for his endless patience, encouragement and excellent advice in its creation;
Ailsa McWhinnie for reading through the drafts;
Mike Davies of Falcon Press (Stockton-on -Tees), for scanning the main images;
Lawry and Mark Stephenson of Falcon Press for their professionalism and expertise;
Jim Harold, Mike Mitchell for showing me the way;
Jean Zunkel, Sally Kneel, Chris Jones, Jonathan Topps, Niall Benvie, Lynn Tait for inspiration, friendship, help and encouragement;
Ralph Young, Graham Merrit, Robert White, Matt Sampson, Jeanette Beattie, Tina and Ian Semple, for technical support beyond the call of commercial duty;
Hiromi Sakanashi for creating the wonderful Ebony camera;
Joni Essex, Liz Johnston, Joe Essex for their work at Joegraphic, and much more;
Sue Bishop, Charlie Waite for the opportunities of Light & Land;
Liz Dombrovskis, Margaret Ricks for keeping alive the incomparable photographs of Peter Dombrovskis;
Cam Crawford for inspiration and guidance in Tasmania;
Chrissie Lane, Nikki Kime, Vicky Barraud, Ron Enzler, Nick Cornish, Paul Harris, David Ward, Phil Malpas, Clive Minnit, my 'companions-in-arms' in the bush, on the hill, in the mountains;
Steve Burge for the wonders of Alaska 98;
Maggie Gowan, Diana Lanham, Sarah-Jane Forder for their tremendous support, and the opportunity of working with the National Trust;
Caroline Cornish for helping type the text, and along with Anne Earle, for unstinting family support;
Chava Eichner for helping type the text and produce test scans;
Jim Lycett for invaluable advice and support with digital queries.